THE ARTISTS IN PERSPECTIVE SERIES
H.W. Janson, general editor

The ARTISTS IN PERSPECTIVE *series presents individual illustrated volumes of interpretive essays on the most significant painters, sculptors, architects, and genres of world art.*

Each volume provides an understanding of art and artists through both esthetic and cultural evaluations.

NORMA BROUDE is Associate Professor of Art History at the American University in Washington, D.C. She is the author of two articles on the relation between Seurat's style and photo-mechanical printing in France in the late 1800s. These and other articles by her on such late nineteenth-century painters as Degas and the Italian Macchiaioli have appeared internationally in journals including *The Art Bulletin, The Burlington Magazine,* and the *Gazette des Beaux-Arts.*

SEURAT
in Perspective

Edited by
NORMA BROUDE

A SPECTRUM BOOK

Prentice-Hall, Inc., Englewood Cliffs, New Jersey

Library of Congress Cataloging in Publication Data
Main entry under title:

SEURAT IN PERSPECTIVE.

(The Artists in perspective series) (A Spectrum Book)
Includes bibliographical references.
1. Seurat, Georges Pierre, 1859–1891—Addresses,
essays, lectures. I. Broude, Norma.
ND553.S5 48 759.4 78–1600
ISBN 0–13–807115–2
ISBN 0–13–807107–1 pbk.

To my parents, Jack and Cecile Freedman

© 1978 BY PRENTICE-HALL, INC.
ENGLEWOOD CLIFFS, N.J. 07632

A SPECTRUM BOOK

Printed in the United States of America

10 9 8 7 6 5 4 3 2 1

PRENTICE-HALL INTERNATIONAL, INC. *(London)*
PRENTICE-HALL OF AUSTRALIA PTY., LTD. *(Sydney)*
PRENTICE-HALL OF CANADA, LTD. *(Toronto)*
PRENTICE-HALL OF INDIA PRIVATE, LIMITED *(New Delhi)*
PRENTICE-HALL OF JAPAN, INC. *(Tokyo)*
PRENTICE-HALL OF SOUTHEAST ASIA PTE., LTD. *(Singapore)*
WHITEHALL BOOKS, LIMITED *(Wellington, New Zealand)*

CONTENTS

PART TWO / Critical Approaches to the Art of Seurat, 1898 to the Present

KEY TO ABBREVIATIONS;
NOTES ON BIBLIOGRAPHY
AND TRANSLATIONS

The following are abbreviations used for works that are frequently cited in the editor's text, comments, and footnotes:

CdH The two-volume *catalogue raisonné* of Seurat's paintings and drawings by César M. de Hauke, *Seurat et son oeuvre*, Paris: Gründ, 1961. Numbers following this abbreviation refer to works by Seurat that are catalogued and illustrated in these volumes.

D.-R. The *catalogue raisonné* of Seurat's paintings by Henri Dorra and John Rewald, *Seurat; l'oeuvre peint; biographie et catalogue critique*, Paris: Les Beaux-Arts, 1959. Numbers following this abbreviation refer to works by Seurat that are catalogued and illustrated in this volume.

Homer (1964) William Innes Homer, *Seurat and the Science of Painting*, Cambridge, Mass.: The M.I.T. Press, 1964, 1970.

Readers seeking bibliographical guidance to works beyond those which are excerpted in this volume are referred to the exhaustive bibliography which is a feature of D.-R., pp. 287–301, and to the extensive, selected bibliography which is to be found in Homer (1964), pp. 305–318.

All translations in the present volume are by the editor, unless otherwise indicated.

ACKNOWLEDGMENTS

Whatever merit or utility the reader may find in this volume must be credited to the fine insights and sound scholarship of those whose work has been anthologized here. Although the literature on Seurat has not been as voluminous as that which has been inspired by some other artists of our era, it has been, uniformly, of an impressively high quality, a happy fact which has necessarily complicated the editor's occasionally painful task of choice and omission.

I am grateful to all those who have kindly permitted me to reprint their writings and to reproduce photographs of Seurat's work. In particular, I would like to thank Henri Dorra, Robert Herbert, William Homer, and John Rewald, who, in various ways, have most generously given me their help and advice.

INTRODUCTION[1]

Norma Broude

Over the course of a brief active career of some ten years, from about 1881 until his tragic and untimely death at the age of thirty-one in 1891, Georges Pierre Seurat manifested a range of development that has since prompted observers to assign to this artist a pivotal position in the evolution of modern painting. He has been rightly regarded both as the culminator of the Naturalist goals that preoccupied his immediate nineteenth-century predecessors and as the precursor of the abstract ideals that were subsequently to guide his twentieth-century spiritual heirs. Enlisting the aid of modern science and its teachings to a degree unprecedented in art since the Renaissance, he first set himself the task of perfecting a scientifically based, "chromo-luminarist" method of capturing and transferring to canvas nature's perfect union of light and color. Then, after 1886, under the dual influence of the esthetic of the literary Symbolists and the ideas of the brilliant young scientist and esthetician, Charles Henry, Seurat turned his attention to the prophetically modernist concept that the emotional content of a work of art may be established and conveyed in exclusively abstract terms, through predictable and measurable combinations of color, value, and line.

Although the nature of Seurat's shifting goals, the pattern of his development, and the historical implications of his achievements are relatively clear to us today, this has not always been the case. Perhaps more so than for any other artist of our era, the real nature of Seurat's practice and intent has been obscured by a series of misconceptions and oversimplifications, which were seized upon and established at a very early date in the

Norma Freedman Broude (1941–) Associate Professor of Art History at The American University in Washington, D.C., Ph.D., Columbia University, 1967. Author of articles on Seurat, Degas, and the Italian Macchiaioli which have appeared internationally in scholarly journals including *The Art Bulletin,* the *Burlington Magazine,* and the *Gazette des Beaux-Arts,* she is currently preparing a book on the writings of Henri Matisse and is planning a work on the sources and origins of French Impressionism.

[1] Bibliographical citations are given in the footnotes only for works not included in the present volume.

1

literature by those who sought to "explain" the complexities of Seurat's art and theory to the public at large. Many of these misconceptions unfortunately still survive today in the popular mind, despite the exceptionally high level of the serious literature that has been devoted to Seurat and his art. The primary sources and critical texts that have been assembled in this volume, therefore, have been chosen not only in an effort to present the full range of attitudes and approaches to Seurat's art, but also in the hope that their juxtaposition may help to dispel, once and for all, some of the popular myths that, for many, still cling to this artist and his work.

Certainly responsible in part for some of the misconceptions that have grown up around the art of Seurat was the artist's own reluctance, until almost the very end of his career, to make public statements or to offer directly any definitive explanation of his theories and his work. The one statement he seems in fact to have directly dictated—the note that concludes the biography of the artist by Jules Christophe in *Les Hommes d'aujourd'hui* (March–April 1890)—did not, according to Seurat's private testimony, accurately reflect his ideas in the form in which it had been printed.[2] Despite this, however, and despite the fact that it bears most directly upon the artist's later work, the Christophe statement, until the early 1920s, was universally accepted as Seurat's definitive explanation of his procedures and goals, and it was frequently interpreted as equally applicable to all phases of the artist's work. Far more illuminating, however, in helping us to understand the sources and goals of Seurat's earlier color practice are the notes the artist made in 1881 on several paintings by Eugène Delacroix, which were then on exhibit in the galleries of Parisian auction houses and dealers. Translated here for the first time, these fascinating documents affirm what Paul Signac was later to insist upon—the importance of Delacroix's art and theory for the early development of Seurat's style. Written at a time when the twenty-two-year-old artist was devoting himself largely to black and white drawing, these notes reveal not only what Seurat objectively saw and remembered when he looked at the paintings of Delacroix, but also what he seems actively and singlemindedly, even at this early date, to have been searching for in these works: the use of complementary hues to create coloristic harmony and, more particularly, the ways in which complementary colors can be used as agents of modeling, to modify and enliven neutral tones of grey.

Of special interest and value to students of Seurat's art over the years have been the witness accounts written by the artist's friends and acquaintances and, in particular, the string of essays written as eulogistic farewells by some of Seurat's closest friends in the weeks and months that immediately followed his death in March of 1891. A few of the most interesting or informative of these have been included here, some of them translated in their entirety for the first time. From all of them, written by Gustave Kahn, Émile Verhaeren, and Teodor de Wyzewa, Symbolist poets who were among the literary supporters of Seurat and his movement, there emerges with remarkable consistency the picture of Seurat as a man who was by nature cerebral and introspective, withdrawn and uncommunicative

[2] See below Seurat's letter of 28 August 1890 to Maurice Beaubourg.

even with members of his own family, but who, upon occasion, could be drawn by a close friend into eloquent and even passionate discourse about his art. Among the most valuable contributions of these witness accounts, in fact, is that they record and preserve a number of statements that Seurat made about his art, documentation all the more precious to us in view of this artist's general reluctance throughout most of his career to make public statements or to divulge the "secrets" of his method.

Many of the major issues and questions that have occupied Seurat scholars in our century were first stated and argued, with remarkable clarity and self-consciousness, by the contemporary critics who sought either to defend or to denigrate Seurat's controversial art. For extensive selections from such contemporary critical material, grouped together for each of Seurat's paintings, students of Seurat's art are indeed fortunate today in having the indispensable *catalogue raisonné* of the paintings by Henri Dorra and John Rewald, which also provides for each painting an impressive cross section of later writings, allowing us to follow the evolution of critical and art historical attitudes toward each of Seurat's major works. The selection of contemporary critical material that is offered by the present volume is of necessity more limited. It has been designed primarily to introduce the reader to the sources of some of the major issues of debate that have recurred in our own century as leitmotifs in the Seurat literature. It is hoped as well that this brief selection of writings may demonstrate that not only were some of the major questions regarding Seurat's art already being asked, but that answers to them were also to some extent already available in the literature that was published during the artist's own lifetime.

The most consistently illuminating of these contemporary sources are the essays of Félix Fénéon, the alert and sensitive young critic whose admiration for Seurat dated from his first exposure to the *Baignade* at the Exhibition of the Independents in 1884. It was at the Eighth Impressionist Exhibition, which was open from 15 May to 15 June of 1886, that Fénéon saw the *Grande Jatte*. And it was there as well that he met and gained the confidence of Seurat and his friends, establishing himself shortly thereafter as the spokesman for these artists whom he himself was to dub the "Neo-Impressionists." His review of the Eighth Impressionist Exhibition, which appeared in the Symbolist publication *La Vogue* in mid-June of 1886, indicates how great already was his immersion in the ideas, methods, and sources of Seurat and his friends. This article, slightly expanded and reprinted as a pamphlet later in 1886, was the first extended piece of serious writing to appear on Seurat, and to this day it remains the most lucid and authoritative explanation of Seurat's early goals. Its authority, in fact, is established by none other than Seurat himself, who, in a letter of August 1888 to Signac, stated that he considered "Fénéon's pamphlet as the exposition of my ideas on painting." [3]

In his review of the Eighth Impressionist Exhibition, Fénéon had presented Seurat's art as a systematic and scientifically based extension and

[3] This letter was first published by John Rewald in 1948. See "Artists' Quarrels" below.

improvement upon the goals and methods of the Impressionists. The latter, he said, seeking to capture sunlight on their canvases, had discovered the advantages of optical mixture. They had "made separate notations, letting the colors arise, vibrate in abrupt contacts, and recompose themselves at a distance." Their use of this principle, however, had been haphazard and irregular. Seurat, on the other hand, by consistently applying his pigments in separate small touches and in dosages that were "complexly and delicately measured out," had succeeded in eliminating the impurities and dullness of color that still resulted in Impressionist pictures from pigmentary mixtures carried out intentionally on the palette or accidentally, through haste, on the canvas itself. The separate spots of color on Seurat's canvases, he explained, would instead recombine in the eye of the beholder as optical mixtures of colored rays of light, producing color sensations that, according to the findings of scientists like Rood, would be far superior in luminosity to those derived from conventional palette mixtures.

The theory of optical mixture thus offered by Fénéon as the basis for Neo-Impressionism soon filtered down to the general public, and even to other artists, in a grossly oversimplified and distorted form. By 1894, for example, Paul Signac complained in his diary that a contemporary painter named Raffaëlli "is so well versed in our technique that he believes it consists solely in placing a red next to a blue in order to obtain violet, and a yellow beside a blue to make green." [4] The idea that optical mixture required Seurat to restrict himself to just the three primaries—an idea quickly dispelled by even the most cursory examination of any of his canvases—was an incorrect, albeit easy, explanation, which has held great appeal for the popular imagination. In art historical circles, this persistent myth was officially debunked in 1944 by J. Carson Webster, and it was definitively laid to rest in 1959 by William Innes Homer, whose study of Seurat's palette showed that it contained no less than eleven spectral colors, each of which, according to Neo-Impressionist theory, could be physically mixed with the colors adjacent to it on the chromatic circle and with white.

But even those among Seurat's contemporaries who were not burdened by the simplistic myth of the three primaries were nonetheless hard put to make their experience of Seurat's pictures conform to their mistaken conception of his theoretical aims. They approached Seurat's canvases, first of all, with the expectation that optical mixture of the separate spots of color would be complete, and they further interpreted claims of greater "luminosity" for such mixtures to mean greater brightness and intensity of hue. As a result, they were perplexed and disappointed to discover that this was not in fact what took place. As opposed to writers like Fénéon and Verhaeren, who consistently praised Seurat's canvases for their luminosity and atmospheric vibration, the majority of less friendly critics found these same works to be dull and grey. Although this "grey dust of light" was considered to be a positive attribute in the seascapes—

[4] John Rewald, "Extraits du journal inédit de Paul Signac, I, 1894–1895," *Gazette des Beaux-Arts* (July–September 1949), 169 (in English translation) (entry of 3 December 1894).

works that were almost universally admired, both by critics of the Naturalist as well as the Symbolist persuasion—it was cause for ridicule in the figure compositions, and it was often cited as indisputable proof of the "failure" of Seurat's method. Even Signac, writing later in 1897, felt compelled to complain of Seurat's *Les Poseuses* (Fig. 19) that "it is too divided, the touch is too small . . . the execution . . . gives to the ensemble an overall grey tonality." [5] Signac's evident embarrassment in the late 1890s over the "greyness" of Seurat's canvas coincides, of course, with his own growing taste at this point for chromatic intensity and a progressively larger brushstroke, and this change in his own taste and style seems to have colored his attitude toward Seurat's original aim.

The supremely Naturalist character of this aim is suggested by the definition of painting that Seurat himself reportedly offered in conversation to Gustave Kahn, a definition clearly most applicable to his early, pre-1888 work. Painting, Seurat told Kahn, is "the art of hollowing out a surface." [6] And clues to the manner in which Seurat pursued this objective with the aid of the theory of optical mixture and the technique of the *petit point* are already clearly to be found in the writings of Fénéon. Using these and other clues from contemporary critical and scientific sources, and carefully analyzing the nature of the optical experience that Seurat's canvases offer, William Homer, in his book of 1964 (excerpted below), has restored to us an understanding of just what it was that Seurat, in this chromo-luminarist phase of his evolution, had set out to achieve.

Seurat's purpose in using optical mixture, Homer reminds us, "was not to create resultant colors that were necessarily more *intense* than their individual components but rather to duplicate the qualities of transparency and luminosity in halftones and shadows experienced so frequently in nature." To achieve this aim, he availed himself of the optical phenomenon known as "lustre," observed by the German physicist Dove and described in *Modern Chromatics* by Rood, an optical vibration that will occur optimally for the viewer only at the correct viewing distance from the canvas: that distance at which the eye struggles toward, but does not yet entirely achieve, a complete synthesis of the separate spots of various colors. This optical phenomenon, which is crucial to the experience of Seurat's paintings, was already described and its source identified by Fénéon in 1886 when he wrote of the *Grande Jatte:*

> The atmosphere is transparent and singularly vibrant; the surface seems to flicker. Perhaps this sensation, which is also experienced in front of other such paintings in the room, can be explained by the theory of Dove: the retina, expecting distinct groups of light rays to act upon it, perceives in very rapid alternation both the disassociated colored elements and their resultant color.

Through this incomplete mixture of a wide variety of hues, Seurat was able to produce a shimmering union of color and chiaroscuro in neutral

[5] J. Rewald, "Extraits du journal inédit de Paul Signac, II, 1897–1898," *Gazette des Beaux-Arts* (April 1952), 270–71 (entry of 28 December 1897).

[6] "Ajoutons qu'en causant, Seurat me définissait la peinture: 'L'art de creuser une surface.' " See Kahn's article of 5 April 1891 in *L'Art moderne,* translated below.

tones that were not dull and inert but subtly warmed or cooled by the lingering optical experience of their dominant constituent hues. With these vibrating halftones and shadows, he thus succeeded in "hollowing out" the surface of his canvas, coloring and modeling his forms simultaneously, and placing them within an ambient of unparalleled atmospheric transparency.

The technique of pigment application, which Seurat first adopted in the winter of 1885–86 to facilitate this achievement, the infamous *peinture au point,* was another major topic for debate in the early literature that has continued to occupy present-day observers. Not only the public but also other artists of the period were disturbed by the apparently impersonal attitude of Seurat and his followers toward the execution of their pictures, and they were quick to label the Pointillist technique as "mechanical" and, hence, nonartistic. In the 1880s and 90s, most supporters and apologists for Neo-Impressionism, including among them Camille Pissarro and Paul Signac, pronounced the whole question of execution to be a matter of little or no importance to the Neo-Impressionist painters,[7] and subsequent writers have sometimes interpreted this to mean that these artists did not regard their Pointillist technique as an important or integral part of their style. But while Fénéon, for example, denounced the gimmickry and easy facility of bravura brushwork, proclaiming optical sensitivity and not manual dexterity to be the mark of the truly gifted artist, he made it clear that he regarded the texturally and descriptively neutral "dot" as the necessary vehicle for the optical effects that the Neo-Impressionists sought: "Since the numerical proportions of the coloring-drops can vary infinitely within a very small area," he wrote in an important article of 1887, "the most delicate nuances of modeling, the most subtle gradations of tints may be translated." Although more recent writers like Meyer Schapiro have taught us to recognize and to value the "intensely personal" character of Seurat's technique ("his touch . . . is never mechanical, in spite of what many have said"),[8] the mechanical associations that this apparently uniform method of execution held for Seurat's contemporaries may well have constituted part of its appeal for Seurat himself, for this artist was a man of radical political leanings with a strong predilection for popular and "democratic" forms of visual expression.

We have come today to attach positive value to what Schapiro has described as "Seurat's sympathetic vision of the mechanical in the constructed environment,"[9] and to consider as prophetically advanced his taste for the science and technology of his period. But many of Seurat's contemporaries—conditioned, no doubt, by the popular notion of a dichotomy between "intuitive" art and "rational" science—were often perplexed and offended by the excessive emphasis they felt that Seurat placed upon scientific principles and theories in his work. Thus we find appearing again and again in the early literature a question that was apparently dis-

[7] See, for example, Pissarro's letter of 6 November 1886 to Durand-Ruel, in Lionello Venturi, *Les Archives de l'Impressionnisme,* (Paris-New York: Durand-Ruel, 1939), II, 24.
[8] Meyer Schapiro, "New Light on Seurat," *Art News,* 57 (April 1958), 44.
[9] *Ibid.,* p. 52.

turbing even to Seurat's closest supporters, and that question might be stated as follows: "What, precisely, have scientific theories to do with Seurat's greatness as an artist?" As usual, Fénéon offered the official defense in an article of 1886 entitled "Impressionism at the Tuileries." The Neo-Impressionists, he maintained, did not subordinate art to science, as many hostile critics had claimed. They merely used science "to direct and perfect the education of their eye and to control the accuracy of their vision." Optical sensitivity, then, according to Fénéon, was the crucial factor for the artist, and without it, he asserted, the average person (Fénéon's hypothetical Mr. Z) "can read optical treatises from now 'til eternity, and he will never paint the *Grande Jatte*." Pissarro echoed these thoughts, although in more personal terms, when he confided in a letter to Signac in 1888: "In short, all of art is not contained in scientific theory. If Seurat had only that, I tell you that he would interest me only moderately." [10] And over half a century later, in 1947, a similar sentiment was expressed by Henri Matisse, who, at an earlier point in his career, had been alternately intrigued and repelled by Neo-Impressionism's promise of an art that could be produced and controlled according to scientific rules. Meditating upon Seurat's color theories, Matisse wrote: "I said to myself, what makes Seurat is not to be found in this, that if there were not something more important than this in his pictures, he would be of no consequence."

Matisse has not been alone among subsequent artists in finding and valuing "something more important" than color theories in Seurat's art. In fact, Seurat's color theories and methods, which had attracted a sizeable group of followers and imitators during his own lifetime, ceased to be influential in their original form after his death, as many of the former Neo-Impressionists began to chafe under the restrictive rigors of the master's method and began to move off in other, more current or appealing stylistic directions. In the 1890s, for example, Pissarro returned to the more congenial spontaneity of his earlier Impressionist technique; his son, Lucien, settled in London and began to devote himself to the applied arts, while in Belgium a similar course was being followed by two other former Neo-Impressionists, Henry Van de Velde and Alfred Finch.[11] The Symbolist writers who had formerly championed Seurat's art now turned their attention increasingly in the 1890s to Paul Gauguin and Vincent van Gogh, and by 1894 Signac could legitimately complain of the "oblivion" into which Seurat's art had so quickly fallen.[12]

It was due in fact almost entirely to Signac's persistent and proselytizing efforts that Neo-Impressionism, as a movement, was kept alive at all in the 1890s. In 1898 the serial publication in *La Revue Blanche* of Signac's persuasive book, *From Eugène Delacroix to Neo-Impressionism*, began at last to reawaken interest in the movement among younger artists,

10 See below John Rewald's "Artists' Quarrels."
11 For information on the lives and careers of Seurat's followers in France and elsewhere, see the excellent catalogue by Robert Herbert, *Neo-Impressionism* (New York: The Solomon R. Guggenheim Museum, 1968).
12 J. Rewald, "Extraits du journal inédit de Paul Signac, I, 1894–1895," 104 (entry of 15 September 1894).

and shortly thereafter, in 1900, the exhibition and sale of an important group of Seurat's works, organized by *La Revue Blanche,* made these works again, very briefly, available to the public after years of being hidden away in private family collections.

But it was not until the Retrospective Exhibition held by the Society of Independent Artists in March of 1905, and the very large and influential exhibition of more than 200 of Seurat's works organized by the Bernheim-Jeune Galleries in December and January of 1908–9, that younger artists in France had their first real opportunity to see and to evaluate Seurat's art for themselves. In the interim, it had been the work of Signac and his friend Henri-Edmond Cross that had been most directly available as models for those younger artists who had become interested in Neo-Impressionism. However, the increasingly independent and abstract color style of Signac and Cross, with its broad, mosaic-like dabs of brilliant hue, although an important liberating influence during the first decade of the twentieth century for artists as diverse as Matisse, Severini, Delaunay, and Mondrian, was nevertheless only loosely related to the original work and theory of Seurat.

Significantly, the first painters of our century who seem to have learned important lessons directly from Seurat's works themselves were the Cubists, who were interested not in Seurat's color practice but in his abstract and conceptual control over his canvases. Particularly instructive and suggestive for the Cubists were the rigorous formal order of Seurat's later, highly planar compositions and the abstract, non-descriptive texture of his pigment surfaces, surfaces that established a crucial modern tradition by questioning for the first time the value and necessity of "hand-made" virtuosity for the work of art. Witnesses like André Salmon report that *Le Chahut* (Fig. 27) hung in reproduction on the walls of the Cubists' studios as "one of the great icons of the new devotion." This must have occurred shortly after the large Bernheim-Jeune exhibition, around 1909–10, as Cubism was entering the advanced stage of its monochromatic first phase, and as the influence of Paul Cézanne, which had been of great importance to the Cubists in the early years after the *Demoiselles d'Avignon,* became less relevant to their increasingly abstract goals. Contrary to popular belief, it was the art of Seurat, not Cézanne, that probably had the most decisive impact upon the Cubists and other artists of their generation, artists who gradually came to feel, as Jean Hélion later put it, that "the way to abstraction is much clearer through Seurat." Pinpointing what had been one of the key differences between these two masters for the early twentieth century, Hélion wrote: "Cézanne keeps on believing in the integrity of the model. . . . I cannot see such devotion to the subject in Seurat. . . . Once he has seized the elements, he stylizes them beyond all resemblance, even to caricature, without consideration for taste, prettiness, normality. The appearance of his picture is never compatible with that of nature."

For the Cubist followers, the major appeal of Seurat's art seems to have resided in its quantifiably measurable character, and the group name these artists assigned to themselves in 1912, the "Section d'Or," makes reference to the ancient mathematical principle for creating harmonious pro-

portion, a principle that, as these artists may have recognized, was the basis for many of Seurat's compositional harmonies.[13]

After World War I, Ozenfant and Le Corbusier, formulators of the esthetic doctrine of Purism, paid special tribute to Seurat, admiring him for his adherence to "esthetic systems" in particular, and for his restoration of intellectual order and control to art in general. Seurat was literally apotheosized in the first issue of their journal, *L'Esprit nouveau*, which appeared in October of 1920—at a time when not a single one of Seurat's major works was as yet in a public French collection. An enthusiastic piece on Seurat was the lead article in the first issue of this official organ of the Purist movement,[14] a journal that declared itself editorially for the "spirit of construction and synthesis, order and conscious will, which . . . is no less indispensable . . . to the arts than it is to the pure or applied sciences or to philosophy." [15]

For the Purists and for artists such as Fernand Léger and others, Seurat was an important spiritual ancestor, not only because of his belief in a rational basis for art, but also because of his essentially optimistic view of the relationship between art and technology in the modern world. Seurat was one of the first artists of our period to find positive beauty in the mass produced, industrial forms with which our world increasingly surrounds us (see Fig. 24, for example), and his prophetic attitude has struck a responsive chord in most of the major artists and movements of the twentieth century, from Cubism to Pop.

A solid foundation for the art historical study of Seurat's work in this century has been laid by a number of eminent scholars. Among them, homage must first be paid to John Rewald, who has gathered the basic documents and factual materials necessary for the study of Seurat and has scrupulously presented these in a series of biographical studies beginning in 1943 and culminating in his text for the indispensable *catalogue raisonné*, which he prepared with Henri Dorra and published in 1959. This catalogue of the paintings, which includes many of the related drawings, is supplemented as a standard reference work by the handsome two-volume catalogue of the paintings and drawings, both related and independent (some 500 in all), prepared by César M. de Hauke and published in 1961 (issued in the autumn of 1962). Félix Fénéon collaborated with de Hauke on the preparation of this catalogue until his death in 1944, and many valuable documents, including letters by Seurat and a posthumous inventory of the artist's studio, which were left by Fénéon to de Hauke, are published for the first time in this most valuable and complete record of Seurat's *oeuvre*.

[13] In a monograph on Seurat published in 1948, André Lhote, who had been one of the *Section d'Or* painters, observed: "La plupart de ses compositions, particulièrement la *Parade* et le *Chahut* sont strictement organisées sur la section d'or" [André Lhote, *Georges Seurat* (Paris: Braun, 1948), 11]. In 1935 Lhote had published a diagrammatic analysis of *La Parade* in accordance with this principle [André Lhote, "Composition du tableau," *Encyclopédie française*, XVI (Paris, 1935), 16.30-6].

[14] G. Bissière, "Notes sur l'art de Seurat," *L'Esprit nouveau*, 1, n.1 (October 1920), 13–28.

[15] *L'Esprit nouveau*, 1, n.1 (October 1920), p. 3.

Much earlier in the century, long before it would have been possible to compile such catalogues as these, several other scholars made illuminating attempts to marshal the often extensive preparatory material that Seurat left, especially for the earlier of his large compositions, and on the basis of this material tried to formulate general conclusions regarding Seurat's techniques and procedures. The earliest and most tentative of these efforts at what was to become an important standard approach to the study of Seurat was made in 1928 by Christian Zervos in an article entitled *"Un Dimanche à la Grande Jatte* et la technique de Seurat." [16] It was followed in 1935 by Daniel Catton Rich's exhaustive and discerning study of the same painting (excerpted below). And in 1941 Benedict Nicolson undertook along similar procedural lines a study of "Seurat's *La Baignade."* [17] Also in 1941, in an article entitled "Some Aspects of the Development of Seurat's style," Robert Goldwater made the first major attempt to define a broad pattern of growth and development in Seurat's style, relative to general changes in taste that were taking place during the late 1880s. Stressing the rapid evolution of Seurat's style after 1886 in the direction of the decorative linear stylizations and spatial flattening that characterized the *fin du siècle* period style known as *Art Nouveau,* Goldwater related Seurat's late work to that of his most advanced contemporaries. The relationship between the structure of Seurat's late paintings and the theories of expression and composition propounded by Charles Henry was examined closely for the first time in 1959 by Henri Dorra in his essay, "The Evolution of Seurat's Style." In 1962 Robert Herbert's book on *Seurat's Drawings* provided a fitting culmination to an earlier body of very perceptive literature on the same subject by Lucie Cousturier, Gustave Kahn, and Germain Seligmann.[18] In this book, Herbert established for the first time the stylistic and thematic criteria for a chronological consideration of Seurat's drawings. And in 1964 William Innes Homer, in his *Seurat and the Science of Painting,* offered the classic and definitive study of the evolution of Seurat's theories and techniques in relation to the scientific and theoretical texts that the artist is known to have consulted in the early as well as the later part of his career.

For the sake of clarity and convenience, other critical approaches to the art of Seurat in our century may be reduced to a few, very basic, conceptual dichotomies, which appear repeatedly in the literature. Early in the century, for example, many writers, following the line that had been established by Signac, were wont to characterize Seurat's art as the logical and inevitable culmination of a nineteenth-century tradition that had its roots in Delacroix. Then, as the implications of Seurat's work for some of the more advanced styles of the early twentieth century became apparent,

[16] *Cahiers d'art* (Paris), n.9, 1928, 361–75.
[17] *The Burlington Magazine,* 79 (November 1941), 139–46.
[18] L. Cousturier, "Les Dessins de Seurat," *L'Art decoratif,* March 1914, reprinted in L. Cousturier, *Georges Seurat* (Paris: Crès, 1921), pp. 25–34; G. Kahn, *Les Dessins de Seurat,* 2 vols., Paris, 1928, English translation in *The Drawings of Georges Seurat* (New York: Dover 1971); G. Seligmann, *The Drawings of Georges Seurat* (New York: Curt Valentin, 1945).

critical attitudes did an abrupt about-face, and sometimes side by side with the older view of Seurat's art as the culmination of nineteenth-century goals, there emerged a new critical emphasis, which saw Seurat as an influential precursor of modernism.

The other major polarity in the literature consists on the one hand of an essentially formalist approach, which treats Seurat as the spiritual and intellectual heir of the classical tradition in general and of the great painter-theorists such as Piero della Francesca, Leonardo, and Nicholas Poussin in particular. The first modern writer to stress this kinship was the English critic, Roger Fry, whose work in the 1920s helped to establish this emphatically formalist approach to Seurat's art.[19] This approach, which stresses the rational and measurable in Seurat's work and views him as a restorer of classical order to late nineteenth-century art, was picked up in the early 1930s by writers such as Robert Rey and Daniel Catton Rich. In 1959 Henri Dorra's extended analyses of Seurat's compositions in relation to the classical principle of the golden section was a recent extension of this same approach.

In 1935, reacting against this prevailing formalist emphasis upon the "classic" nature of Seurat's art, Meyer Schapiro pointed to important connections between Seurat's work and the nature of contemporary social experience. Arguing that the formal structure of the paintings cannot be fully understood without reference to their content and to the social factors that helped determine that content, Schapiro focused critical attention upon a hitherto much neglected aspect of Seurat's art. Stressing in particular Seurat's positive response to the influences of industry and technology on modern life, Schapiro wrote: "In common with certain engineers and architects of the time, Seurat identified the "progress" of art with technical invention, rationalized labor, and a democratic or popular content." Schapiro's thought-provoking observations opened new avenues of inquiry for the next generation of scholars and gave rise to a still developing body of literature, which has explored the relevance for Seurat's outlook and art of a variety of contemporary factors including radical politics (Eugenia and Robert Herbert), the poster art of Jules Chéret (Robert Herbert), and the developing technology of photo-mechanical printing (Norma Broude).[20]

Since the appearance of Schapiro's influential article in 1935, these two clearly definable strains in Seurat's art have been treated in the literature largely as isolated, and sometimes even as antagonistic, phenomena. But for Seurat himself, they appear to have been closely interwoven, in a

[19] In addition to Fry's article of 1929 on *La Parade*, reprinted below, see also his essay on Seurat in *The Dial*, 81, 1926, 224–32. The same essay appears in Fry's *Transformations, Critical and Speculative Essays on Art*, London, 1926, pp. 188–96, and is reprinted in *Seurat* (London: Phaidon, 1965), pp. 9–22.

[20] In addition to the articles by Herbert and Broude reprinted below, see Robert L. and Eugenia W. Herbert, "Artists and Anarchism: Unpublished Letters of Pissarro, Signac, and others—I," *The Burlington Magazine*, CII, 1960, 473–82; and N. Broude, "The Influence of Rembrandt Reproductions on Seurat's Drawing Style: A Methodological Note," *Gazette des Beaux-Arts* (October 1976), pp. 155–60.

manner that was probably sanctioned for him by the Beaux-Arts tradition out of which he grew. In an article in 1964, entitled "Seurat and Piero della Francesca," Albert Boime investigated Roberto Longhi's earlier references to academic copies of the Arezzo frescoes, which would have made Piero's works accessible to Seurat while the latter was still a student at the École.[21] Boime's examination of the academic philosophies and values that nurtured Seurat, and particularly the attitudes of Charles Blanc, the influential Beaux-Arts administrator and historian whose writings Seurat consulted and admired, is most illuminating and suggestive within the context of our discussion here. Described as "a utopian Socialist in the tradition of Saint Simon," Blanc regarded the Renaissance tradition as the model *par excellence* for the contemporary society that wished to achieve social and artistic progress through science.

Charles Blanc's equation between classicism on the one hand, and social and artistic transformation through science and technological advance on the other, was clearly relevant to Seurat's thinking, and it is an equation, I would suggest, that can help us to reconcile this artist's dual allegiance to classical form and modern technology. Thus Seurat's persistent attachment to the Beaux-Arts tradition, an attachment regarded with great suspicion by the other artists in his circle,[22] may contain the key that finally banishes apparent contradictions, showing us that the diverse strains of Seurat's thought were in fact the elements of a unified, consistent, and timeless vision.

[21] Roberto Longhi, *Piero della Francesca,* 2nd ed. (Milan, 1942), p. 158; also, R. Longhi, "Un disegno per la Grande Jatte e la cultura formale di Seurat," *Paragone* (Florence, January 1950), pp. 42–43.

[22] Consider, for example, Pissarro's warning to Signac in a letter of 1888: *"Seurat is of the École des Beaux-Arts,* he is impregnated with it . . . Let us take care then, for there is the danger. . . ."* See below, Rewald's "Artists' Quarrels."

PART ONE / Seurat as Seen through His Own Writings,
through Comments by His Contemporaries,
and by Other Artists

WRITINGS BY SEURAT

Georges Seurat

NOTES ON DELACROIX (1881) *

February 23, 1881—Saw the *Fanatics of Tangier*.[1] Effect of light concentrated on the principal fanatic. His shirt is streaked with delicate red strokes. Subtle tones of his head and arms. Yellowish or orangey trousers. The one who is biting his arm, on the ground: garment streaked yellow and black, with blue sleeves—I think. Delicacy of the orange-grey and blue-grey ground. Little girl in the left foreground. She is frightened. Grey-green white cloth accompanied by pink streaked undergarment, which is visible at the arm and at the lower part of the leg. (Harmony of red and green.)

The flag is green with a touch of red at the center. Above, the blue of the sky and the orange-white of the walls and the orange-grey of the clouds.

The horse is blue-grey with an orange-color harness.

One of the fanatics—the one whose head is beneath the arm of one of the others—wears a red undergarment. This red is intensified by the green piping around the edge of his yellowy, grey-white burnoose. From one of the houses, a group watches the scene. Axis of the painting. Some carpets hang from the roof—a red one, a very small portion of which oc-

"Notes inédites de Seurat sur Delacroix," *Le Bulletin de la vie artistique*, April 1, 1922, pp. 154–58.

These notes were written in ink in a disorderly graphic style, which suggested to Félix Fénéon, who first published them in 1922, that Seurat had written them from memory, back in his studio, shortly after he had seen Delacroix's paintings in the windows or galleries of Parisian dealers ("Notes inédites de Seurat," p. 154). For a reproduction of one of these pages of notes, see D.-R., p. xxxvii, Fig. 7. [Editor's note]

[1] This painting is number 662 in the *catalogue raisonné* of Delacroix's work by Alfred Robaut, *L'Oeuvre complet de Eugène Delacroix* (Paris: Charavay Frères, 1885): *Convulsionnaires de Tanger*, 1838; sold at auction in Paris on 24 February 1881 (vente Edwards). [Editor's note]

cupies the central section: it is made up of yellow-green and grey (blue?)-white bands; a very harmonious conception of coolness.

In the foreground, red, or rather orange, man. Next to him, on the right, a young boy, dark blue clothing. The blue and the orange harmonize again in the man to the right of the fanatic who is falling backwards. He is wearing a vivid orange garment in which there is a great deal of vermilion; this color is surrounded by the blue-grey fabrics in which the figures of the middleground are dressed.

Elsewhere on the roofs, greyed by the distance, hangs a blue drapery, harmonizing with the orange-white of the wall.

In the right-hand corner are figures dressed in yellow-white cloth tinged with violet. They have yellow slippers on their feet.

"Sterility," writes Eug[ène] Del[acroix], is not only a misfortune for art, it is a flaw in the artist's talent. Human production which does not flow abundantly is necessarily marked by strain. One cannot create a school without providing many great works as models." [2]

Seen at the same time as the *Fanatics*:

1. *The Watering Place.* Two horses, one mounted by a Turkish rider. They are followed by two greyhounds. Mountains in the background.

2. *The Shipwreck of Don Juan* (sketch).

Friday, May 6, '81—Saw the *Attacked Lion* and the *Sultan of Morocco and his Entourage*,[3] by Eug[ène] Del[acroix].

The lion is on a grassy patch of ground. In the lower right, a plant with red flowers. A background of mountains. The sky, yellow-grey at the horizon, somewhat violet-grey above. A dark, violet-grey cloud is in the upper left.

The Sultan of Morocco, dressed in a yellow burnoose, is mounted upon a blue-grey horse; rose harness; on the saddle at the rear is some violet material. At each side are two people whose dress derives its harmony from red and green. Similarly, the immense parasol, silhouetted against the sky, is red inside and green outside, and is held by a third person placed behind the horse. Behind this group, the crowd and the soldiers are ranged. At the right, the yellow walls of a city, and some fragments of mountains, blue-grey, are seen in the distance. The sky is grey-blue and grey-orange. The ground is yellow-grey and yellow.

The picture is dated 1858 or 1856.

The execution resembles that of the *Jewish Wedding* and the *Fanatics* in that there is not much impasto, and the extremely subtle tones become still more so by virtue of the superimposition which is very visible.

[2] On the sources through which Delacroix's writings would have been available to Seurat in 1881, see Homer (1964), pp. 269–70, note 24. [Editor's note]

[3] See Robaut, *L'Oeuvre complet de Delacroix*, number 1295: *L'Empereur du Maroc passant la revue de sa garde*, 1855 or 1858(?); sold at auction in Paris in May of 1881 (vente F. Hartmann). The picture is a variant of the motif first treated by Delacroix in 1845 in the better-known picture, which is today in the museum in Toulouse. It is also similar to another variant painted by Delacroix in 1862 (Robaut 1441). [Editor's note]

November 11, 1881—Saw at Goupil's 5 Delacroix, 4 of which [are] very interesting from the point of view of means of expression:

1. An *Oriental*. Head very finished, marvelous. What is most interesting is the manner in which this canvas is painted: a marvel of values, the background not at all finished, the cloak heavily painted in the embroidered gold ornaments.

2. *Algerians in an Interior*. One can clearly see the underpainting and how the canvas developed.

3. *Jesus and the Apostles in a Barque*. Two magnificent little torsos, cross-hatched, subtle in tone.

4. A study for the *Fanatics* in all probability. Very interesting sky. Delicate strokes.

It is the same whether Delacroix paints St. Sulpice [4] or number 1, the Oriental with the finely finished head. The only difference is that the brushstrokes become smaller as the work diminishes in size.

That little head is a marvel. The shadows and everything else, broken and vibrant—the cheekbone, the shadows of the turban. Here is the strictest application of scientific principles seen through a personality.

LETTER TO OCTAVE MAUS (1889)[1]

PARIS, 17 FEBRUARY 1889

I thank you very much for what you wrote about me in *La Cravache* on the 16th.[2] Please accept my gratitude. I would like to know the name of the collector. If you could get 60 francs for my drawing, I would be satisfied.

As for my *Poseuses* [Fig. 19], I am very much at a loss [*embarrassé*] to fix a price for it. I compute my expenses on the basis of one year at 7 francs a day: thus you can see where that leads me.[3] In conclusion, I

Georges Seurat, Letter to Octave Maus, February 17, 1889, in M.-O. Maus, *Trente années de lutte pour l'art, 1884–1914,* Brussels, 1926, p. 87.

[4] Mural decorations in the Chapel of the Holy Angels, in the Church of St. Sulpice in Paris (1856–1861). [Editor's note]

[1] Octave Maus was Secretary of *Les XX,* a group of avant-garde Belgian artists with whom Seurat had been invited to exhibit in 1887 and 1889. Maus had just written to Seurat on behalf of a collector to ask the prices of *Les Poseuses* and one of the drawings being exhibited in Brussels that year. [Editor's note]

[2] Octave Maus, "Le Salon des XX à Bruxelles," *La Cravache Parisienne* (Paris), February 16, 1889. [Editor's note]

[3] John Rewald has estimated that, at this rate, and not including Sundays, Seurat's expenses—and consequently his asking price—would have amounted to about 2,200 francs. This price, which so troubled Seurat, was nevertheless a modest one if one considers that, a year earlier, Van Gogh had suggested that his brother purchase the *Poseuses* and the *Grande Jatte* at a price of 5,000 francs each. Even this price was relatively low

will say that the personality of the collector can compensate me for the difference between his price and mine.

LETTER TO FÉLIX FÉNÉON (1890)

PARIS, 20 JUNE 1890

Permit me to correct an inaccuracy in your biography of Signac, or rather, to remove any doubt, permit me to clarify.[1]

" - Elle séduisit, - C'était vers 1885," p.2, par.4. Once begun, the evolution of Pissarro and Signac was slower. I protest and I establish to within 15 days the following dates:

The purity of the spectral element being the keystone of my technique—as you yourself were the first to state.

Having sought, ever since I began to paint, an optical formula on this basis 1876–1884.

Having read Charles Blanc at school [*au collège*] and being acquainted with Chevreul's laws and Delacroix's precepts for this reason.

Having read the studies of the aforementioned Charles Blanc on the aforementioned painter (*Gazette des Beaux Arts,* vol. XVI, if I recall correctly).

Being acquainted with Corot's ideas on tonal values (copy of a personal letter, 28 October 1875) and Couture's concepts on the subtlety of hues (at the time of his exhibition), being impressed by the intuition of Monet and Pissarro, sharing some of Sutter's ideas on the ancient art of the Greeks, upon which I meditated while at Brest (*Journal de l'Art*) March and February 1880.

Rood having been brought to my attention by an article by Philippe Gille, *Figaro,* 1881.

I wish to establish the following dates which demonstrate my prior paternity.

1884 *Grande Jatte* study—exhibition of the *Indépendants.*

1884–1885 *Grande Jatte* composition.

1885 Studies at La Grande Jatte and at Grandcamp, resumption of work on the *Grande Jatte* composition.

Georges Seurat, Letter to Félix Fénéon, June 20, 1890, in the collection of César de Hauke and published in facsimile in the latter's *Seurat* (Paris: Gründ, 1961), 1, xxi.

in comparison with the sums then being paid by the French government for the works of recognized official artists or with the 580,650 francs paid in this year by an American dealer for Millet's *Angelus!* See D.-R., p. lxviii, note 49.

On Seurat's attitude toward pricing his work, see also Meyer Schapiro in the article excerpted later in this volume. [Editor's note]

[1] Ever on guard to protect his claim of priority as the inventor of Neo-Impressionism, Seurat wrote this letter to Fénéon to correct certain statements that had been made by Fénéon in his biography of Signac (published in the June 1890 issue, N. 373, of the weekly periodical *Les Hommes d'aujourd'hui;* reprinted in part in D.-R., pp. xxv–xxviii). Seurat's letter provides invaluable information about the sources, both literary and artistic, to which the artist turned during his formative years. It exists in three

October '85 I meet Pissarro at Durand-Ruel's.[2]

1886, January or February, little canvas by Pissarro at Clozet's the dealer in the rue de Châteaudun—divided and pure.

Signac—who was finally won over and who had just modified his *Modistes* while I was finishing the *Jatte*—painted in accordance with my technique:

1. *Passage du Puits Bertin, Clichy*, March–April 1886.
2. *Les Gazomètres, Clichy*, March–April 1886 (catalogue of the *Indépendants*).

For these reasons, coolness with Guillaumin, who had introduced me to Pissarro and whom I saw because of Signac's old friendship.

You will admit that there is a slight discrepancy here, and while I may have been unknown in 1885, I and my vision existed nonetheless—that vision which you described in an impersonal form so very well, apart from one or two insignificant details.

M. Lecomte had already sacrificed me to Charles Henry, whom we did not even know before the rue Lafitte (error rectified).[3]

It was at Robert Caze's that we were brought into contact with several of the writers associated with *Lutèce* and *Le Carcan* (*Petit Bottin des arts et des lettres*).

Pissarro went there with Guillaumin.

Then you brought me out of the shadow—with Signac who benefited from my researches.

I count upon your fairness to [insure that you will] pass these notes on to MM. Jules Christophe [4] and Lecomte.

<div align="right">With a cordial and sincere handshake,</div>

FROM A LETTER TO MAURICE BEAUBOURG (1890)[1]

28 AUGUST [1890]

. . . In conclusion, I am going to restate for you the esthetic and technical note which concludes the work of M. Christophe and which comes

Georges Seurat, Letter to Maurice Beaubourg, 28 August [1890].

different versions (see Homer, 1964, p. 268, note 20), the most complete of which is translated here. For more on Seurat's relationship with and attitude toward his followers, see John Rewald's "Querelles d'Artistes," which is translated below. [Editor's note]

[2] This item is almost entirely crossed out in the original manuscript. [Editor's note]

[3] The reference is to Georges Lecomte's biography of Camille Pissarro, which had appeared earlier that year as N. 366 of *Les Hommes d'aujourd'hui*. [Editor's note]

[4] Jules Christophe was a friend of Seurat's and author of the brief biography of the artist that had appeared in March or April of 1890 as N. 368 of *Les Hommes d'aujourd'hui*. For more on this biography, see note 1 in "From a Letter to Maurice Beaubourg (1890)" in this volume. [Editor's note]

[1] Facsimile reproductions of this letter may be found in R. Rey, *La Renaissance du Sentiment Classique* (Paris: Les Beaux-Arts 1931), opposite p. 132, and in D.-R., p. xcix. [Editor's note]

from me. I am modifying it somewhat since it was not properly understood by the printer.[2]

ESTHETIC

Art is Harmony.

Harmony is the analogy between opposites and the analogy between elements similar in *tonal value, color,* and *line,* considered in terms of the dominant, and under the influence of lighting, in gay, calm or sad combinations.

The opposites are:

For tonal value, a more luminous (lighter) tone against a darker one.

For color, the complementaries, i.e., a certain red contrasted with its complementary, etc.

$$\left\{\begin{array}{l} \text{red–green} \\ \text{orange–blue} \\ \text{yellow–violet} \end{array}\right.$$

For line, those forming a right angle.

Gaiety in terms of tonal value is a luminous dominant tonality; *in terms of color,* a warm dominant color; *in terms of line,* lines above the horizontal ⟍↓⟋

Calmness in terms of tonal value is an equal amount of dark and light; in terms of color, an equal amount of warm and cool; and in terms of line, the horizontal.

Sadness in terms of tonal value is a dominant dark tonality; in terms of color, a cold dominant color; and in terms of line, downward directions ⟋↑⟍

[2] The theoretical statement by Seurat that follows is an expanded and corrected version of a statement that had been published several months earlier, in March or April of 1890, as the concluding section of Jules Christophe's biography of Seurat (N. 368 of the periodical *Les Hommes d'aujourd'hui*). Seurat, as he indicates in this letter, was dissatisfied with the manner in which the statement had been printed, and it is his corrected version, in this letter to Beaubourg, that consequently stands today as the definitive statement of his theory. It should be remembered, however, as William Homer has pointed out, that the Beaubourg letter was not published until the early 1920s, when it first appeared in English translation in Walter Pach's *Georges Seurat* (New York: Duffield and Co., The Arts Publishing Corp., 1923, pp. 24–25) and then in the original French in Gustave Coquiot's *Georges Seurat* (Paris: Albin Michel, 1924, pp. 232–33). Prior to these publications, only the version published in Christophe's biography was generally known. Frequently alluded to by contemporary critics, this shorter and presumably inaccurate version was long accepted as the artist's final statement on his art. It was reprinted in whole or in part in several of the early articles on Seurat, including the one by Gustave Kahn (1891), translated below (see Homer, 1964, p. 186). [Editor's note]

TECHNIQUE

Given the phenomena of the duration of a light impression on the retina, synthesis is the unavoidable result. The means of expression is the optical mixture of tonal values and colors (both local color and the color of the light source, be it sun, oil lamp, gas, etc.), that is to say, the optical mixture of lights and of their reactions (shadows) in accordance with the laws of *contrast,* gradation, and irradiation.

The harmony of the frame contrasts with that of the tonal values, colors, and lines of the picture.

WITNESS ACCOUNTS (INCLUDING REPORTED STATEMENTS BY SEURAT)

Gustave Kahn
From Two Writings

FROM A CONVERSATION
WITH GEORGES SEURAT (1888) *

. . . One of the young, impressionist innovators defined his vision of art for me in the following way: "The Pan-Atheniac Frieze of Phidias was a procession. I want to make the moderns file past like the figures on that frieze, in their essential form, to place them in compositions arranged harmoniously by virtue of the directions of the colors and lines, line and color arranged in accordance with one another." [1]

"SEURAT" (1891) †

Death, cruel to arts and letters even when it strikes an artist already laden with years and accomplishments, is more bitter still, more bewildering, when it chooses a man still young, in his thirties, an apostle of a new truth, the axioms and applications of which he had only just barely the time to work out.

Seurat is dead at the age of thirty-one.

* Gustave Kahn, "Chronique de la Littérature et de l'Art: Exposition Puvis de Chavannes," *La Revue Indépendante*, 6, January 1888, 142–46. This excerpt, pp. 142–43.

† Gustave Kahn, "Seurat," *L'Art moderne*, 11, April 5, 1891, 107–10.

Gustave Kahn (1859–1936) French Symbolist poet and editor of the journal *La Vogue*. His writings include important personal reminiscences of his friendship with Seurat.

[1] The identification of Kahn's interlocutor as Seurat was first made by Robert Herbert. See his *Seurat's Drawings* (New York: Shorewood Publishers, Inc., 1962, p. 168, note 35). [Editor's note]

Physically, he was tall and well-proportioned. Thanks to his abundant black beard and his thick, slightly curling hair, his face, apart from its flaring nostrils, resembled those of the mitered Assyrians on the bas-reliefs. His very large eyes, extremely calm at ordinary moments, narrowed when he was observing or painting, leaving visible only the luminous points of the pupils beneath the lowered lashes. An accurate but very badly printed profile drawing by Maximilien Luce shows him at the easel (in *Les Hommes d'aujourd'hui*).

Beneath a somewhat cold exterior appearance, dressed always in dark blues and blacks—a neat and correct appearance that prompted Degas in a moment of humor to nickname him "the notary"—he guarded within himself a nature full of kindness and enthusiasm. Silent in large groups, among a few proven friends he would speak animatedly about his art and its aims. The emotion that filled him at these moments made itself visible in a slight reddening of his cheeks. He spoke in a literary manner and at considerable length, seeking to compare the progress of his own art with that of the auditory arts, intent upon finding a basic unity between his own efforts and those of the poets or musicians.

• • •

The biography of Georges Seurat is uneventful and lacking in picturesque details. While still young, he entered the studio of Lehmann at the École des Beaux-Arts. He remained there for four years, and as a souvenir of this, he kept hanging upon his wall an academy (a painted study of a male nude) and a conservative landscape. Discouraged by his attempts at painting, not yet having found his path, but gifted enough to perceive that conventional daubing was not to be his destiny, he took refuge in pure drawing. For several years he used nothing but black and white, amassing in this way an impressive collection of notes; he discovered, moreover, at least embryonically, the process he would later apply to painting.

His research consisted of rigorously transposing into *values* the gradations of shadow, the contrasts of white and black, of working the drawing as though he were in fact painting with a restricted palette. Instead of enclosing his figures with wirelike lines, he worked with masses of black and white, thus achieving vigorous modeling. Four portfolios are filled with these experimental works. They include the figures for his first large painting, the *Baignade,* studied, restudied, diversely modeled, until he had attained the simple, full, and flowing line that constituted for him the major interest of drawing. They include, too, studies of nocturnal shadows on lighted windowpanes, curious masks chosen for the intensity and simplicity of their expression.

We next encounter the first large painted canvas, the *Baignade* [Fig. 6], which marks Seurat's passage through Impressionism and is his single most important effort in this style. In 1886 he exhibited totally new works, and with Camille Pissarro, Paul Signac, and others, he founded Neo-Impressionism, a school based on a new technique that he had invented.

I do not wish to review here the theory of Neo-Impressionism in 1886,

the theory of a school that vulgar criticism has labeled Pointillist. The reader will find it very well described in a work by Félix Fénénon, *The Impressionists in 1886*.[1] What may be said here to characterize this stage in the artist's thought is that this technique had been indicated to him by two sources, the writings of Chevreul and Rood, and by presentiments of the technique in the work of older painters; he himself cited Delacroix's murals in Saint Sulpice, and he also claimed to have discovered divided color in works by Veronese and Murillo.

He had been attracted, moreover, by the early technique of Renoir and also that of Camille Pissarro, two painters who had tried, in essence, to achieve modeling in painting by means of the interlacing of small, colored lines. The question of the frame of the painting, very important to Seurat, was resolved by the white frame, which acted upon the canvas as an isolating agent. The usual gilt frame was rejected because it had too darkening an effect. The white frame, in its function, reflected the technique of these colorists, who, in order better to judge a color or tone, were in the habit of lowering their eyes for a moment to a neutral white surface like a sheet of paper or a newspaper.

His achievement was the construction, from diverse principles, of a rigorous and new esthetic.

The success of the Neo-Impressionists was so great at this point, especially among their literary colleagues, that they became the object of jealousy, and hostilities developed between them and members of the old Impressionist group.

Seurat was still not completely satisfied. He was living in a studio on the seventh floor of a house on the Boulevard Clichy. A small, monastic room, it contained a low, narrow bed, facing some of the older canvases, *the Baignade,* and some seascapes. In this white-walled studio hung his souvenirs of the École des Beaux-Arts, a small painting by Guillaumin, a Constantin Guys, some works by Forain—paintings and drawings that had become habitual for him and, in their coloration, a familiar part of his wall—a red divan, a few chairs, a small table on which sat side by side some friendly reviews, books by young writers, brushes and pigments, and his horn of tobacco. Standing against a panel, covering it completely, the *Grande Jatte* [Fig. 15], which he studied again and again with a restlessness ever renewed, searching out all of its tiniest defects, seeking perpetually to satisfy his conscience.

In this small, narrow, and uncomfortable studio, cold in winter and torrid in summer, Seurat lived before his canvas daily for three months. Grown thinner, he left it to rest himself by painting seascapes, and he returned with six canvases, all different in motif and intent.

Seurat's restlessness grew out of the following reflections: "If, scientifically, with the experience of art, I have been able to find the law of pictorial color, can I not discover a system equally logical, scientific, and pictorial that will permit me to harmonize the lines of my painting as well as the colors?"

[1] Paris, 1886. Translated in part later in this volume. [Editor's note]

Seurat's dream was to discover this logically. For even though he believed that a scientific esthetic could not impose itself entirely upon a painter, because there are intimate questions of art and even of technique that only a painter can raise and resolve, he nevertheless felt an absolute need to base his theories on scientific verities. His mind was not entirely that of the born painter, a painter like Corot, content to place pleasing tonalities on a canvas. He had a mathematical and philosophical mind, fit to conceive art in some form other than painting. I can explain more readily by saying that if some painters—and good painters at that—give the impression that they could have been nothing but painters, Seurat was one of those who give the impression that they have been induced to devote themselves to the plastic arts because of one aptitude that they possess among many, an aptitude that happens to be more highly developed in them than any of the others.

It was during this period of searching that he became acquainted with the work of Charles Henry on a scientific esthetic, in particular, the *Chromatic Circle* [Paris, 1889], the preface to which goes well beyond the single question of color to fathom the phenomena associated with line. This provided Seurat with only the basis, the precise and demonstrable basis that he had needed, and it enabled him to arrive at his final synthesis, noticeable ever since his seascapes at Crotoy [2] and fully affirmed by his canvases *Le Chahut* [Fig. 27] and *Le Cirque* [Fig. 29].

This latest step in his evolution was clearly described in a biography by Jules Christophe, and certainly this exposition of the principles involved had been approved by the painter. We reproduce it in its entirety in order to leave unaltered its conciseness and its clarity.

"Art is Harmony, Harmony is the analogy between Opposites and the analogy between Elements Similar in tonal value, color and line; tonal value, that is, light and shadow; color, that is, red and its complement green, orange and its complement blue, yellow and its complement violet; line, that is, directions from the Horizontal. These diverse harmonies are combined into calm, gay and sad ones; gaiety in terms of tonal value is a luminous dominant tonality; in terms of color, a warm dominant color; in terms of line, lines ascending (above the Horizontal); calmness in terms of tonal value is an equal amount of dark and light, of warm and cool in terms of color, and the Horizontal in terms of line. Sadness in terms of tonal value is a dominant dark tonality; in terms of color, a cold dominant color; and in terms of line, downward directions. Now, the means of expression of this technique is the optical mixture of tonal values, colors and their reactions (shadows), in accordance with very fixed laws, and the frame is no longer, as at first, simply white, but contrasts with the tonal values, colors and lines of the motif." [3]

Let us add that, in conversation, Seurat defined painting for me as "the art of hollowing out a surface."

[2] Seurat painted at Crotoy in the summer of 1889. [Editor's note]

[3] From the biography of Seurat by Jules Christophe, *Les Hommes d'aujourd'hui*, N. 368, 1890. See also the article "From a Letter to Maurice Beaubourg (1890) in this volume. [Editor's note]

• • •

His taste in older art leaned in the direction of the hieratic, as in the Egyptians and the primitives. He was particularly attracted by the most flexible works, like Greek friezes and the works of Phidias; his choices among the romantic masters and the landscapists were broad, but, save for Delacroix, without enthusiasm.

Among the old style Impressionists, he stated freely that the three most important leaders. by virtue of their work and the influence they exerted upon other painters, were Degas, Renoir, and Pissarro.

Like almost all of the Impressionists, he was indebted to the Naturalist movement. And why not? For in their preoccupation with modern Paris and the modern street, in their evocation of the contemporary scene, the writers aligned themselves with the painters, at least in principle.

He declared himself able to paint only what he could see. The frescoes of ideological painting seemed to him lacking in essential qualities of luminosity. He did not feel, moreover, that in order to be intellectual a painting had to convey an allegory or a dramatic scene. For him, the dream was contained by the canvas itself, evoked by the canvas, by the idealization of the models or the motif.

That is why, in his ideal of harmony, in placing around his figures those accessories relevant to them, he wanted to give them a value by means of the direction of their lines and their arbitrary coloration. And, certainly, the modest accessories that surround his *Poseuses* [Fig. 19], female bodies transfigured by light and by the elegance of line, are they not, by virtue of their essentially pictorial qualities, as beautiful and as decorative as the background décor of any imaginary fresco? And if one were to look really carefully at *Le Chahut* [Fig. 27], one would see it, not as a painted image, but as a diagram of ideas, and one might read it thusly: [4]

Dancers in a single rhythm, animated by the direction of the movement, congealed because it is the dominant movement, the leitmotif of the only action that interests us in these dancers, their dance. The female dancer's head, made admirably beautiful by the contrast of its official smile, almost priestly, with the tired delicacy of its small, fine features, marked by desire, conveys to us that this beauty has its complete meaning only in this principle activity of this feminine mind, thus to dance: this act becomes for the dancer something solemn because it is habitual. The male dancer is ugly, ordinary, a banal coarsening of the feminine physiognomy next to him. The smiling light of the female figure diminishes him, for he is not exercising an aptitude peculiar to his sex; he is merely plying an ignoble trade. His coat tails are forked, like the devil's tail in pictures by the old visionaries. The orchestra leader, chance director of this solemnity, closely resembles the male dancer; they are stamped out of the same mold and are both there by trade. As a synthetic image of the public, observe the pig's snout of the spectator, archetype of the fat reveler, placed up close to and below the female dancer, vulgarly enjoying

[4] Kahn, a symbolist poet, had acquired *Le Chahut* from Seurat in 1890, and he owned it when he wrote the following analysis of the painting. [Editor's note]

the moment of pleasure that has been prepared for him, with no thought for anything but a laugh and a lewd desire. If you are looking at all costs for a "symbol," you will find it in the contrast between the beauty of the dancer, an elegant and modest sprite, and the ugliness of her admirer; between the hieratic structure of the canvas and its subject, a contemporary ignominy.

This truly pictorial and artistic manner of seeking the symbolic (without troubling too much over the word) in the interpretation of a subject was, in his opinion, the most truly suggestive, and he was not alone in this opinion.

This demonstration of the subject, as it exists in *Le Chahut,* can be found in other canvases as well, particularly in *La Parade* [Fig. 21], his first night effect in the cities, so willfully pallid and sad. But all of this is pointless. I had simply wanted to show that, for Seurat, the cerebral element, the value of thought, was equal to the value of all else, solely preoccupied as he was with painting as an ideological system.

Émile Verhaeren

From "Georges Seurat" (1891)

. . . The first painting by Seurat that I ever saw? *La Grande Jatte* [Fig. 15], in 1886, rue Laffitte.[1] It took up almost an entire wall, flanked by the *Bec du Hoc* and the *Rade de Grandcamp*. At first, the novelty of this art aroused my curiosity. Not for an instant, though, did I doubt the complete sincerity and profound innovation that was clearly to be found there. I spoke to other artists about it that evening at Poucet's—they attacked me with laughter and mockery. . . .

I returned next day to the rue Laffitte. The *Grande Jatte* impressed me as a decisive effort in the search for real light. No disturbances. An evenness of atmosphere; a smooth passage from one plane to another; and, especially, an astonishing sense of depth at the horizon. Monet, although amazingly light, never gave me this impression of the immateriality and purity of breathable, circulating air, of a world in sunlight and

Émile Verhaeren, "Georges Seurat," *La Société nouvelle,* April 1891, pp. 420–38. These excerpts, pp. 430–38.

Émile Verhaeren (1855–1916) Belgian poet and critic. Saw *La Grande Jatte* at the last Impressionist Exhibition in May 1886. Became Seurat's friend, fervant admirer, and vocal supporter in the Belgian press.

[1] At the eighth and last Impressionist exhibition, which opened at the Maison Dorée in the rue Laffitte on May 15, 1886. [Editor's note]

shadow; he made me think of pearly tones, of beautiful, delicate harmonies, of the transparency and mobility of the blues of water and sky—in short, of his palette. The *Grande Jatte,* on the other hand, impelled me to forget about color altogether and spoke to me only of light. I was completely won over by what I saw.

I gave no thought to the technique. I paid attention only to the result that had been obtained; the method seemed secondary to me. Later, I became convinced that it was thanks to this method, assisted by the keen and discerning vision of the artist, that the result had in fact been obtained. But to arrive at this conclusion, I had to learn about a multitude of laws of whose very existence I was, at the moment, still ignorant. One thing displeased me: the hieraticism of all of those almost wooden figures. . . .

Les XX [2] invited this innovative painter to exhibit. Octave Maus had also felt the shock waves on the rue Laffitte, and knowing that this group of which he was the secretary delighted in bringing together all that was unconventional, he worked to have the *Grande Jatte* hung at our next exhibition in February [1887]. The first article to be published on Seurat in Belgium (*L'Art moderne,* June 1886) appeared under his signature. . . .

It was possible, perhaps for the first time, to examine the work at the requisite distance, where the fusion of the pure pigments can be accomplished by the eye. In Paris, the too narrow dimensions of the room had not permitted this, and the bare technique had assailed the spectator. For to experience a Neo-Impressionist canvas properly, a considerable distance is necessary. Since the tones are united by the eye itself instead of mixing on the palette, it is essential that this fusion be permitted, physically, to take place. [3]

It was at the exhibition held by *Les XX* that I was able to observe how the orange light of the sun spread into the shadow, coloring it, modifying it, removing its opacity and making it live. I became aware of the contrasts and the play of complementaries; I seized upon the variations in the local colors, their metamorphoses, their protean character, and little by little I deciphered some of the primordial laws of the new art. Patiently, I gained certain control and I was able to verify my ideas in each square decimeter of the canvas. And the joy of finally encountering

[2] The Twenty, a group of avant-garde Belgian artists. [Editor's note]

[3] Not everyone shared Verhaeren's view on this. Signac, for example, after returning from the Brussels exhibition, reported in a letter to Pissarro: "In my opinion, the *Grande Jatte* loses a little in that big hall. It displays a certain meticulousness, which at that distance is unnecessary and disappears. One feels that this large canvas has been painted in a small room without much space for stepping back sufficiently. As a matter of fact this was an observation made by several members of the XX. They told Seurat: 'We like your *Grande Jatte* better at close range than from a certain distance. You probably did not paint it in a large room.' It is evident that this infinitely delicate division, exquisite on smaller canvases, becomes too timid for a canvas of several yards. Obviously, for a ceiling decoration the brushstroke must be larger than for an easel painting" (quoted in John Rewald, *Post-Impressionism,* New York, 1956, p. 104). For more on the issue of the correct distance from which to view Seurat's works, see the discussion by William Homer, reprinted below. [Editor's note]

a clear foundation upon which judgments could be based was not without its influence upon the decisive taste that now carried me away. For me, the *Grande Jatte* was a battle fought and won.

I made the acquaintance of the painter. He seemed timid and very quiet. We had to break a great deal of ice in order to reach each other. It was in Paris, the next year, in his studio on the Boulevard de Clichy, that our uneasiness with each other was dissipated. One morning in June, I found him in his sixth floor studio under the eaves. A few cigarettes, then a pipe. And the friendly smoke enveloped us in an atmosphere of intimacy.

He told me little by little about his beginnings, his apprenticeship with Lehmann, his years at the *École,* the whole story of hopes and ambitions overcome by routine and dreary practices. Then, how he had found himself again, beneath everything else, by means of lessons and rules, as one discovers the existence of unsuspected gems beneath stratifications of terrain and soil.

I then saw his *Baignade* [Fig. 6], light, but not yet divided systematically, even though he was already taking into consideration the reactions and the modulating influences of light.

And the studies lining the walls, in the corners, in portfolios, beneath and upon the furniture. And the *Grande Jatte* against the wall.

A few landscapes, one on an easel. This was his summer work, undertaken annually at the seaside or on the outskirts of Paris. Asnières! [4] Nowhere else could he find sites endowed with a light that was as moist and as charmingly alive.

He concluded: a large canvas in winter, a canvas of research and if possible conquest . . .

"A thesis piece," I interrupted.

But he gave no sign of agreement and continued . . . then, in the summer, to wash the days in the studio from the eyes and to translate exactly the real light with all of its nuances. An existence divided in two by art itself.

During other meetings, in the evenings, in the brasseries of Montmartre or at the openings of exhibitions in the spring at the Gallery Petit and elsewhere, occasionally even on the upper deck of an omnibus with life flowing about this island jostled by the countercurrent of the crowds, he revealed to me—and you may be sure that I was the most attentive of listeners—his new preoccupation with design. He arrived at it gradually, and then the problem of the frame disturbed him just as much.

The problem of the frame, even to this day, is not yet solved, but Seurat has opened the path to its solution. At first, he colored the edges according to the law of complementaries. Where the edge of the work was blue, orange was indicated as a boundary; if red, then green would set it off, and so on. It was only recently that he added complementary contrasts. He had imagined that at Bayreuth, the theater was darkened in order to present the illuminated scene as the unique center of attention.[5] This

4 An industrial suburb of Paris, the locale for Seurat's *Baignade* [Fig. 6]. [Editor's note]
5 A reference to Wagnerian stage practice. [Editor's note]

contrast of great light amidst shadow induced him to adopt dark frames, although retaining, as in the past, their complementary relationship to the image.

The mistake of the latter, to my mind, is that in the theater the contrast is continued and extends itself to meet the eye of the spectator, while on the wall of a room or gallery, it has, so to speak, no space, the frame being narrow and bordering the picture the way a binding or hem borders a piece of drapery.

The last renovation attempted by Seurat was concerned with the study of the laws governing line. The poster artist Chéret, whose genius he greatly admired, had charmed him with the joy and the gaiety of his designs. He had studied them, wanting to analyze their means of expression and uncover their esthetic secrets.[6] From another source, in the *Grammaire des arts plastiques* by Charles Blanc, he found the formulation of a complete theory, which seemed precise in its basic premises.[7] He used this as his point of departure. One year later, he arrived at the *Chahut* [Fig. 27] and then the *Cirque* [Fig. 29]. And Jules Christophe, probably under the painter's direction, gave a substantial summary of all of his new theory in *Les Hommes d'aujourd'hui*. It is pointless to reprint it here.[8]

To hear Seurat explain and reveal himself before each of his annual exhibitions was to follow someone who was sincere and to be won over by someone who was persuasive. Calmly, with careful gestures, his eye never leaving you and his slow, unemphatic voice searching for the slightly preceptorial words, he pointed out the results achieved, the clear certainties, what he called the "basis." Then he asked your opinion, called you to witness, waited for the word that would indicate that you had understood. Very modestly, almost timidly, even though one could feel his quiet pride in himself. He never belittled others, even pretended admirations that at heart he did not feel, but one sensed then that he was condescending and devoid of envy. He never complained about the success of others, even though it was upon him that success should have been bestowed.

And now, the end come, it is distressing to think about the future of his endeavors. The disappearance of one man never stops a movement. . . . But the day will surely come when the name of the dead man will be thrown up to his friends. . . . He will be exalted so that the conclusion may be drawn that he alone counted, that he alone was capable of bringing the new effort to a successful issue, that he alone possessed the qualities of a leading master, while the others will be seen as minor imitators. . . .

[6] On Seurat and Jules Chéret, see the article by Robert Herbert, reprinted below. [Editor's note]

[7] Charles Blanc (1813–82) was an influential figure in the official Parisian art world during the nineteenth century. Founder and editor of the *Gazette des Beaux-Arts,* he was the director of the Administration des Beaux-Arts (during 1848–50 and in 1870) and a member of the Academy. The important pedagogical text by Blanc, to which Verhaeren here refers, is the *Grammaire des arts du dessin* (Paris, 1867). For a discussion of the relevance of this text to Seurat's late theory of expression, see Homer (1964), pp. 208 ff. [Editor's note]

[8] It is quotel in the article "Seurat" 1891) by Gustave Kahn, reprinted in this volume. Editor's note]

At this moment, the large majority of painters and critics regard the Neo-Impressionists as buffoons. I have heard doctors declare them to be afflicted with a disease of the eyes, when, in order to see clearly and correctly, they follow the very laws that these learned men teach. There are those who cling blindly to their habitual reactions and in the face of the clearest proof still claim to see no luminosity in the *Grand Fort Philippe* and the views of Crotoy,[9] crying out in their donkeys' voices that all of Neo-Impressionism is dull and bleached: "Like paper!"

It is therefore in the heat of the debate that Seurat has left us. If the destruction of his idea is not to be feared, we must at least anticipate a halt in its drive toward victory. All of his painter friends and others felt that he was the real force in the group. . . . He lived only for his goal, unreceptive to any influence that did not come from his books and his few chosen masters. He never glanced at the comrades who fought alongside him. . . . He went his own way, sure of himself, trusting in the fertility and richness of his own esthetic sense.

If it were necessary to characterize him in one word, we would venture to write that he was, first and foremost, a synthesizer, using the word in its artistic sense. Risk, luck, chance, excitement, these were unknown to him. Not only did he never begin his canvases without knowing where he was going, but his concern went even beyond their success as individual works. For him, they had no great meaning if they did not prove some rule, some artistic verity, some conquest of the unknown. If I understand him correctly, Seurat gave himself the mission of releasing art from the tentative, the vague, the hesitant, and the imprecise. Perhaps he thought that the scientific and positivist spirit of his time required, in the realm of the imagination, a more clear and solid tactic for the conquest of the beautiful. He wanted to inscribe this tactic point by point at the very foundation of each of his canvases, and often he succeeded. And that is why, each year, a great work appeared, more theoretical perhaps than simply beautiful, but magnificent in terms of truth sought and will victorious. Considered from this point of view, the history of this painter is one of the most strictly exemplary.

His goal, nearly reached even at the age of thirty-one, was made up of two aims: on the one hand, to fix the fundamental principles and sources of color as divorced from all intuited whim—the local color, light source, the reactions and interactions of things; on the other hand, to determine the esthetic and intellectual expression of lines, be they straight, horizontal or curved; that is to say, the whole painting, in the special sense of this term.

Limited as he was to this single concern, one might think that his mind was solely positivist and realist in its bent. This, however, was not the case, and far from it.

Through his research on line, he arrived at arrangement, composition, broad and ideal decoration. Each step ahead leading to the next, he had in fact arrived at a series of intellectual works, conceived in the

9 D.-R., 206, 192, and 193. [Editor's note]

mind, while still preserving the solid foundations of art. The emotional power of line would have opened and revealed the splendor of legends, the attitudes of history, the independent beauty of all things, beauty for and by itself. Although starting from the accidental, thanks to his ability to synthesize and to purify his conceptions, he would have risen to the general and perhaps, as far as possible, to the absolute. If the future had been kind to him, we would doubtless have seen him attempt the highest form of decorative art, perpetuating the work of a Puvis de Chavannes, while at the same time renewing and perfecting it.

For us, as he appeared to us, it is Ingres whom he most consistently called to mind. Already he had cast certain of his ideas into axioms. He theorized readily; he liked doctrines, fixed precepts, sure and indisputable methods. He was austere, calm, cool. His canvases attest to the fact that he put little sensuality into his work. His dancers are chaste. He liked color that is precise, clear, pure, not sensually pleasurable.

And he was persistent, exclusive, and rational . . . eager to proselytize, to explain his ideas, and to demonstrate his art. To perform this duty—for, in his eyes, to illumine and to justify were moral obligations—he mastered his natural timidity and reserve, not before an auditorium, but in a one-to-one relationship, in intimate conversation, and thus, at certain times, he revealed his accumulated reflections and conclusions.

Solitary by nature, he opened his intimate experience and allowed all who were sincere, searching, and not malevolent to enter through this wide-open door. He spoke endlessly about art, emphasizing not what he had already done but what he planned to accomplish. The past, from which he revived Delacroix and Ingres, was for him, if not dead, then at least something that one need not heed. To foresee seemed to him more necessary than to see. . . . And there is an important part of the future that is extinguished with his glance and immobilized with his hand. What wounds me the most is that he was not even able to execute the new and bold project that he outlined for me during the last conversation we had together. And here he is already far away from us in death, and his last work, the *Cirque* [Fig. 29], an unfinished canvas, will remain for me from now on as the symbol of his artistic life, cut cleanly like a rail, stopped suddenly, whereas the train, stoked and prepared for its complex journey, arrives at full speed to find its future course undefined.

Teodor de Wyzewa

Georges Seurat (1891)

I have had upon several occasions the opportunity to spend a few hours in the company of this gentle and pensive young man, who had already planned out the program of his work some thirty years into the future and who, now, has departed for one knows not where, leaving hardly the first bare outlines of the mighty work of which he had dreamt. With his great height, his long beard and his guileless eyes, he seemed to me like one of the Italian masters of the Renaissance, who were also strong but disdainful of their strength, striding ahead assuredly in pursuit of their ideal.

And, from the first evening I met him, I discovered that his soul was also one of past times. The secular disenchantment that makes the task so difficult for artists today had not touched him. He believed in the power of theories, in the absolute value of methods, and in the lasting effects of revolutions. And my joy was great at having found here in a corner of Montmartre so admirable an example of a race that I had supposed extinct, a race of painter-theorists who combine idea with practice, unconscious fantasy with deliberate effort. Yes, I felt strongly Seurat's kinship with the Leonardos, the Dürers, and the Poussins. I never tired of hearing him explain in detail his researches, the sequence he planned to use, and the number of years he proposed to expend on each. And he never tired of explaining it to me.

I would add that his research dealt with the same problems that had occupied the old masters, the problems most worthy, to my mind, of occupying an artist. He wanted to make of painting a more logical art, more systematic, where less room would be left for accidental effect. Just as there are rules for technique, he wanted them also for the conception, composition, and expression of subjects, realizing that personal inspiration would suffer no more from these rules than from others. First of all, he had analyzed color; he had sought the different ways of rendering it, trying to discover the means that rendered it with the greatest accuracy and variety. Then he was attracted by the expressiveness of color. He

Teodor de Wyzewa, "Georges Seurat," *L'Art dans les deux mondes*, n.22, April 18, 1891, pp. 263–64.

Teodor de Wyzewa (1862–1917) Symbolist writer and critic, born in Poland and educated in France. He was co-founder of the *Revue Wagnerienne* (1886) and a frequent contributor to the *Revue Indépendante*. Although he was unsympathetic to Seurat's theories, he nevertheless admired the artist for his talent and ability.

wanted to know why certain color combinations produced an impression of sadness and others an impression of gaiety. And he made himself, from this point of view, a sort of catalogue in which each nuance was linked with the emotion it suggested. In its turn, the expressiveness of line seemed to him a problem susceptible to a fixed solution. For lines, too, have in them a secret power of joy or of melancholy, and all painters feel this instinctively in the use they make of them. In the meantime, questions of less general interest, but of great importance, had claimed his attention. For example, the question of the confines of a picture: how to make of a painting a complete harmony, how to isolate it from other objects without creating too abrupt a discordance?

To all of these problems—problems that he was alone in raising but that are important and may be resolved only by a painter—Georges Seurat had found solutions that were sufficiently to his liking. His solutions, I must admit, did not always satisfy me as completely as his choice of questions. I could not believe that the Pointillist method, although in greater conformity with scientific hypotheses concerning color, was necessarily better than any other method for translating color in a painting; nor that it was enough to draw ascending lines to suggest gay emotions; nor that to color the frame of a painting would have the effect of completing its harmony and isolating it from other objects. But I readily credited Seurat with the ability to find more definitive solutions, expecting that he would have the years ahead of him to pursue more thoroughly the noble problems that preoccupied him.

And now he is dead, at the age of thirty [*sic*], and we are forced to judge him simply on the work that he has left. I fear that this work will not succeed in placing him in the position that he merits by virtue of the power and originality of his artistic temperament. Men of his stamp require an entire lifetime to realize their ideal. Their early works are only preparatory experiments or studies destined one day to be destroyed. Experiments and studies, these are all that are left us of Seurat. His figural compositions, the *Grande Jatte,* the *Parade,* the *Modèles,* the *Cirque,* are clearly only provisional experiments, first attempts to apply, in progression, methods still unfixed. Still, one may find there superb passages that reveal the artist side by side with odd passages that still bear witness to his search; and, then, passages in which the neglect of this or that element, sacrificed to more interesting elements, is too apparent. No doubt, for example, that in time Seurat would have succeeded in removing from his figures that stiffness and rigidity that often prevent us from appreciating the magisterial purity of their design.

As for the small landscapes that he has left, he himself never regarded them as anything more than studies. Several of them are charming, lighter, and more delicate than other contemporary landscapes, but this finesse and this lightness and the delicate melancholy that accompanies them result more, I believe, from Seurat's soul than from his methods and his theories.

There is, however, one mode in which it seems to me that Seurat realized all of the qualities of his genius: I have seen charcoal drawings by him that are marvelously skillful, sober, luminous, alive, the most ex-

pressive that I have ever come across. Did he keep them? Will we be able to see them again? I recall that he treated them with disdain, as though he would have preferred to have the admiration they elicited transferred to his painting.

Of Seurat's inventions, little remains. Only his invention of Pointillism has found imitators. It has led Signac and van Rysselberghe[1] to achieve effects of remarkable softness and delicacy of nuance. But it has led them to this end only after much groping, and I fear that along the way it has caused them to lose more than one quality.

And thus it may be that the name of Seurat, without ever having been well known, will one day be forgotten. Death has taken him treacherously. But, at least, I may be permitted to affirm that he was one of the forces of the art of our time, that he was better than all others of his age, with his more highly developed curiosity and his nobler mind. With him is gone one of our hopes of seeing the resurgence of a new art amidst the anarchy, the ignorance, and the vulgarity of the contemporary art world.

Edmond Aman-Jean, Charles Angrand
Reminiscences (1924)

BY EDMOND AMAN-JEAN

Physically, he resembled Donatello's *St. George* . . . he was handsome.

In Seurat, instinct and talent dominated; he was prodigiously gifted to have accomplished what he did at so early an age. I owe him much; our discussions were endless. . . .

We met in a small municipal art school on the rue des Petits-Hôtels, near the church of Saint Vincent-de-Paul. His family lived in that district, as did mine. From there we went on to the École des Beaux-Arts under the rule of Henri Lehmann, a student of Ingres who had inherited

Excerpts from letters by Edmond Aman-Jean to Gustave Coquiot, published in Gustave Coquiot, *Georges Seurat* (Paris: Albin Michel, 1924), pp. 26–29.

Edmond Aman-Jean (1860–1936) Painter and early boyhood friend of Seurat, whom he met in 1875 at a municipal art school in Paris. In 1878, they went on together to study at the École des Beaux-Arts under the tutelage of Henri Lehmann and shared a studio for a while during this period.

[1] Théo van Rysselberghe (1862–1926) was a founding member of Les XX and one of the principal Belgian Neo-Impressionists. See Robert L. Herbert, *Neo-Impressionism* (New York: The Solomon R. Guggenheim Museum, 1968), pp. 178–86. [Editor's note]

only Ingres' pedantic side but not his ability to open up vistas and lead the young with a word. . . .

It was drawing that put Seurat on his true path. . . . In our youth, Puvis de Chavannes [it was said] did not know how to draw; the mindless, wirelike line of Jules Lefebvre was what most people thought of then as drawing, and so it has remained. The theory of complementaries fascinated us. The visible, divided touch, which has become a process, was perfected by him. He had under way the most beautiful things. He was well-read and had a taste for the difficult. The slipshod character of most painting today was insupportable to him, false finish even more so. . . .

We had taken a little studio together on the rue de l'Arbalete (very old street in the fifth arrondissement, in the Panthéon-Mouffetard district). Seurat's father came there. To me, disrespectful dauber that I must have been then, he seemed the perfect model of the bourgeois. Seurat's mother, whom I saw only once, was of the same type. . . .

In his youth, Georges Seurat was serious and disciplined. Our little municipal art school was directed by a sculptor, Justin Lequien, who taught us how to draw noses and ears from lithographed models. It is a mystery how, from this kind of teaching, he managed to do what he did.

We read endlessly, passing judgments upon literature. Goncourt was our divinity at that time. Ingres was for a long time Seurat's god. His judgment, his tastes, his earliest perceptions and acts were instinctive, but of an instinct that never errs, producing the rapid achievements of one who is destined soon to depart.

BY CHARLES ANGRAND

. . . I met him around 1884, through Signac, I believe . . . I remember going with him to his mother's house and seeing on her walls many of those drawings—for example, *Le Dîneur* [Fig. 4]—that were among his earliest studies.

I found him regularly at Signac's gatherings, 20 Avenue de Clichy, with Paul Adam, Dubois-Pillet, Régnier, and others. I visited him in his studio on the Boulevard de Clichy. . . . He complained of the lighting, which varied with the sky. On the wall, many of the little thumb-box sketches he said were his joy. . . .

In 1885–86, I often went to work alongside him on the island of La Grande Jatte. Because the vigorous summer grass was growing high on the river bank, hiding from view a boat that he had placed in the foreground—and since he complained of this adversity—I did him the service of cutting this grass, for I suspected that he was about to sacrifice his boat. He was not nature's slave, however, not at all! But he was respectful of

Excerpts from letters by Charles Angrand to Gustave Coquiot, published in Gustave Coquiot, *Georges Seurat* (Paris: Albin Michel, 1924), pp. 38–44.

Charles Angrand (1854–1926) French neo-Impressionist who was a close friend and early follower of Seurat. He was a founding member of the Société des Artistes Indépendants in 1884, and through this organization he met Seurat and Signac, who were also members.

it, since he was not imaginative. His special concern was for tonal values, hues, and their reactions. . . .

At day's end, we left the island by ferry, which dropped us on the Boulevard de Courbevoie, recently created along the river. Trees had just been planted, and Seurat delighted in making me see that their green crowns against the grey sky were haloed with pink. . . . We know how readily—and legitimately—he would talk about "my method." We talked about it frequently, as you may well imagine. He once added to me: "They —meaning writers and critics—they see poetry in what I do. No. I apply my method and that is all." His position made sense, didn't it? For isn't poetry ultimately imponderable?

I still preserve the memory of an afternoon chat that we had in his studio in the Passage de l'Elysée des Beaux-Arts. He was working on the *Cirque* [Fig. 29]. Impelled by I know not what, I objected to his theoretical refinements—for binary harmonies were becoming tertiary ones and the lines were following the colors—when, seizing his stool to gesture with, this man who was usually silent and embarrassed became eloquent, with an eloquence born of conviction. This gesture struck me singularly. . . .

The meetings of the Society of Independent Artists were held during his time at the Café Marengo in the neighborhood of the Louvre. He never missed them. I can see him there still. He sat habitually against the wall on the left-hand side of the room, always in the same seat if it were not taken—and silently, attentively, he smoked. . . .

The meetings' over, we would leave together. . . . More than once along the way, Seurat pointed out to me the complementary halo around the gas lamps. He was applying this in his *Parade* [Fig. 21], as you know. His eye was constantly searching for such contrasts. . . . At the teas held by Signac, Avenue de Clichy, he listened silently except when directly questioned. Gathered there were the young writers who were the first to comment in the reviews on this new technique called Neo-Impressionism. Seurat, to whom it was due, was jealous of his paternity. And he remained touchy on this point. I found him very disturbed over it one evening. The biographer of Pissarro in *Hommes d'aujourd'hui*[1] had not attributed the new "manner" to Pissarro, who had been trying his hand at it—but he had written without stating precisely who it had been who had started it. And Seurat fretted himself over this. I tried to restore him to reason through my protestations. I took him out to the Café Guerbois—and, truly, it would have taken no less a diversion than this to lift him a bit out of his mood of inexplicable anxiety. . . .

[1] The biography of Pissarro, N. 366 of *Les Hommes d'aujourd'hui,* was by Georges Lecomte. [Editor's note]

CONTEMPORARY CRITICISM

Félix Fénéon

From Some Critical Writings

FROM *THE IMPRESSIONISTS IN 1886* (1886)

From the beginning, the Impressionist painters, with that concern for the truth which made them limit themselves to the interpretation of modern life directly observed and landscape directly painted, have seen objects conjointly related to one another, without chromatic autonomy, participating in the luminous qualities of their neighbors; traditional painting considered them [these objects] as ideally isolated and lighted them with a poor and artificial daylight.

These color reactions, these sudden perceptions of complementaries, this Japanese vision, could not be expressed by means of shadowy sauces concocted on the palette: these painters thus made separate notations,

Félix Fénéon, "Les Impressionnistes en 1886 (VIIIᵉ Exposition Impressionniste)," *La Vogue,* 13–20 June 1886, pp. 261–75; reprinted with additions late in 1886 as a pamphlet under the title *Les Impressionnistes en 1886;* reprinted in *Félix Fénéon, Oeuvres,* ed. Jean Paulhan (Paris: Gallimard, 1948); in D.-R., pp. xi–xiii; and in Félix Fénéon, *Au-delà de l'impressionnisme,* ed. Françoise Cachin (Paris: Hermann, 1966), pp. 64–67. The English translation and notes by Linda Nochlin are reprinted from *Impressionism and Post-Impressionism, 1874–1904,* Sources and Documents in the History of Art (Englewood Cliffs, N.J.: Prentice-Hall, 1966), pp. 108–10. © 1966. Reprinted by permission of Hermann and Prentice-Hall, Inc., Englewood Cliffs, New Jersey.

Félix Fénéon (1861–1944) Symbolist writer and art critic. Founded the *Revue indépendante* in 1884 and contributed frequently to *La Vogue* and the Belgian publication *L'Art moderne.* Early established as the primary literary spokesman for Seurat and his followers, whom he dubbed "Neo-Impressionists." His review of their work at the 8th Impressionist Exhibition (1886) was the first serious and knowledgeable consideration of these artists, and it remains today an authoritative explanation of Seurat's early goals.

letting the colors arise, vibrate in abrupt contacts, and recompose them-
selves at a distance; they enveloped their subjects with light and air,
modeling them in the luminous tones, sometimes even daring to sacrifice
all modeling; sunlight was at last captured on their canvases.

They thus proceeded by the decomposition of colors; but this de-
composition was carried out in an arbitrary manner: such and such a
streak of impasto happened to throw the sensation of red across a land-
scape; such and such brilliant reds were hatched with greens. Messieurs
Georges Seurat, Camille and Lucien Pissarro, Dubois-Pillet, and Paul
Signac divide the tone in a conscious and scientific manner. This evolution
dates from 1884, 1885, 1886.

If you consider a few square inches of uniform tone in Monsieur
Seurat's *Grande Jatte,* you will find on each inch of its surface, in a whirl-
ing host of tiny spots, all the elements which make up the tone. Take this
grass plot in the shadow: most of the strokes render the local value of the
grass; others, orange tinted and thinly scattered, express the scarcely felt
action of the sun; bits of purple introduce the complement to green; a
cyanic blue, provoked by the proximity of a plot of grass in the sunlight,
accumulates its siftings toward the line of demarcation, and beyond that
point progressively rarefies them. Only two elements come together to pro-
duce the grass in the sun: green and orange tinted light, any interaction
being impossible under the furious beating of the sun's rays. Black being
a non-light, the black dog is colored by the reactions of the grass; its
dominant color is therefore deep purple; but it is also attacked by the
dark blue arising from neighboring spaces of light. The monkey on a
leash is dotted with yellow, its personal characteristic, and flecked with
purple and ultramarine. The whole thing: obviously merely a crude
description, in words; but, within the frame, complexly and delicately
measured out.

These colors, isolated on the canvas, recombine on the retina: we
have, therefore, not a mixture of material colors (pigments), but a mix-
ture of differently colored rays of light. Need we recall that even when
the colors are the same, mixed pigments and mixed rays of light do not
necessarily produce the same results? It is also generally understood that
the luminosity of optical mixtures is always superior to that of material
mixture, as the many equations worked out by M. Rood show.[1] For a
violet-carmine and a Prussian blue, from which a gray-blue results:

$$\underbrace{50 \text{ carmine} + 50 \text{ blue}}_{\text{mixture of pigments}} = \underbrace{47 \text{ carmine} + 49 \text{ blue} + 4 \text{ black}}_{\text{mixture of rays of light}}$$

for a carmine and green:

$$50 \text{ carmine} + 50 \text{ green} = 50 \text{ carmine} + 24 \text{ green} + 26 \text{ black}$$

[1] In *Modern Chromatics (Students' Text-Book of Color)*, published in 1879, a book that
was to be extremely influential upon Seurat and his group, the American physicist,
Ogden N. Rood, a professor at Columbia University, had explained the important dif-
ference between mixing *pigment* (subtractive mixture) and mixing *light* (additive mix-
ture), demonstrating the latter by means of Maxwell's Discs, and insisting upon its
superior luminosity.

We can understand why the Impressionists, in striving to express extreme luminosities—as did Delacroix before them—wish to substitute optical mixture for mixing on the palette. Monsieur Seurat is the first to present a complete and systematic paradigm of this new technique. His immense canvas, *La Grande Jatte* [Fig. 15], whatever part of it you examine, unrolls, a monotonous and patient tapestry: here in truth the accidents of the brush are futile, trickery is impossible; there is no place for bravura— let the hand be numb, but let the eye be agile, perspicacious, cunning. Whether it be on an ostrich plume, a bunch of straw, a wave, or a rock, the handling of the brush remains the same. And if it is possible to uphold the advantages of "virtuoso painting," scumbled and rubbed, for rough grasses, moving branches, fluffy fur, in any case "la peinture au point" [literally "well-done (cooked) painting"] imposes itself for the execution of smooth surfaces, and, above all, of the nude, to which it has still not been applied.

The subject [of the *Grande Jatte*]: beneath a canicular sky, at four o'clock, the island, boats flowing by at its side, stirring with a dominical and fortuitous population enjoying the fresh air among the trees; and these forty-odd people are caught in a hieratic and summarizing drawing style, rigorously handled, either from the back or full-face or in profile, some seated at right angles, others stretched out horizontally, others standing rigidly; as though by a modernizing Puvis.[2]

The atmosphere is transparent and singularly vibrant; the surface seems to flicker. Perhaps this sensation, which is also experienced in front of other such paintings in the room, can be explained by the theory of Dove:[3] the retina, expecting distinct groups of light rays to act upon it, perceives in very rapid alternation both the disassociated colored elements and their resultant color.

FROM "IMPRESSIONISM AT THE TUILERIES" (1886)

. . . Against the reform promulgated by the three or four painters with whom these notes are concerned, ineffectual arguments abound. "Uniformity and impersonality of execution will deprive their pictures of any distinctive style." [So say those who] confuse calligraphy with style. These pictures will be different from one another because the temperaments of

Félix Fénéon, "L'Impressionnisme aux Tuileries: Correspondance particulière de *L'Art moderne* (à propos de la IIe Exposition de la Société des Artistes Indépendants)," *L'Art moderne,* Brussels, September 19, 1886. Reprinted in Félix Fénéon, *Au-delà de l'impressionnisme,* ed. Françoise Cachin (Paris: Hermann, 1966), pp. 73–80. This excerpt, pp. 79–80. By permission of Hermann.

2 Pierre Puvis de Chavannes (1824–1898), painter of poetic and idealized allegories, best known for his murals, and greatly admired by the Symbolists.

3 Heinrich-Wilhelm Dove (1803–1879), German physicist and meteorologist, whose "theory of luster," probably transmitted through Rood's writing, was influential upon Seurat.

their creators are different. "A recent work by Pissarro, a Seurat, a Signac cannot be distinguished one from the other," the critics proclaim. As usual, the critics have arrogantly made the most distressing statements. These painters are accused of subordinating art to science. Instead, they only make use of scientific data to direct and perfect the education of their eye and to control the accuracy of their vision. Professor O. N. Rood has provided them with valuable facts. Soon Charles Henry's general theory of contrast, rhythm, and measure will arm them with new and precise information.[4] But Mr. Z. can read optical treatises from now til eternity, and he will never paint the *Grande Jatte*. Between his courses at Columbia College, Mr. Rood—whose artistic perspicacity and erudition appear to be nonexistent—paints: those pictures must be dreadful. The truth of the matter is that the Neo-Impressionist method requires an exceptional delicacy of vision: all of the skills that cover up visual insensitivity with manual dexterity must flee in terror before its dangerous honesty. This painting is accessible only to *painters*. . . .

FROM "NEO-IMPRESSIONISM" (1887)

I

. . . One thinks back to the first Impressionist exhibitions. Confronted by definitive canvases and fearsome scribbles, the constitutionally stupid public was flabbergasted. That a color should give rise to its complementary—ultramarine to yellow, red to blue-green—seemed demented to it, and even though the soberest physicists had assured its members in a scholarly tone of voice that the ultimate effect of darkening any of the colors of the spectrum was actually to add greater and greater quantities of violet light to them, the public still rebelled against violet tinges in

Félix Fénéon, "Le Néo-Impressionnisme" (Correspondance particulière de *L'Art moderne*, à propos de la IIIᵉ Exposition de la Société des Artistes Indépendants, Pavillon de la Ville de Paris, 26 mars–3 mai 1887), *L'Art moderne*, Brussels, May 1, 1887, pp. 138–39. Reprinted in D.-R., pp. xviii–xx, and in Félix Fénéon, *Au-delà de l'impressionnisme*, ed. Françoise Cachin (Paris: Hermann, 1966), pp. 91–93. The English translation is by Linda Nochlin and is reprinted from *Impressionism and Post-Impressionism, 1874–1904*, Sources and Documents in the History of Art (Englewood Cliffs, N.J.: Prentice-Hall, 1966), pp. 110–12. © 1966. Reprinted by permission of Hermann and Prentice-Hall, Inc., Englewood Cliffs, New Jersey.

4 Charles Henry (b. 1859) was a brilliant young scientist and experimental esthetician whom Seurat met in 1886. This reference to him by Fénéon is one of the earliest indications of his importance for Seurat. As John Rewald has pointed out, Fénéon's reference is to Henry's *Cercle chromatique, présentant tous les compléments et toutes les harmonies de couleurs, avec une introduction sur la théorie générale de la dynamogénie, autrement dit du contraste, du rythme et de la mesure*, not published until 1888–89, but in preparation by 1886 (D.-R., p. xvii, note 11). Already available to Seurat at this time was Henry's "Introduction à une esthétique scientifique," published in *La Revue contemporaine* in August of 1885, which set forth some of Henry's ideas regarding the expressive correlation between certain configurations of line and color and specific emotional states (see Homer, 1964, pp. 181 ff). [Editor's note]

the shadows of a painted landscape. Accustomed to the bituminous sauces cooked up by the master-cooks of the schools and academies, light colored painting turned its stomach. . . .

As far as technique was concerned, still nothing was precise: the Impressionist works presented themselves with an air of improvisation. The technique was summary, brutal, and hit-or-miss.

II

Since 1884–1885, Impressionism has come into possession of this rigorous technique. M. Georges Seurat was its instigator.

The innovation of M. Seurat, already implicitly contained in certain works of M. Camille Pissarro, is based on the scientific division of the tone. In this way: instead of triturating the pigment on the palette in order to come as close as possible to the tint of the surface to be represented, the painted places directly on the canvas brushstrokes setting out the local color—that is to say, the color that the surface in question would take on in white light (obviously the color of the object seen from close up). This color, which he has not achromatized on the palette he achromatizes on the canvas, by virtue of the laws of simultaneous contrast, by the intervention of other series of brushstrokes, corresponding to:

1. The portion of colored light which is reflected, without change, on the surface—this will generally be a solar orange;

2. The weak portion of colored light which penetrates farther than the surface and which is reflected after having been modified by a partial absorption;

3. The reflections projected by neighboring bodies;

4. The surrounding complementary colors.

Strokes which are not executed with a slashing brush, but by the application of tiny coloring-spots.

Here are some of the advantages of working in this way:

I. These strokes unite on the retina, in an optical mixture. Now, the light intensity of an optical mixture is much greater than that of a pigment mixture. This is what modern physics means when it says that every mixture on the palette is a step toward black.

II. Since the numerical proportions of the coloring-drops can vary infinitely within a very small area, the most delicate nuances of modeling, the most subtle gradations of tints can be translated.

III. This spotting of the canvas demands no manual skill, but only— only!—an artistic and experienced vision.

III

The spectacle of the sky, of water, of greenery varies from instant to instant, according to the original Impressionists. To seize one of these fugitive appearances on the canvas was their goal. Thus the necessity arose of capturing a landscape in a single sitting, and a propensity for making nature grimace to prove that the moment was indeed unique and would never be seen again.

To synthesize the landscape in a definitive aspect which perpetuates the sensation [it produces]—this is what the Neo-Impressionists try to do. (Furthermore, their manner of working is not suited to hastiness and requires painting in the studio.)

In their scenes with figures, there is the same aversion to the accidental and transitory. Thus the critics in love with anecdote whine: they are depicting dummies, not men. These critics are not tired of the Bulgarian's portraits, which seem to ask: guess what I am thinking! It doesn't bother them at all to see on their wall a gentleman whose waggishness is eternalized in a wicked wink, or some flash of lightning *en route* for years.

The same critics, always perspicacious, compare the Neo-Impressionist paintings to tapestry, to mosaic, and condemn [them]. If it were true, this argument would be of meager value, but it is illusory; step back a bit, and all these varicolored spots melt into undulating, luminous masses; the brushwork vanishes, so to speak; the eye is no longer solicited by anything but the essence of the painting.

Is it necessary to mention that this uniform and almost abstract execution leaves the originality of the artist intact, and even helps it? Actually, it is idiotic to confuse Camille Pissarro, Dubois-Pillet, Signac, and Seurat. Each of them imperiously betrays his disparity—if it be only through his unique interpretation of the emotional sense of colors or by the degree of sensitivity of his optic nerves to such and such a stimulus —but never through the use of facile gimmicks.

Among the throng of mechanical copyists of externals, these four or five artists produce the very effect of life; this is because to them objective reality is simply a theme for the creation of a superior, sublimated reality in which their personality is transformed.

Émile Hennequin

From "Notes on Art: The Exhibition
of Independent Artists" (1886)

. . . Monsieur Seurat, who passes for the inventor of the new technique, paints not by using colors prepared on the palette but by placing in juxtaposition a series of small touches of pure color, which, at a certain dis-

Émile Hennequin, "Notes d'Art: Exposition des artistes indépendants," *La Vie moderne,* September 11, 1886, pp. 581–82. This excerpt, pp. 581–82.

Émile Hennequin (1858–1888) French critic and writer who was unfriendly to Seurat's methods. Two articles by him on Seurat appeared in 1886 in *La vie moderne.* Other writings include *La critique scientifique* (1888).

tance, mix optically to produce the desired color. Thus, on Monsieur Seurat's canvases, each apparently uniform area of color is really a multi-colored spotting in which one of the pigments dominates by virtue of the number of its touches; at a distance it is this pigment that one perceives, modified by the reactions and mixture of the other tones.

That is the technique; it is unquestionably ingenious and possesses, theoretically, unquestionable advantages. It permits a closer imitation of nature, where colors usually result from the optical mixture of diversely colored masses or molecules. Besides, it has been established by physicists (N. Rood, *Scientific Theory of Colors*) that the luminosity of optical mix-ture produced through juxtaposition is superior, sometimes markedly so . . . to colors obtained by the fusion of pigments on the palette.

Nothing, however, is more imprecise than these apparent facts. By established habit, we see nature as homogeneously colored masses: the artist who, in painting a road, composes the color from all the colors of the molecules of dust, is putting himself to needless trouble; for we no longer consciously see these components, just as in a meadow we do not discern the different greens of the various types of grass. Moreover, Mon-sieur Seurat does not confine himself to such absolute precision: he uses orange to render the yellow of scorched grass, pure green for the bluish-green of the sea, and multicolored dots for the fairly homogeneous masses of a red dress or the painted hull of a boat.

His method, then, like all pictorial methods, is an artifice, and in these terms it is proper to judge it only on the basis of its ability to render nature more truly than others have done. Now the really strange thing, for those who are not initiated, is that Monsieur Seurat's pictures, like those of the artists who follow him, are almost entirely lacking in lu-minosity.

Contrary to what his theory would indicate, Monsieur Seurat's sea-scapes excel precisely because they are grey; but as for his picture the *Grande Jatte* [Fig. 15], in which strollers are placed in a half-shadow cast by a full sun, you cannot imagine anything more dusty or lustreless. We do not know to what this phenomenon may be attributed; but it exists, and it must surely also have struck the English critic Ruskin. The latter, talking about painting in dots, in a passage cited by Rood, advises artists to accompany each touch of pigment with a touch of white "if you want the color thus added to appear brilliant." Monsieur Seurat's failure on this point, precisely where it would have seemed necessary that he suc-ceed, demonstrates clearly that esthetics can expect little from preliminary theorizing, that it has its own laws, which must be established through observation and which cannot be predicted by means of physical experi-ments.

The talent of Monsieur Seurat and his followers is not in question, but it is impossible to over-emphasize that one technique more or less can contribute little to art, to the beauty of works of art, which is to say, to their ability to move us. When Monsieur Seurat uses his method to paint Norman seascapes, especially, as in that marvelous canvas entitled *Grandcamp* [D.-R., 155], when he describes the grey arrival of evening, he is excellent. But if, as in the *Grande Jatte,* he attacks the problem of

sunlight and the fading figure, he is glaringly unsuccessful, not only because of the absence of light but because of the absence of life in these figures whose outlines have been painstakingly filled in with colored dots as in a tapestry. They are painted Gobelin tapestries, as unpleasant as the originals. . . .

Joris Karl Huysmans

From "Chronicle of Art:
The Independents" (1887)

. . . Last year, Monsieur Seurat exhibited, in addition to the *Grande Jatte,* several truly beautiful seascapes, quiet seas beneath calm skies; these canvases, light and blond, enveloped in a grey dust of light, reveal a very personal yet very accurate conception of nature. . . .

The seascapes he exhibits this year, his views of Honfleur, especially his *Lighthouse* (D.-R., 168), affirm the very real talent of which he has already furnished indisputable proof. These pictures still depend upon the sensation they express of a nature more dormant than melancholy, a nature calmly at ease beneath wrathless skies, sheltered from the wind . . . I find in them a repose for the quiet soul, a distinction of pallid indolence, a caressing sea that lulls all weariness and disperses it.

Strange thing! This landscape painter whose seascapes can induce monotonous dreams becomes all unsuggestive facade when he places painted personages upon his stage; and it is here that his technique—that arpeggio of little strokes, that mesh of tiny stitches, those mosaics of colored points— trips him up.

. . . Monsieur Seurat succeeds—but no better than did his predecessors the Impressionists—in rendering the vision of the human figure in light; and as a result of concentrating all of his efforts on this goal, he neglects to penetrate further and deeper. Strip his figures of the colored fleas with which they are covered, and underneath there is nothing; no soul, no thought, nothing. Nothingness in a body of which only the con-

Joris-Karl Huysmans, "Chronique d'art: Les Indépendants," *La Revue indépendante,* II, 2, April 1887, 51–57. These excerpts, pp. 53–55.

Joris-Karl Huysmans (1848–1907) French novelist and critic. In the 1870's, he was a follower of Zola's objective Naturalism, which he gradually abandoned in the early 1880's. In 1884, he published the popular and influential *A Rebours,* which became the very prototype of the "decadent" Symbolist novel for the period.

tours exist. Thus in his picture of the *Grande Jatte,* the human armature becomes rigid and hard; everything is immobilized and congealed.

I fear that there are too many methods here, too many systems, and not enough of the flame that ignites, not enough of life. . . .

Émile Verhaeren

From "The Exhibition of the Twenty
in Brussels" (1887)

. . . The *Grande Jatte* [Fig. 15] deserves a detailed examination.

So luminous is it that, as soon as one sees it, it becomes impossible to take any interest in the landscapes around it . . . A purity of atmosphere and a total aerial vibration fill it. The Seine, the green shadow, the golden grass and the sky, influencing each other, coloring each other, penetrating each other, create a tremendous sensation of life. . . .

The *Grande Jatte* is painted with a primitive naïveté and honesty. Standing before it, one is reminded of Gothic art. Just as the old masters risked rigidity by arranging their figures hieratically, so, too, Monsieur Seurat synthesizes attitudes, poses, and movements. What they did to express their time, he attempts for his own, with the same care for precision, concentration, and sincerity. He does not repeat what they did. He makes original use of their profound method in order to sum up modern life. The gestures of these strollers, their groupings, their comings and goings, are *essential.* . . .

Émile Verhaeren, "Le Salon des Vingt à Bruxelles," *La Vie moderne,* Paris, February 26, 1887, pp. 135–39. This excerpt, p. 138.

Albert Michel

From "Neo-Impressionism" (1888)

. . . Applied to this school, the term Neo-Impressionist is entirely inaccurate and can only create a very false idea.

There is, in reality, no school that takes impression, in the sense of the unexpected, less into account. Nothing is left to chance, to imagination, to inspiration; instead, everything is calculated to achieve a mathematically certain result. And that, in short, is what distinguishes Neo-Impressionism from Impressionism, to the extent that they are at opposite poles from one another.

The opponents of Neo-Impressionism—and they are legion—criticize it in particular for allowing method to play a preponderant role. . . .

The argument is specious . . . for if one wished to declare war upon method, one would have to begin by condemning the entire evolution of the plastic arts, which is none other than a constant transformation of methods in the direction of an ever fuller search for reality. I do not say that method is everything in art; I maintain simply that it constitutes not the only, but certainly the principal, goal of artistic evolution. Genius and talent are appreciably the same in the Italian primitives and the masters of the Renaissance; as for their methods, there are almost no grounds for comparison. Was not the revolution effected by the discovery of the laws of perspective a revolution in method, and did this not then entirely change the physiognomy of art? Either words are no longer words and change meaning when applied to identical situations, or we shall have to stop reproaching the Neo-Impressionists for concerning themselves exclusively with the transformation of methods.

There is, if I understand it correctly, another criticism that is aimed at the Neo-Impressionist school. This second argument says that its mechanical methods lead to the suppression of all originality in the artist, or that, rather, originality here is something that is entirely superfluous and in the way. Nothing, it is said, resembles Monsieur Seurat more than Monsieur Signac; nothing resembles Monsieur Signac more than Monsieur Dubois-Pillet. The reproach is perhaps justified; but in this instance it says nothing really against the method, but rather against the artist. Take any school: around the master is there not a crowd of faceless, unoriginal

Albert Michel, "Le Néo-impressionnisme," *L'Art moderne*, Brussels, March 10, 1888, pp. 83–85. These excerpts, p. 84. (Article occasioned by the Salon des XX of 1887 and originally published in *La Flandre libérale*.)

disciples? When we examine the works of one or another of the innumerable painters of the seventeenth century, are we not often hard put to distinguish between what is peculiar to the artist and what is the common patrimony of the school? And even in our own time, for a Corot or a Millet, how many "followers-of!" But what does that prove against the methods of these masters?

. . . As for the results achieved by the application [of their theory], they are astonishing. These artists, drunk with light, have accomplished the seemingly insane dream of taking the sun by the scruff of the neck, so to speak, and making it shine in their works. . . . Assuredly, the art of putting light into a picture was not discovered today, but in the past it was achieved by conventional means: a more or less accentuated contrast between dark and light tones. In this way, an identical effect may be achieved by using very different tones; it is necessary simply to observe very closely their relative value. It is this that explains how two landscape painters, placed before the same bit of landscape, can color it very differently, yet both be true to it. The phenomenon is analogous to that of transposition in music. But for the Neo-Impressionist, transposition doesn't count: light is neither conventional nor relative; it is what it is in reality. Consequently, no more opaque shadows, no more blackened colors; brightness everywhere. And, I repeat, the results are astonishing; the most distant horizons are thus endowed with remarkable transparency, fluidity, and depth. . . .

Paul Adam

On *Les Poseuses*:
From "The Impressionists at the
Exhibition of Independent Artists" (1888)

. . . Seurat's *Les Poseuses* [Fig. 19] attains perfection. Three nude women, one standing, the other two seated, one at each side, [are posed] before the grey wall of the studio, which is cut suddenly at an angle by the *Grande Jatte,* that work so commented upon by the public and the press. The figures, in stiff, dominical attitudes, are the same height as the models. We encounter one of them there, dressed, on the arm of a superb gentle-

Paul Adam, "Les Impressionnistes à l'Exposition des Indépendants," *La Vie moderne,* Paris, April 15, 1888, pp. 228–29. This excerpt, p. 229.

Paul Adam (1862–1920) French Symbolist poet and early critical supporter of Seurat and the Neo-Impressionists.

man; she moves through the deep perspective vista of the leafy isle, which extends the grey perspective of the studio. Here [*Les Poseuses*] are people in their natural simplicity, on their lips an enigmatic feminine smile, with elegant contours, the tiny breasts of adolescent girls and lustrous, soft skin. There [*La Grande Jatte*] are people in their holiday attire, stiff and starchy, solemn beneath the warm summer foliage, with gestures and poses that make them resemble the figures who file by in pious processions on Egyptian stelae and sarcophagi.

The synthesis of these two worlds, joined together by the painter's art, is expressed by the sumptuous tonal harmony out of which these three splendid female bodies shine. Their flesh retains its fullness, its color, flushed or pale, the shadows sleeping in the hollows of their frames. Even more than the science of skin tone, the unity of the structure compels our attention, the unity of precisely proportioned figures in their sheathing of flesh. Although they are at rest, one feels that these slim, supple, and alert women are ready for life, for movement, for laughter, for desire.

Close by, one's attention is claimed by a circus sideshow [Fig. 21], inundated by the light of stationary gas lamps. It is an extremely fine study of relief and light and shadow. . . .

COMMENTS AND REACTIONS
OF OTHER ARTISTS,
1886 TO THE PRESENT

Camille Pissarro

From a Letter
to His Son Lucien (1886)

PARIS [MARCH, 1886]

Yesterday I had a violent run-in with M. Eugène Manet[1] on the subject of Seurat and Signac. The latter was present, as was Guillaumin. You may be sure I rated Manet roundly—which will not please Renoir. But anyhow, this is the point, I explained to M. Manet, who probably didn't understand anything I said, that Seurat has something new to contribute, which these gentlemen, despite their talent, are unable to appreciate, that I am personally convinced of the progressive character of his art and certain that in time it will yield extraordinary results. Besides I am not concerned with the appreciation of artists, no matter whom. I do not accept the snobbish judgments of "romantic Impressionists" to

Camille Pissarro: Letters to His Son Lucien, edited with the assistance of Lucien Pissarro by John Rewald, translated by Lionel Abel (New York: Pantheon Books). © 1944, 1972. This excerpt, pp. 73–74. By permission of Pantheon Books, a division of Random House, Inc.

Camille Pissarro (1830–1903) Major Impressionist painter who met Seurat in October 1885. He brought Seurat and Signac into the last Impressionist Exhibition in May 1886 and was an enthusiastic follower of Seurat for several years. Eventually, however, he regretted the loss of his Impressionist spontaneity, and by the early 1890's, he had abandoned Seurat's method.

[1] Brother of the painter, Edouard. Eugène and his wife, Berthe Morisot, were active in organizing the eighth and last Impressionist exhibition, which was held from May 15–June 15, 1886. Pissarro, a former Impressionist, had met and become a follower of Seurat in October of 1885. His eventually successful struggle, against bitter opposition from his former comrades, to have the work of Seurat and Signac included in the 1886 exhibition, is recorded in this letter. [Editor's note]

whose interest it is to combat new tendencies. I accept the challenge, that's all.

But before anything is done, they want to stack the cards and ruin the exhibition. Monsieur Manet was beside himself! I didn't calm down. They are all underhanded, but I won't give in.

Degas is a hundred times more loyal. I told Degas that Seurat's painting was very interesting. "I would have noted that myself, Pissarro, except that the painting is so big!" [2] Very well—if Degas sees nothing in it so much the worse for him. This simply means there is something precious that escapes him. We shall see. Monsieur Manet would also have liked to prevent Seurat from showing his figure painting [reference to the *Grande Jatte*]. I protested against this, telling Manet that in such a case we would make no concessions, that we were willing, if space were lacking, to *limit our paintings* ourselves, but that we would fight anyone who tried to impose his choice on us.

But things will arrange themselves somehow!

Vincent van Gogh

From Two Letters
to His Brother Theo (1888)

[ARLES, 1888]

As for stippling and making halos and other things, I think they are real discoveries, but we must already see to it that this technique does not become a universal dogma any more than any other. That is another reason why Seurat's *Grande Jatte*, the landscapes with broad stippling by Signac and Anquetin's boat, will become in time even more personal and even more original. . . .

• • •

The Complete Letters of Vincent van Gogh, 3 vols. (Greenwich, Conn.: New York Graphic Society, 1958). These excerpts, vol. 3, letter 528, p. 21, and letter 539, p. 44. By permission of Little, Brown and Company for the New York Graphic Society and of Thames & Hudson Ltd.

Vincent van Gogh (1853–1890) Dutch Post-Impressionist painter who knew Seurat only slightly, but admired him. Van Gogh was influenced by Neo-Impressionist color and brushwork in 1887, when he sometimes worked with Signac.

2 Seurat intended to show his large canvas *A Summer Sunday on the Island of La Grande Jatte.* [Author's note]

What is Seurat doing? I should not dare to show him the studies already sent, but the ones of the sunflowers, and the cabarets, and the gardens, I would like him to see those. I often think of his method, though I do not follow it at all; but he is an original colorist, and Signac too, though to a different degree; their stippling is a new discovery, and at all events I like them very much. . . .

Gino Severini

From *A Painter's Life*

My preference for Neo-Impressionism dates from my earliest works: occasionally, I have wanted to suppress it, but it always reasserts itself. . . .

I wrote to Boccioni that he could put my signature under the famous manifesto; [1] as for Divisionism, to which it seemed he was so attached, I told him that it was certainly still and more than ever my own path. In fact, at that time, after having penetrated both the letter and the spirit of Seurat's work (which was the principal reason for my coming to Paris),[2] I had begun to divide forms in the same way that I had divided colors. . . .

Gino Severini, *Tutta la vita di un pittore* (Milan: Garzanti, 1946). These excerpts, pp. 72, 117–18. By permission of A.D.A.G.P., Paris.
Gino Severini (1883–1966) The most French-oriented of the Italian Futurist painters. He moved to Paris in 1906. He was much influenced early in his career by the art of Seurat and by Neo-Impressionist theory, both of which would serve as an important basis for the early style of the Futurists. Signer of both Futurist painting manifestos (1910), he became an important link between the Parisian Cubists and the Milanese Futurists.

[1] *The Technical Manifesto of Futurist Painting,* signed by Umberto Boccioni, Carlo Carrà, Luigi Russolo, Giacomo Balla, and Gino Severini. Dated 11 February 1910, it was first published as a leaflet in Milan, and then appeared in translation in the Paris *Comoedia* on 18 May 1910. See Marianne W. Martin, *Futurist Art and Theory, 1909–1915,* Oxford University Press, 1968, pp. 46–47, 50 ff. [Editor's note]
[2] Severini first arrived in Paris in October of 1906. [Editor's note]

Robert Delaunay

From "Historical Notes
on Painting" (ca. 1913)

It was the genius Chevreul, through his theoretical studies, who made us aware of the laws of simultaneous colors. Seurat was responsive to this, but he was not bold enough to break compositionally with all of the conventional, descriptive methods of painting. You still see in his work the *retinal* image, the image in the sense of popular imagery. Line and light and shadow are still at the plastic foundation of his art.

. . . Seurat struggled against the exuberance of his age in search of truly constructive means. He returned to the source of reality in nature: light. . . .

. . . From light Seurat alone extracted something: contrast (as a means of expression). His premature death perhaps prevented his pursuit of these discoveries. (He may be cited among the Impressionists for having achieved the highest point in this search for means.) His contribution is in the contrast of colors: optical mixture applied by him and his followers; but since this was only a technique, it is not as important as contrast used as a means of construction and for the expression of pure [abstract] Beauty. . . .

Robert Delaunay, *Du cubisme à l'art abstrait*. Documents inédits publiés par Pierre Francastel (Paris: S.E.V.P.E.N., 1957). These excerpts, pp. 113, 117, 119. By permission of the École des Hautes Études en Sciences Sociales, Paris.

Robert Delaunay (1885–1941) French painter who developed a coloristic, and eventually non-objective, extension of Cubism, a style that was dubbed "Orphism" by Apollinaire. He was interested in scientific color research, as Seurat had been, but he was critical of Seurat's more literally descriptive goals.

Fernand Léger

From "Contemporary Achievements in
Painting" (1914)

. . . Neo-Impressionism has said all it had to say, its curve was very, very short—in fact it was a very small circle, in which there remains nothing of worth.

Seurat was one of the great victims of this mediocre formula in many of his pictures, and he wasted a lot of time and talent by confining himself to that small touch of pure colour—which indeed does not colour at all, for the question of the effective power of colour also has to be taken into consideration. When you employ contrast of tone as a source of dynamic mobility to eliminate local colour, your colour loses some of its power; a yellow and a violet contrasted in equal volume are "constructive," of course, but only at the expense of the power of colour; in this case the optical mixture is grey. Only local colour has its maximum colouristic effect. The system of multiple contrasts alone permits of using it; while the Neo-Impressionist formula has the paradoxical but inevitable result that pure tones are used to produce a final effect of grey.

Fernand Léger, "Les Réalisations picturales actuelles," *Soirées de Paris,* June 15, 1914, pp. 349–54 (a lecture given at the Académie Wassilieff). Translated in Edward Fry, *Cubism* (New York and Toronto: McGraw-Hill Book Company, 1966), pp. 135–39. This excerpt, p. 139. By permission of McGraw-Hill Book Company.

Fernand Léger (1881–1955) French painter who developed a personal extension of Cubism. He disliked the muted character of Neo-Impressionist color but shared with Seurat a positive appreciation for the beauties of urbanism and the modern machine.

Juan Gris
From a Letter to Daniel-Henry
Kahnweiler (1915)

PARIS, DECEMBER 14, 1915

. . . Sometimes everything I paint seems to me like so much folly *(sic)*.
I never seem to be able to find any room in my pictures for that sensitive,
sensuous side, which I feel ought always to be there. Maybe I'm wrong
to look for the pictorial qualities of an earlier age in a new form of art.
At all events I find my pictures excessively cold. But Ingres is cold too,
and yet it is good, and so is Seurat; yes, so is Seurat, whose meticulousness
annoys me almost as much as my own pictures. Oh, how I wish I had
the freedom and the charm of the unfinished! Well, it can't be helped.
One must after all paint as one is oneself. My mind is too precise to go
dirtying a blue or twisting a straight line.

Amédée Ozenfant
From "Seurat" (1926)

. . . There are many of us . . . who take extreme delight in Seurat;
there is in us a certain predisposition of the senses that draws us to his

Letter by Juan Gris to Daniel-Henry Kahnweiler, in D.-H. Kahnweiler, *Juan Gris, His
Life and Work,* translated by Douglas Cooper (New York: Harry N. Abrams, Inc., 1969),
p. 212, note 123. By permission of Harry N. Abrams, Inc. and Éditions Gallimard.

Juan Gris (1887–1927) Important Cubist painter, born in Spain, active in Paris. Imposed
a more predictable order on the irregular solid-void facetings of analytic cubism, thus
developing a significant personal variant of that style.

Amédée Ozenfant, "Seurat," *Cahiers d'Art,* 1, September 1926, 172. By permission of
S.P.A.D.E.M.

Amédée Ozenfant (1886–1966) French painter and co-founder, with Le Corbusier, of the
esthetic doctrine known as Purism. Admired Seurat as a spiritual ancestor for the qualities
of rational order and control that he had restored to late 19th-century painting. Con-
tributed many articles to *L'Esprit nouveau,* which was founded in 1920 and was the official
literary organ of the Purist movement. Other writings, co-authored with Le Corbusier,
include *Après le Cubisme* (1918) and *La peinture moderne* (1925).

works rather than to others. As receivers of the vibrations they emit, we must put ourselves on their wavelength. If you like sweetness in painting, if only candy-pink flesh and hair as virginal blond as wheat will set you vibrating, then certainly you will not be in tune with Seurat; Seurat is dry, as dry as a dry champagne. Does that please you? If not, we won't insist: it is your right to prefer mouthwash to champagne—this is a free country, isn't it?

We have always liked in Seurat the dryness of the great French tradition, with its clarity, its good breeding, its finely grained surface covering the rich substances within. This is not to say that we like nothing but that: we also like the immediacy of Renoir: what emotion is felt before the two reclining women in the Luxembourg, his last work! We also like flowers and trees and flesh. But do not reproach Seurat for being a descendant of the Athenian rather than the Flemish tradition; the Greek train is a good train, are you going to criticize it for not taking you to Amsterdam? You use it when you need it, that's all, and you would do well not to miss your station. Seurat and Renoir must be used for different journeys.

Let us board Seurat's train.

It is a dry country, but an agreeable one. Here is the *Grande Jatte*. Is it descriptive? Never could chance be this judicious. Seurat has said that "art is harmony"—which can mean everything or nothing. Seurat no doubt wished to express by this the idea understood by the geometricians of ancient Greece—the harmony that our mind creates and imposes on things, the discipline to which we like to think the world submits, the regulation of chance, real or apparent, which allows us to submit phenomena to the rule of law.

This is what we like—order; so much so that we have a special weakness for formal geometries, the perfection of which excites us and occasionally leads us into excess, into forgetting that literal geometry is a bit too sparse for the senses: let us not forget after all that the senses are the necessary channels of communication for painting. In Seurat, too, there is geometry, in his ordered formulations and the ionic spiral of the monkey's tail (the monkey is also a spiral), and in the silhouette of a woman's back and bustle, which are of a generous geometry. . . .

Let us worship Euclid and the clarity of formulae that make of the world a system of crystalline foundations; but let us not mistake for them the gross appearances that our humanity permits us to construct—circles, triangles, angles, cubes, and so on.

When we arrange squares and circles, we forget that to depict a triangle or a circle is merely to imitate. When Seurat paints trees, grass, a woman, he discovers in them a common law that creates harmony. The circle, the square, the triangle are simple facts—like a little dog or a woman; whether one copies the little dog or the triangle, one is committing the same mistake. What is important is the law of construction, which produces the harmony of which the Greeks spoke. Everything is proper material for art, provided that it can generate some law and that it moves us. What we, who believe nothing to be superior to the ancients, but who recongize that our own needs are different, what we admire in Seurat

is the transfiguration of reality into an emanation of the transcendental.

Seurat knew many things, the sacred laws of common sense, which we neglect no doubt because they are too simple.

That it is not instinct that composes, but intellect; that instinct—genius—proposes and the lucid mind disposes, composes, translates the impulse, the imperfectly formed, sketchy need that we call inspiration. [For example,] I am dying to have a beautiful castle in Spain; I have an inner feeling of how it should be. My intellect then applies itself and searches for the means with which to build this castle and thus to satisfy me: a collaboration that is certainly not without its tensions.

A painter may intellectualize, and Seurat was not averse to doing so. But, ultimately, we know that certain works are possessed of that radiance, that sublimity, those resonances that no apparatus, no formula can measure, explain or dissect, but that we feel, that excite us, transport us, make us forget everything else. There are certain canvases by Seurat that have this magic.

Henri Matisse

Comments in 1935 and 1947

FROM "ON MODERNISM AND TRADITION" (1935)

The simplification of form to its fundamental geometrical shapes, as interpreted by Seurat, was the great innovation of that day. This new technique made a great impression on me. Painting had at last been reduced to a scientific formula; it was the secession from the empiricism of the preceding eras. I was so much intrigued by this extraordinary method that I studied Post-Impressionism, but actually I knew very well that achievement by these means was limited by too great adherence to strictly logical rules. Those around me knew of this feeling. Standing in front of a canvas that I had just finished, Cros [*sic*][1] said to me: "You won't stay with us long."

Henri Matisse, "On Modernism and Tradition," *The Studio*, 9, May 1935, 236–39. This excerpt, p. 238. By permission of S.P.A.D.E.M.

[1] Henri-Edmond Cross (1856–1910). Matisse worked with Cross and Signac at St. Tropez in the summer of 1904. [Editor's note]

FROM A LETTER
TO TERIADE (1947)

[VENCE, 1947]

I said to myself a moment ago, looking at the rocky mountain they call hereabouts "Baou," standing out against the sky in illuminated and shadowed areas—observing the contrasts of *tone* (according to Signac, after Seurat) that divide the sky reciprocally into dark and light areas— I said to myself that what makes Seurat is not to be found in this, that if there were not something more important than this in his pictures, he would be of no consequence. One is amazed to see that the colors of his pictures, placed with such care in the application of his theory, have so changed with time that the cadmium orange has become yellow ochre or even something less vibrant than that, but his paintings have lost nothing of their principal interest.

Pierre Cabanne

From *Dialogues with Marcel Duchamp*
(1966)

All painting, beginning with Impressionism, is antiscientific, even Seurat. I was interested in introducing the precise and exact aspect of science, which hadn't often been done, or at least hadn't been talked about very much. It wasn't for love of science that I did this; on the contrary, it was rather in order to discredit it, mildly, lightly, unimportantly. But irony was present. . . .

Henri Matisse, "Lettre à Tériade," in *Henri Matisse, Écrits et propos sur l'art,* ed. Dominique Fourçade (Paris: Hermann, 1972), pp. 309–11. This excerpt, p. 311. By permission of the publisher.

Henri Matisse (1869–1954) Renowned French painter and colorist of the 20th century and one of the principal artists of the Fauve group in 1905. He was exposed to and influenced by Neo-Impressionism through the writings, works, and personal friendship of Signac and Cross, and he painted briefly in that mode, first in 1899 (*Sideboard and Table*) and again in 1904 (*Luxe, calme et volupté*).

Pierre Cabanne, *Dialogues with Marcel Duchamp* (Documents of 20th Century Art), English translation by Ron Padgett (New York: The Viking Press, 1971). These excerpts, pp. 39, 69, 93, 103.

. . . In the production of any genius, great painter or great artist, there are really only four or five things that really count in his life. The rest is just everyday filler. Generally, these four or five things shocked when they first appeared. Whether it's *Les Demoiselles d'Avignon* or *La Grande Jatte,* they're always shocking works. In this sense, I do not feel like going to admire every Renoir, or even all of Seurat . . . Still, I like Seurat a lot—that's another question. . . .

Among the Impressionists, Seurat interests me more than Cézanne. . . .

. . . I'm sure that when people like Seurat started to do something, they really just wiped the past right out.

FROM EUGENE DELACROIX TO NEO-IMPRESSIONISM [1898]*

Paul Signac

If Neo-Impressionism results directly from Impressionism, it also owes much to Delacroix . . . It is the fusion and the development of the doctrines of Delacroix and of the Impressionists, a return to the tradition of the one with every benefit of the others' contribution.

The genesis of Georges Seurat and Paul Signac proves this to us.

Georges Seurat studied at the École des Beaux-Arts, but his intelligence, his will, his clear and methodical mind, his pure taste and his painter's eye saved him from the École's depressing influence. Assiduously frequenting the museums, leafing through art books and engravings in the libraries, he drew from the study of the classical masters the strength to resist the teachings of his professors. In the course of these studies, he discovered that there are analogous laws that govern line, light and shadow, color, and composition in Rubens as well as in Raphael, in Michelangelo as well as in Delacroix: rhythm, measure, and contrast. The oriental tradition, the writings of Chevreul, Charles Blanc, Humbert de Superville, O. N. Rood, and H. Helmholtz were his teachers. He analyzed at length the work of Delacroix, discovering there the application of traditional laws governing both color and line, and he saw clearly what still had to be done in order that the goal glimpsed by Delacroix might be achieved.

Paul Signac, *D'Eugène Delacroix au néo-impressionnisme* (Paris: Éditions de la Revue Blanche, 1899). First published serially in the *Revue Blanche* in 1898 and in the *Revue populaire des Beaux-Arts* in 1898–1899. Excerpted here are portions of Chapter IV, section 7, from the 1964 edition, ed. Françoise Cachin (Paris: Hermann), pp. 96–98, 99–100. By permission of Hermann.

Paul Signac (1863–1935) French painter. A member of the original Neo-Impressionist group, he was a close friend of Seurat and his most faithful follower. After Seurat's death, he assumed the position of leader and vocal proselytizer for the movement. His influential book *From Delacroix to Neo-Impressionism* (1898–99) was widely read among avant-garde painters around the turn of the century.

* For an English translation of other, substantial excerpts from this book, as well as a general summary of its contents, the reader is referred to Linda Nochlin's anthology, *Impressionism and Post-Impressionism, 1874–1904* (Englewood Cliffs, N.J.: Prentice-Hall, 1966), pp. 117–23.

The result of Seurat's studies was his judicious and fruitful theory of contrast, to which, from then on, he submitted all of his works. He applied it first of all to light and shadow: with these simple resources, the white of a sheet of Ingres paper [1] and the black of a conté crayon, skillfully shaded or contrasted, he executed some 400 drawings, the most beautiful "painter's drawings" ever created. Thanks to the perfect science of values, one might say that these "black and whites" are more luminous and more colorful than many paintings. Then, having thus mastered tonal contrast, he treated color in the same spirit, and from 1882 on, he applied the laws of contrast to color and painted with separated elements—using diminished colors, it is true—without having been influenced by the Impressionists, of whose very existence he was at this point still unaware.

Paul Signac, on the other hand, from his earliest studies in 1883, submitted to the influence of Monet, Pissarro, Renoir, and Guillaumin. He attended no studio, and it was in working from nature that he discovered the harmonious play of simultaneous contrast. . . .

In 1884, at the first group exhibition of the Society of Independent Artists, in the barracks at the Tuileries, Seurat and Signac, who did not yet know each other, met. Seurat exhibited his *Baignade* [Fig. 6], which had been rejected that year at the Salon. It was painted with large, flat strokes, swept one over the other, and it resulted from a palette that was composed, like Delacroix's, of both pure and earth colors. Because of these ochres and earths, the picture appeared dulled and less brilliant than those of the Impressionists, who had reduced their palette to the colors of the prism. But the observation of the laws of contrast, the methodical separation of elements—light, shadow, local color, reaction—and their correct proportion and balance conferred upon this canvas a perfect harmony.

Signac was represented with four landscapes, painted with only the colors of the prism, placed upon the canvas in small, comma-like strokes in the Impressionist manner, but already without diminished mixtures upon the palette. Contrast was observed in these works, and the elements mixed optically, but without the precision and balance of Seurat's rigorous method.

Illuminating for each other their mutual researches, Seurat soon adopted the simplified palette of the Impressionists, and Signac profited from Seurat's precious contribution: the methodically balanced separation of the elements. . . .

[1] A reference to the Michallet brand of drawing paper, favored by Seurat and distinguished by its rough surface texture. It was also known as "Ingres paper" because of that artist's preference for it. [Editor's note]

GEORGES SEURAT [1920]

André Salmon

Georges Seurat, the reconstructor, will make it possible for the future to reconcile adverse elements in French art in the traditional channels which were re-discovered at the end of the 19th century. Without Seurat we should not have had either Matisse or cubism, which does not derive entirely from Cézanne. We know what cubism owes to Cézanne, but we should remember that the first cubist studios were hung with photographs of works by Ingres and Seurat, notably the *Chahut* [Fig. 27], one of the great icons of the new devotion. It is Seurat, understood and absorbed by the young painters of the 20th century, who eventually made it possible for them to recognize Delacroix. . . .

. . . the work of the cubists was not derived from vacancy. No, indeed. Even Cézanne would not have sufficed them without the neo-impressionist enterprise, and more especially the work of Georges Seurat. This needs demonstrating, but I hope at least to have established what appears to me to be an incontestable affinity. Was it only through a vain caprice that the first cubists, most religious of painters, ornamented their studios with reproductions of the *Chahut* of Seurat, even when unaccompanied by the *Odalisque* or *Bain turc* of Ingres, David's *Sacre,* or some of the *Arlequins* of Cézanne? I am inclined to think that the wisest and most clairvoyant among the devotees of this cult were those who, like Georges Braque, were unwilling to break the nudity of the white studio wall with anything but the *Chahut,* which in itself contained the whole lesson. This lesson was not one of servile imitation, but of reasoned daring, well-founded audacity, and temerity submitted to proof in advance. . . .

. . . Seurat was the first to be concerned in the return to the great classic composition. He dared to attempt a picture when, except for the

André Salmon, "Georges Seurat," *The Burlington Magazine,* 37, September 1920, 115–22. T̶ ̶erpts, pp. 115, 116, 121, 122. By permission of *The Burlington Magazine.*

mon (1881–19?) French writer and critic, he was a friend of Picasso and Braque
·ly supporter of the Cubist esthetic. Stressed the importance of Seurat's late work
bists. Writings include *La Jeune Peinture Française* (1912) and *Propos d'Atelier*

indigent academic *genre* painters, no one since Courbet had had a taste for anything but studies which grew more and more fugitive. Seurat was the first to construct and compose, and he will have had his reward since his work is, by itself, characteristic of his epoch. It is the most living and the most evocative, although with the spirit of a scientific investigator. The frequentor of laboratories and disciple of Chevreul, he has boldly discarded all attempt at the immediately picturesque. In truth, Cézanne would not have sufficed to preside at the great task which occupies the strongest and most spontaneous energies of to-day. There is a certain sylvan vulgarity in the candour of Cézanne. From Seurat comes the aristocratic feeling and the austerity without sterility of modern creations. . . .

Even in the earliest manifestations of the painter, synthesis, as practiced by Seurat, assured the modern aesthetic revolution, from the cubists to Derain. Seurat was the first who ceased to consider objects according to their apparent existence and preferred their value as a means of expression. From this point to the attainments which we witness to-day lies the course I have attempted to indicate, though always fearful of spoiling, through too much reasoning, that sacred freedom of expression which is the glory of Seurat's work. Seurat never realized himself so fully in this sense as in his *Cirque* [Fig. 29], which dates from 1891, two years after the *Chahut*.

The influence of Seurat on our century is so profound that canvases like the *Cirque* and the *Chahut* decided the orientation of the futurist movement, although a better knowledge of the genius of Seurat and of his exact intentions should have prohibited so sterile an enterprise. If one remembers the atmosphere of the "Paris artiste" of his time, one realizes that no master of any age was more isolated than Seurat. Now, however, that we can take him at his true historical value, it is Seurat who, to our enraptured eyes, becomes the true iconographer of the age. All naturalistic literature falls into dust at the breath which blows through *La Grande Jatte* [Fig. 15], and the black parallel legs of the vulgar puppets in the *Chahut* will make lasting folk-lore. Through the sensitive precision of his architecture, Seurat attained something beyond the merely picturesque. Of what other painter working at the time of Seurat's death can it be said that he attained dignity of style?

. . . Seurat is summed up without difficulty. He opened the way to the true tradition and prepared the task of the constructors. If he was truly classical in his habit of premeditation, it was because he had control of his natural riches. Theory for him was a liberator and was favorable to the continuity of his inventiveness. Thus the most calculated art of the closing 19th century, an art materialist to the point of gross naturalism, is raised to the front rank among the arts of free expression of which Raphael holds the key.

SEURAT'S *LA PARADE* (1929)

Roger Fry

In a hundred different ways critics have tried to express a peculiar feeling which great works of art arouse—the feeling, I mean, of their isolation from all else, the feeling that the great work of art exists and persists by its own internal coherence rather than by its references to what lies outside of it—that it is, as it were, a self-conditioned, self-subsistent organism, containing within itself, if anywhere, the justfication for each part of it being what it is. But even the purest and most abstract work of art has some references to the surrounding world of actual life. At the very least it derives somewhere from an experience which occurred to the artist in that world. This would be true, for instance, of the purest music ever invented, but for the painter it is almost certain that not only did the artist's original experience occur in the actual world but that a great number of visual data will have entered into that experience, and being an essential part thereof will have passed over into the work of art. These visible data, these facts of appearance, will, indeed, probably tell us what the picture is *about,* in the crude, external sense; tell us what kind of a scene is represented, what, in short, the title of the picture is likely to be. But the relation of these visible facts to the final result, to the essential meaning of the picture, is by no means a fixed one. It requires, sometimes, a great deal of tact to find the way from one to the other. Indeed, I suspect that it is somewhere in this passage that the majority of gross mistakes in appreciation are made. It is somewhere on the way between the ostensible external appearance and the innermost significance of the forms that so many people, including critics, occasionally trip up. It is probably some difficulty in the relation between these two terms that causes those long delays in the recognition of certain artists and that, even when they have once been recognized, may at any time deprive them of critical or popular esteem.

Roger Fry, "Seurat's *La Parade,*" *The Burlington Magazine,* 55, December 1929, 289–93. By permission of *The Burlington Magazine.*

Roger Fry (1866–1934) English art historian and critic who introduced Post-Impressionism to England. Promulgator of an influential, formalist approach to the appreciation of these artists. Major collections of his essays are *Vision and Design* (1920), *Transformations* (1926), and *Last Lectures* (1939).

Seurat's picture of *La Parade* [Fig. 21] is an instance of how complicated and unexpected this relation of external facts and ultimate meaning may be. For it would be hard to find another instance of a greater stretch between the two terms involved. On the one hand, at the terminus *a quo* we have facts, the most minutely—one might say trivially—particular, facts of a photographic literalness, and at the other—at the terminus *ad quem* —something as abstract, as universal and as unconditioned as pictorial art ever attained to, at least, before the days of cubism. Almost all other works of art find both point of departure and point of arrival in some intervening region between the two that Seurat has chosen. Thus one can scarcely think of any other artist since primitive times who would accept such minute visual data as Seurat does in the dressed-up page-boy or in the profiles and hats of the crowd. It is this precision in what is most unessential and momentary that is so surprising. And this is so marked that I suppose anyone familiar with the details of late nineteenth century costume would be able to date this picture to within a year or so by the evidence of these profiles.

From this point of view it is interesting to put side by side Seurat and his contemporary, Toulouse Lautrec. Both frequented Montmartre and saw similar sights, both might have stopped outside the same circus somewhere in the Boulevard Clichy. Toulouse Lautrec would have seized at once on all that was significant of the moral atmosphere, would have seized most of all on what satisfied his slightly morbid relish of depravity, with just too little of detachment for irony but not for an amused and half-disdainful complicity. No shade of all that such indications would have meant to an alert and initiated Parisian would have escaped him and he would have woven therefrom something that had, after all, a kind of lyrical glamour. But Seurat, one feels, saw it almost as one might suppose some visitant from another planet would have done. He saw it with this penetrating exactness of a gaze vacant of all direct understanding. Form after form he notes down with a more rigid precision than his contemporary's brilliant impressionist shorthand could ever attain to. The turn of a feather in a hat went exactly so, a nose stuck out under the hat brim at just that angle, a bowler hat fitted on to a head in just that improbable way; but he noted all with this gaze that refused to see any implications other than visual elements in a scheme of fixed and abstract perfection. Each figure seems to be so perfectly enclosed within its simplified contour, for, however precise and detailed Seurat is, his passion for geometricizing never deserts him—enclosed so completely, so shut off in its partition, that no other relation than a spatial and geometrical one is any longer possible. The syntax of actual life has been broken up and replaced by Seurat's own peculiar syntax with all its strange, remote and unforeseen implications. For these figures have nothing left of the life of the Boulevard Clichy. A magician's wand has made out of momentary poses an eternal monument. That moment of hurried life, of bustle and eagerness, of excitement, anticipation and noise has become transfigured into something of more than Egyptian, more than hieratic, solemnity and stillness. It would give a wrong impression to say that the life of the instant had been arrested, or frozen, for there is nothing momentary in

any of the forms, however momentary the pose from which they are taken.

It is as though Seurat had not only painted the "Grecian urn" but had written Keats's poem on it all in a single action for, certainly, here far more than in any Grecian urn and without external aid, we feel that "this silent form doth tease us out of thought as doth eternity." Even among Seurat's works this picture seems to me to be unique in the completeness with which the most literal facts of everyday life have been transmuted into the purest, most abstract of spiritual values.

This transmutation results from the extreme simplification of all the forms according to certain conscious and deliberate principles. Thus we note that across the elaborate rectilinear framework of the design are played two main formal elements, an ovoid exemplified in the two blue patches on the *affiche* repeated in the numbers behind the central figure and again and again in the bowler hats and shoulders of the men and, in contradiction to this, the conical shapes of the trombone-player's head and hat, inverted in his legs and again in several of the women's hats. It is perhaps this continuous repetition of a few simple forms that gives to the picture its strange fixity and stillness.

No less important, however, in bringing about that transmutation of the actual scene is the rigorous counterpoint which controls their relations in the picture space. In this, indeed, one seems to see something almost like a direct influence of Poussin. Here, as before a Poussin, we recognize a perfect harmonic treatment of intervals, an impeccable sense for the relative proportions of parts. As in Poussin, the centre line is deliberately accented by the central figure and by the rigid vertical made by his trombone carried so wilfully down one side of his leg; and as in some of his works there is a sharply marked difference in the building up of the two counterpoised halves. But it would be foolish to press this comparison far, for however similar the underlying methods of composition may be, the temperament of these two are very distinct and the moods each expressed are utterly diverse. For Poussin had nothing of the peculiar tenderness of Seurat, nothing of his tremulous anxiety about the quality of his forms nor his almost religious respect and delicacy of feeling. But they share alike a rare passion for the significance of abstract and architectural formal harmonies.

I wish I could say that our reproduction dispensed with any need to talk of the colour, but alas! Seurat's subtleties elude our mechanical processes far more than I had suspected they would. One gathers, indeed, truly enough, from this reproduction how restrained and deliberately simplified the colour scheme is, how much Seurat has moderated the actual contrasts of hue of such an effect in nature so as to keep it in a narrower key; what one misses are the subtle noises of dull, almost grey-violet with which the reds and oranges are everywhere muted, whereby the intensity and warmth of the main tone of the shadows is suffused by the pervading luminosity of the atmosphere.

THE RENAISSANCE OF CLASSICAL SENSIBILITY IN FRENCH PAINTING AT THE END OF THE NINETEENTH CENTURY (1931)

Robert Rey

To study the life and work of Seurat is to be made aware of one of the most singular of the phenomena produced at the end of the nineteenth century by the need for classical order that is the very subject of our study. . . .

Almost all of the great artists at the end of the nineteenth century were tormented by the need to reconceive everything, technique as well as expression: not only Seurat, but also Cézanne, Gauguin, and Renoir. . . .

In Western culture, the need for an intellectualized and ordered creativity is so deeply ingrained in the spirit of the race that even those artists who think themselves concerned only with Realist and Impressionist aims search, in spite of themselves, for an order that is both more arbitrary and more rational. In this sense, the example of Seurat admirably complements that of Cézanne. . . .

Clearly, a state of mind is now developing that will soon reveal Seurat to us as one of the great renewers of the art of painting. In effect, what is dominant in his work is the idea that at the root of every sensation of harmony—be it in the plastic arts (architecture, drawing, painting, sculpture) or in the musical arts (music, poetry)—are "numbers," the relationships between which are not accidental. Harmony consists simply of the pleasing relationship of these numbers to one another. If one operates within the limits of possibility to which human intelligence must accede, one is forced to recognize certain inescapable arithmetic truths, to recognize them, and to submit to them. These involve the greater or lesser amounts of light that a volume will reflect, the reciprocal relation-

Robert Rey, "Seurat," *La Renaissance du Sentiment Classique dans la Peinture Française à la fin du XIXe Siècle* (Paris: Les Beaux-Arts, 1931), pp. 95–134. These excerpts, pp. 95, 96, 97, 100, 102, 120, 124, 125–28, 130, 131, 132, 133, 134. By permission of Les Beaux-Arts and the heirs of M. Robert Rey: Mme. Robert Rey, Mme. Secuten and Mme. Ducourtial.

Robert Rey (1888–19?) French art historian. Author of *La Renaissance du Sentiment Antique* (1931), an important study in which he defines a period of classical revival in late 19th-century French painting, with particular reference to the works of such major masters as Degas, Renoir, Gauguin, and Cézanne as well as Seurat.

ship between two colors (which are themselves simply the result of numerically measurable vibrations upon the retina), the effects that lines have upon one another according to their respective lengths and directions —all of this is ultimately reducible to "numbers," to ratios, which may be usefully studied only in relationship to one another. They carry their results within themselves. Imagination and inspiration are powerless against them. And only those results from which well-balanced equations are derived can provide for the eye, heart, and mind a sensation of complete, almost physical satisfaction: a sensation of harmony.

Simplistically summarized, these are the concerns that Seurat formulated and that clearly evolve in his thought. Certainly, he did not invent them. They are the basis of all antique philosophy from Pythagoras to Plato, which is to say, in effect, all of Western culture . . . From the earliest stirrings of human thought, poets (and here one must give to this word the antique meaning of "creators") knew how to detect these numerical laws, knowledge of which gave them the power to create that divine imponderable: harmony . . . By and by these laws were openly revealed by rationalist initiates. Da Vinci, Dürer, among others, used them. They spread these numerical secrets over the arts to guard against the errors in which architects, poets, painters, and sculptors can fall when taste falters, in instances where this unsteady guide is relied upon exclusively. . . .

At first partially preserved in the formulae that are applied without being understood by certain old craftsmen like carpenters, this science was eventually abandoned and then almost entirely forgotten. Poussin was among the last of the great artists to use it. Although the texts of the ancients, the works of da Vinci and Dürer, and the plans of the cathedrals still existed as archives of harmony, they were no longer referred to. In the interim between the writings of Viollet-le-Duc on the art of the cathedrals and the works of Sutter (by which Seurat was obviously inspired), these laws were neglected. In our own time, they have again assumed great importance, as may be demonstrated by writings like Gino Severini's *From Cubism to Classicism: the Esthetic of the Compass and the Number.* . . .

If we recognize Seurat as the most recent painter to proclaim the necessity of concerning himself with numbers and obeying their imperious dictates, one must then concede that he, even more than Cézanne, is the direct precursor of the artistic movements of our own time. . . .

Seurat would not have embraced the science of numbers as enthusiastically as he did had not his temperament (a factor we must not neglect) predisposed him in this direction. . . .

In the *Grande Jatte* [Fig. 15], one already vaguely feels that the work is constructed in accordance with a series of geometric relationships, which are generators of harmony, and that the contrasts of lines with each other, verticals, horizontals, diagonals, have been purposefully created. One is even tempted to wonder whether Seurat did not try to apply in some places that "law of frontality" so dear to the sculptors of antiquity . . . From this point on [in Seurat's career], linear contrasts will assume an increasingly important compositional role. . . .

In 1889, Seurat apparently devoted himself with intense fervor to the study of linear contrasts. Could this not have been a period during

which his conversations with Charles Henry increased in frequency? . . .

The results of his meditations were on view at the sixth Exhibition of Independent Artists, from 20 March to 17 April, 1890. . . .

The *Chahut* [Fig. 27] was his most important entry. It is a very disconcerting work. In the theme, there is certainly far less a study of the facial types, gestures, clothing, and entertainments of Seurat's period than a pretext for translating movement by means of premeditated linear arrangements . . . The problem that clearly interests him is to create the illusion of movement, noise, the clash of cymbals, using nothing but lines and colors that are themselves motionless. The male dancer's mustache, the slits of his lowered eyes, his brow; the mouth, eyelids, and brows of the dancer in front of him, the locks of hair on her neck, the ribbons on her shoes, all of these details take the form of concentric commas placed upside down and diagonally. In this *Chahut,* with its carefully regulated turbulence, if we extend the axis of the fan held by the first dancer, it will converge at right angles with the extended line of the orchestra leader's baton (maximum contrast of lines), and from this we are given to understand that the orchestra leader's baton, as it dips, will cause all of these legs to lower simultaneously, as though by means of an invisible crank rod . . . Certain instantaneous photographs that try to show us a person walking succeed only in giving us the impression that the person is staggering along. They seize upon a single phase of a movement that has not yet been resolved. Seurat knew how to avoid this danger; his silhouettes are arrested in that incalculably tiny moment of immobility during which the leg, unable to rise further, ready to descend, is motionless, the entire body balanced: a fatiguing balance, one that is impossible to maintain, but a balance nonetheless. From this is undoubtedly derived the strength and precision with which Seurat is able to suggest movement. . . .

There are motifs that appear in the *Chahut* like signs in a synthetic ideograph—for example, the globe of the gas lamp, strangely floral in form, suspended in the void, its brightness darkening by contrast the surrounding shadow above the scroll of the double-bass. It is a motif that imperiously signals the world of nocturnal pleasures, artificial illumination, a dusting of light—in a word, the café concert. But above all, one feels that not a line here was executed by chance. One can feel in this picture a search for a geometric key that produces remarkable discoveries. . . .

Let us consider the rectangle ABCD that forms the picture [see Fig. 28]. Line IH divides it into two unequal rectangles. The width CI of the larger of the two rectangles is obtained by dividing the length CB according to the golden section.[1] The diagonal AC is very important. It is like the concealed mainspring of the picture. The painter does not place any essential element upon it, but it is the direction of the perpendicular to this diagonal that establishes the principal right angles of the picture, from the flute in the lower left-hand corner (FG) to the direction of the dancers' right legs, which are strikingly parallel. As for the tips of their

[1] Name given to a proportion known and considered to be intrinsically harmonious since antiquity. It is strictly defined as the division of a line into two unequal segments, so that the smaller part is to the larger as the larger is to the whole. For example, line AB cut at C, so that AC:CB = CB:AB. [Editor's note]

left feet, they are exactly aligned (and the principal shadow they cast underscores this) on a line that is perpendicular to the diagonal DB.

For the directions of the accessories, the neck of the double-bass and the tips of the bow, he uses other triangles. Thus, while the right edge of the neck of the double-bass is parallel to the diagonal DB and duplicates the triangle ABC already observed, the left edge establishes, along with the edges of the canvas, the famous triangle called the Egyptian triangle (dear to Charles Henry), the sides of which bear to each other the ratios of 3 to 4 to 5.

The conductor's baton divides the edge AD according to the golden section. As for the curves, to determine most of them, Seurat used the simplest and most perfect of curves: the circle.

If we choose the point that divides the lower edge of the picture (AB) so that a golden section is determined (going from left to right), and if we raise a perpendicular from this point, we will divide the canvas into two unequal rectangles already designated, ADRS and SRCB. We note that line SR is tangential to the broad curve created by the dress of the first dancer. If the corners of the larger of the two rectangles are connected diagonally, they intersect at a point P. Now the artist has arranged the curves so that the most important of them are concentric and have for their center this point P. That this was premeditated seems impossible to deny.

In addition, we may determine that the center of the curve enframing the group of dancers (edge of the skirt of dancer number 2) is on side BC (right-hand side of the picture), and the curve in front of the dress of dancer number 2 itself belongs to a circle tangent to side DC (upper edge of the picture).

The bulging chest of the spectator in the lower right-hand corner of the picture establishes a curve belonging to a circle, the center of which lies on the extended right edge of the picture. One feels, again, that this is not a matter of simple chance.

Increasingly, Seurat was preoccupied with problems of this sort. Among his papers, his friends found many documents, in particular, pages cut from certain issues of the magazine *L'Art* (number 269, 22 February 1880, and number 272, 14 March 1880, pp. 195, 196, 197, 268, 269). These pages contain observations made by Monsieur D. Sutter under the title *The Phenomena of Vision*. In these writings, Sutter studied a portrait of Caligula; a decorative painting, the *Birth of Venus*, discovered at Gragnano in 1762; the painting from Pompeii known as the *Conqueror Crowned by Victory;* and one from Herculaneum entitled *Theseus Vanquishing the Minotaur.* Seurat apparently read and agreed with the accompanying commentaries. Sutter wrote: "In Greek art, everything is planned with taste, feeling, and a thorough science. No detail is placed by chance; everything is related to the whole by means of the play of esthetic lines . . . It cannot then be said that rules spoil the spontaneity of invention or execution, in spite of their absolute character."

This, too, was Seurat's own firmly held opinion; he considered these rules to be so independent of subject matter that we might speculate that he chose the theme of *Chahut* precisely in order to demonstrate their

perennial excellence. In the margins of Sutter's articles, Seurat marked with a cross those reflections that seemed to him most apt; for example, this one: "For there is something common to all types of pictures, to all modes of feeling and styles; it is the perfect application of the laws of unity, order, and harmony. And since all of the arts have the same foundation, the same rules should therefore serve as the basis of all artistic teaching."

More emphatic still is the pencil mark next to these words: "It is therefore necessary to find the clear and precise formulation of the rules governing the harmony of lines, light, and colors, and to establish the scientific grounds for these rules. . . . We emphasize this essential point: since all rules are derived from the laws of nature, nothing is easier to learn in principle and nothing is more indispensable. In the arts, everything must be deliberate."

Finally, these words, which Seurat honors in the margin with an even larger cross: "With the support of rules, which, like all truths, are simple . . . one clearly proves that beauty cannot exist without a logical relationship of taste submitted to the laws of harmony, and that these laws are constant, no matter what the subject."

Let us not insult Sutter or Seurat, his attentive reader, by suggesting that they considered rules capable of replacing genius. The 167th and last of Sutter's aphorisms states: "Science teaches itself, the sensibility improves itself, but genius may be derived only from God."

Now Seurat was modest. He did not consider himself a genius. He aspired only to be the most obscure, but the most active, pioneer of a renaissance of order through science, at a time when the great classical traditions seemed to have been universally abandoned.

Seurat was undoubtedly acquainted with all of Sutter's writings. Among his papers was found the obituary notice, framed in black, with which *L'Art* announced to its readers the death of this philosopher-geometrician. . . .[2]

The *Cirque* [Fig. 29] was to be Seurat's last major canvas. The theme was inspired by the Circus Fernando (now the Circus Medrano). More than ever, Seurat schematizes and plans the figures and their poses. Once again, there is not a line that lacks significance or does not find within the composition as a whole another line that balances or enlivens it. . . .

Seurat did not have enough time to finish this picture. He nevertheless considered it "finished" enough to be exhibited. In many places beneath the still incomplete covering of divided touches, there still appears the light blue line with which Seurat established his volumes. In his student days, Seurat had investigated line. Although a fervent admirer of Delacroix, he would allow no one to slander Ingres. Much later, in his conversations with Henri Edmond Cross, he said that a composition would always present itself initially to his eye and to his mind in terms of masses and the play of values. This is true. Few artists have better understood how to create volumes, even though Seurat usually presented

[2] For further discussion of the importance of Sutter's writings for Seurat, see Homer (1964), pp. 43–48, 207–08. [Editor's note]

his figures from angles that were most conducive to silhouetting. The blue line that surrounds the horse [in *Le Cirque*], for example, is very character- istic of his research, which is so different from that of the Impression- ists. . . .

Seurat was unquestionably the leader of a school, but in this ca- pacity, too, his destiny was to be an unusual one. . . .

One would have thought that his teachings, which are as trans- mittable as a multiplication table, would have spread easily from genera- tion to generation. Not at all. Except for a few fervent Divisionists, Seurat's method found no converts. But with the passage of time, as soon as it has survived the group of his few faithful followers, Seurat's esthetic . . . will serve as the rallying point for a whole world of artists who admire and honor him, without, however, forcing themselves to paint in accordance with the prescriptions of his very rigorous method.

The already considerable place that Seurat holds in the history of contemporary art will increase even further before very long.

SEURAT AND THE EVOLUTION OF
LA GRANDE JATTE (1935)

Daniel Catton Rich

PICTORIAL ANALYSIS OF
LA GRANDE JATTE

Despite the exactness of its title *A Sunday Afternoon on the Island of La Grande Jatte* [Fig. 15] was not to be in any sense a souvenir of a particular group of people in a particular park along the Seine. Never in nature could the artist discover its rigorously integrated design; nature to him merely furnished the data from which to select and invent. Every sensation coming to his eye must be tested by his peculiar method and organized in terms of his acute sensibility. Of what did Seurat's method consist? First, of an extensive analysis in which he broke up the parts of his composition, subdividing and classifying each according to its elements; second, of a long period of synthesis during which he revised these parts, joined them together, and intensified the whole. Seurat's procedure demanded the wealth of preparatory material we know today. Not only was each step to be taken slowly, but each was to be explicitly tested.

For the analysis he employed drawings and painted sketches automatically separating his observations into those dealing with line and tone and those having chiefly to do with color. The drawings in conté crayon were made on Ingres paper whose texture would somewhat resemble the canvas for the large picture.[1] Most of them are for single figures and seem to have been studied from life. Perhaps the shifting population of the

Daniel Catton Rich, *Seurat and the Evolution of* La Grande Jatte (Chicago: The Renaissance Society of the University of Chicago, 1935). This excerpt, pp. 15–25.

Daniel Catton Rich (1904–1976) Director of the Art Institute of Chicago (1943-1958) and the Worcester Art Museum (1958-1976). His still valuable book *Seurat and the Evolution of "La Grande Jatte"* (1935) was the first extended effort to examine the relationship between a major work by Seurat and the preparatory material for it and to deduce from this, general conclusions regarding the artist's methods and goals.

[1] See the list of these, pp. 59–60 [of the original edition]. [This and all following footnotes are the author's.]

island may have unknowingly lent itself as models for some;[2] in others, which are more detailed, posed figures seem to have been used.[3] There are a few sheets where the relation of figures to background is carefully studied; there is at least one drawing for the landscape alone, and several in which the figures have already found the linear and tonal arrangement of the finished canvas.

The painted sketches—or *croquetons*,[4] as Seurat liked to call them —made up the next class. These are all on panel, most of them painted in rich, rather deep color, with notes of the warm wood showing through. The panels are of the "thumb-box" size, each approximately 6¼ by 9¾ inches (15.8 by 24.8 cm.), and were chiefly executed on the island, though, as in the case of the drawings, there are some obviously made in the studio, representing a further stage where the figures are now painted into groups and brought into alliance with the background. Others were probably done out of doors and re-worked at home, Seurat laying in new figures to try out various effects. These sketches, which reproduce part of the identical landscape, are so perfect in proportion that they render the sense of the large painting in a truly remarkable way. Certain of them (and I am inclined to think the earliest) represent the landscape as almost swallowing up tiny figures; in others, quick, deft strokes of paint summon the poses of the more important characters; and in a few the figures emerge with something of their final authority. There is considerable variety in the way the paint is applied to the panel; some are done in broad, almost even strokes of broken hue, while in others the colors are brushed together to form larger masses, and a few are dappled with colored spots.

These little panels Seurat regarded as extremely significant, judging from their number and from the fact that he cared to exhibit them.[5] On the wall of his studio at 110 Boulevard Magenta, where the painting was in progress, an observer noted quantities of these little thumb-box sketches, several to a frame, which Seurat admitted were his constant joy.[6] He used to glance up at them from time to time when he wished to revive the vividness of a color impression, and with the crayon drawings pinned up near by, they formed the sole decoration of the room.

Finally, there were at least three larger studies on canvas, two of which were undoubtedly painted in the studio, and marking definite steps in the solution of the composition as a whole.[7] In general, the studies are more carefully detailed than the sketches and lead directly on to the large canvas. Seurat depended greatly on one of these, a final study, when he came to enlarge the design to mural-like proportions.

[2] It should not surprise us that Seurat executed drawings on the spot. His early conté crayon sketches before *The Bathers* show remarkable ability in the swift translation of nature, and there are witnesses to the fact that for later canvases, like *The Sideshow* and *Le Chahut,* he drew sketches directly from Montmartre performances.

[3] This procedure was consistent with his training and extensively followed in *The Models.*

[4] See the list of these, p. 60 [of the original edition]. Paul Signac [letter dated November 29, 1934] says that Seurat found the word (lit. "Sketchette") in De Goncourt.

[5] All his life he showed them along with the smaller canvases and larger works.

[6] Letter from Angrand to Coquiot, quoted by Coquiot, *Seurat* (1924), p. 39.

[7] See p. 61 [of the original edition] for a list of these.

In the first step toward the composition we find Seurat employing another typical separation. Stated most simply, the pictorial problem of *La Grande Jatte* is the relation of figures to landscape and to each other. Now the artist conceived the idea of developing the landscape first [Fig. 13].[8] Probably he had already made a few documentary sketches, which led him next to concentrate on the background. There were certain advantages. By itself the landscape could serve as a stage for trying out these figures, enormously reducing the complications which would surely arise were a new avenue of tree trunks and a different patch of river chosen for each one. It had the quality of remaining fixed when he wished to move groups back and forth; furthermore, he could mark off its expanding area of grass into alternating zones of sun and shadow, already looking forward to the time when he would use the darker sections as platforms for his figures. Amid the thousand-and-one changes through which his characters are transformed, the background remains fairly constant.[9]

There are two other types of material utilized by the artist and generally passed over in discussions of *La Grande Jatte,* which were to aid him in suggesting and testing certain arrangements. Though it has been said that Seurat destroyed much of his early student work, during the two or three years before *The Bathers* he made a number of striking drawings. Now these drawings and some of their contemporary small paintings were to furnish him with hints for massing and posing figures as well as possibilities of linking figures to landscape.[10]

The period of 1884–86 was a strenuously creative one, for not only did he assemble material and paint the large picture, but he finished a number of other works along the way. These were not the deviations from *La Grande Jatte* one might suppose, for in them Seurat successfully solved some of the pictorial problems he would meet in the main work. A painting like *The Seine at Courbevoie* [CdH 134] was more valuable, in some ways, than even a definitive sketch, for it treated the identical island with its bank, trees, and opposite shore; it detached one of the figures—the woman with the monkey—from the projected larger work, and perhaps, most useful of all, allowed him to test, on a canvas of fair size, something of the new technique he intended to employ for *La Grande Jatte.*

If none of the introductory material for the picture had come to light, and if we were unfamiliar with Seurat's process in other works, we might, upon observing the organic unity of *La Grande Jatte,* imagine that the artist had first seen the composition in large masses and later worked out its subtler interrelationships. But the drawings and sketches prove that an opposite method was followed. Seurat knew exactly how to "lay by in pigeon-holes" (the phrase is Roger Fry's) his various sensations. Many of the figures were drawn in conté crayon, and all were, at some time, fixed

8 While I find no preliminary sketches leading up to it, an early note for a very similar arrangement is the panel illustrated by Cousturier, *Seurat* (Paris, 2d ed., 1926), Pl. I, dated by her 1882. The large drawing [CdH 641], to judge from its widened format and greatly increased feeling of space, was done later.

9 The drawing [CdH 641] may have been employed to broaden and strengthen the landscape.

10 See "List of Associated Works" on pp. 59–61 [of the original edition].

against sections of the landscape.[11] In the drawings he emphasizes essential structure. In what is probably one of the first drawings for the woman with the monkey [CdH 625],[12] we see his unfailing accent on the silhouette. The figure is placed in left profile—the favorite pose in *La Grande Jatte*—and rendered with an effect of closed contour. At a little distance it appears as though the figure had been entirely surrounded by a drawn line, but such a limiting would have conflicted with Seurat's parallel objective: to render the sensation of volumes in space. Now contour and suggested volume are in a way irreconcilables, for line tends to flatten out form just as we are about to be convinced of its third dimension. Seurat makes a visual compromise. What appears to be a fixed contour is in reality a delicately blurred edge, and where a dark form touches a light background not only does the dark grow almost imperceptibly lighter, but the background deepens correspondingly. By devices of this sort, which spring directly from his research in optics,[13] he manages to reconcile intense oppositions of light and dark without destroying the feeling of stability so important to him. In other drawings, like that of the woman fishing [CdH 635], he hints at the same time, through his scale of subtly graded values, at a complete color harmony.

If Seurat employed black-and-white drawings to define the structure of his figures, he closely studied reactions between their local and atmospheric color in his little painted sketches, where invariably standing figures are contrasted with horizontal stripes of sun and shadow or compared with the slender verticals of the trees. Remembering the drawing for the woman with the monkey, let us turn to what is probably an early painted version of the figure [Fig. 11]. Could we see this sketch in color, we would note that here the artist is far less interested in structure than in the play of hues in the hat and costume against the complementary hues of background. Again, as in Seurat's draftsmanship, there is a counterpull. He wishes to respect the local color of his forms, but equally he desires to note the action of reflected light upon them. If this latter intention were carried too far, the whole figure would be reduced to a color haze. Once more the artist effects a compromise. The color is so divided as to permit subtle analysis, but these touches at a little distance draw together to suggest a single mass. The color, moreover, is organized. Where one hue impinges on another, it calls up its opposite; for example, a red is faintly surrounded by a green, a blue by an orange.[14] The consistency of his method allowed him to analyze complicated color into simple hues and still retain a sense of larger color areas.

[11] Letter of Paul Signac, already quoted.

[12] It may have been made earlier and utilized here. A series of drawings of women in bustles are connected with it. See "List of Associated Works," p. 59 [of the original edition].

[13] Rey, *La Renaissance du Sentiment Classique* (1931), pp. 104–6, extensively illustrates the scientific background of Seurat's drawing.

[14] Rey (*op. cit.*, pp. 106 ff.) goes into elaborate detail on the optical justification. Angrand relates the following: "On the Boulevard Courbevoie, recently built along the river, they had just planted some trees. Seurat was delighted to point out to me that their green mass against the grey sky was haloed with pink." (Letter to Coquiot; quoted by Coquiot, *op. cit.*, pp. 40–41.)

We may imagine Seurat spending a number of months in this early stage, multiplying the sketches done from nature, continuing to accumulate new data to be compared and classified. But when he had finished his landscape background, when he had assembled a certain number of drawings and small panels, he still had a collection of fragments. He was like some builder with the idea of a splendid temple in mind, who still found the unfinished stones at his feet. There was considerable variety in this material; some of it had been done in the morning on the island and had imprisoned the cooler morning light; other panels contained figures spontaneously set down that must be restudied before they could relate satisfactorily with the pattern of the whole. As Seurat's conception of the picture grew, so had grown his power of clarification. Could the sketches be arranged chronologically—an impossible feat since no one but the painter knew in what order they were made—it is probable that we would see him, step by step, turning away from the immediate, enveloping impression of nature toward a more abstract and intensely felt attitude. Obviously Seurat's next problem was to synthesize. Now the studio became more important than the island.

The first direction of this synthesis was toward simplification. If you will turn again to the early drawing for the woman with the monkey [CdH 625], you will find that, in spite of the effect of a single mass of dark against a luminous gray ground paling to white, there are parts of this drawing, notably the left and right profiles of the skirt, which are a little meaningless and betray the fact that Seurat carried over from the model certain details detracting from that breadth of handling he desired. To compare another (and I am convinced a later) drawing for the seated woman with the parasol [CdH 629] is to see him eliminating such chance descriptive reactions. Here the figure is more geometricized: the head is an ovoid set on the cylindrical neck, and simple solids make up the volumes of the body, the silhouette noticeably stressing the opposition of straight and curved edge. Within the forms, planes and details are suppressed and the dark-and-light contrast strengthened. Not only are the forms of nature simplified, but the proportion of head to neck and bust to trunk is completely made over. In general, as he progressed Seurat drew out his figures for expressive as well as compositional reasons. By comparison with the elegantly proportioned lady of fashion in the big picture, the first drawing for her is almost commonplace.

The same process went on in color. The early sketch for the woman with the monkey [Fig. 11] has an effect of quick translation from the model; it is spontaneous, momentary, and somewhat incomplete. But if another sketch lacks this sense of surface animation [Fig. 12], the design is far more stable. No longer do such bits as the hat and bustle strike us as casual. All has been consolidated in hue and amplified in effect while the landscape has been put in more successful order. I think we may imagine the early sketch as having been painted on the island and the later one in the studio.

As Seurat proceeds, we become more and more aware that the only relationship that interests him is the purely formal one. The painting is to be strictly composed; no extra-artistic action, no distracting charm of

surface will be tolerated. Once the interweaving of line, color, and tone has begun, the artist's sovereign control never relaxes. Linear structure is most carefully managed. When a figure is to be connected with a section of the landscape, we see him employing the comparison of lines [CdH 616]. In this drawing the man is placed beside a tree, helping to emphasize the vertical in both. But the instant that Seurat's alert eye notices this similarity, it detects a possibility of contrast; if prolonged, the line of the man's legs would almost exactly oppose the diagonal of the lower trunk of the tree, yet why should antithesis stop even here? The sloping bank may be compared with two parallel shadows, these in turn forming a counter-movement to the horizontal line of distant shore.

If drawings of this transitional stage emphasize the developing linear structure, there are painted sketches like the one illustrated in [CdH 120], which suggest combinations of groups united through spotting and accenting of color. This panel is typical of a number of these sketches; in some, dissimilar techniques are combined in a single panel, suggesting that Seurat introduced new figures on top of the already completed landscape. In them Seurat works slowly toward the rich and consistent color pattern of the ultimate canvas, repeating his notes in a more ordered arrangement. In many cases the local color is broken over with dabs of another hue, which in themselves have begun to set up the comparison and contrast found in the completed canvas.

The composition is gradually elaborated through these sketches until in such a study as this [Fig. 14] we find most of the characters in place.[15] This study, which we may take as definitive, is chiefly concerned with the color harmony. Nowhere in all of Seurat's preliminary work, perhaps, do we come across a more deeply saturated arrangement of hues. Touch by touch the canvas is covered with rich and harmonious color, in low, vivid complementary arrangement echoing across fields of intense contrast. Here, too, Seurat has established something of the tonal background for the large painting. In intensity of reds and greens, violets and blues, this study exceeds the finished painting, for when it came to enlarging the design to the proportions of a great wall decoration, Seurat was to reject this maximum of contrast as inappropriate. What this work lacks, however, the final picture was to have in abundance: an amazingly clarified arrangement of line, volume, and space, barely hinted at in any of the preparatory material, and here submerged in the artist's densely brushed surfaces.

From the final study the plan of *La Grande Jatte* is now apparent: it will be composed according to certain conventions. In the drawings and sketches we have observed Seurat liking to place his figures in profile. This position allows the artist not only to stress his expressive contours but to state the areas within those contours as parallel to the picture's frontal plane.[16] In the final picture this system is followed with regularity, aiding him in another convention: the designing of the composition in a

15 Probably intermediate is the sketch shown in CdH 141.
16 In an excellent article on "The Theory of Seurat," Guy Eglinton points out that the picture is constructed somewhat in the manner of an early stage set, i.e., in a series of horizontal planes, one behind another. See *International Studio*, 81 (1925), 291.

pattern of retreating planes. In the study of the landscape alone, as early as 1884, Seurat had evidently planned to relate his figures to contrasting bands of light and dark, and in the large canvas, a succession of planes, beginning with the large, shadowed area of the foreground, is ranged, one above another, into distance.

Conventions like this clearly show Seurat's absorbing concern with the architectonic. *La Grande Jatte* is to be "filtered" of all those casual and easy pictorial effects, admitted to the sketches done from nature and gradually eliminated through the progressive synthesis. It is a problem in pure structure; from the shifting, multi-colored pattern of a Sunday crowd on an island in the Seine, he is to derive and build a complete architectural form. . . .

SEURAT AND *LA GRANDE JATTE* (1935)

Meyer Schapiro

. . . Seurat derived from the more advanced industrial development of his time a profound respect for rationalized work, scientific technique, and progress through invention. He wished to rationalize painting, to make it an art of systematized construction, whereas the Impressionists, despite their "science" of color, admitted that they painted as the bird sings. The maturity of Seurat was exactly contemporary with the Parisian World Fair of 1889 (planned in the earlier 80s), in which the chief objects were great constructions, the Eiffel Tower [Fig. 24], and the Hall of Machines. The first was an artistic triumph of engineering (compared by Eiffel himself with the Pyramids), designed to provide, among other things, an elevated vista of Paris and to serve as the central spectacle of the Fair and as a landmark of the city. In the Hall of Machines, also a great monument of modern architecture, technology becomes a magnificent popular spectacle, withdrawn from the factories, like the assembled works in a museum, but differing from the latter in their absolute novelty and modernity. The Eiffel Tower offers indeed a formal resemblance to the art of Seurat; and it is worth recalling that the tower was originally painted with newly invented pigments which produced an impressive iridescence that disgusted the academic artists. In common with certain engineers and architects of the time, Seurat identified the "progress" of art with technical invention, rationalized labor, and a democratic or popular content. Just as the developments in the building were largely tied to public show architecture, to exposition buildings and department stores, so Seurat iden-

Meyer Schapiro, "Seurat and *La Grande Jatte*," *The Columbia Review*, 17, November 1935, pp. 9–16. This excerpt, pp. 15–16. By permission of the author.

Meyer Schapiro (1904–) Art historian and University Professor at Columbia University. Author of important studies on Early Christian and Medieval as well as Modern Art. In two pioneering studies, "Seurat and *La Grande Jatte*" (1935) and "New Light on Seurat" (1958), he was the first writer to stress the connection between the formal structure of Seurat's paintings and their content as a reflection of contemporary social experience. Other works by him in the field of Modern Art include *Vincent van Gogh* (1950), *Paul Cézanne* (1952), "On the Nature of Abstract Art" (1937), and "Courbet and Popular Imagery" (1941).

tified the content of art with an aesthetic world, and represented on a large scale (that is, on a public as opposed to private, intimate scale) only aesthetic aspects of popular experience—either spectacles or spectators, the masses of the people in the parks or in the circus or vaudeville, or the actors and clowns and acrobats and dancers, or in one case the models posing in his studio. There is no action or situation in Seurat's work which has to be "understood," or which turns the spectator back into himself, like the moral content in Poussin or the patriotic, religious, and erotic subjects of Ingres.

Seurat was an earnest democratic spirit, a humble, laborious, intelligent technician, unlike the intellectually and artistically aristocratic and genius-conscious classicist artists, Poussin and Ingres, with whom Seurat is often compared. His nature and tendency are evident in two remarkable aspects of his activity to which little attention has been paid. He was the first master to introduce the plain white frame. He sacrificed the traditional carved gilt frame to heighten the brilliance of color. Every element of the picture down to the frame had to be brought into the calculations of his systematic technique and theory of color. But this bold change had still another effect; it transformed the painting from the precious intimate object, the private jewel set in expensive, elaborately ornamented gold, into a democratic object, with an humble, matter-of-fact frame. In one of his paintings, *La Poudreuse* [Fig. 25], there hangs on the wall a picture which originally represented the artist, but which was changed into a still-life. It is coarsely framed by wooden sticks, crossed like the unsmoothed frames of rustic "souvenirs."

The second aspect is his valuation of his own paintings. When asked the price of a picture, the *Poseueses,* he wrote that he was very much embarrassed in fixing the price; that he reckoned it as one year's work at seven francs a day, but that he would be willing to reduce it if he liked the personality of the buyer. Thus Seurat rationalized even his own labor as a sum of units of work, in contrast to his contemporaries who identified every stroke with the experience of a life-time or the priceless effect of inspired genius.

SEURAT AS A PREDECESSOR (1936)

Jean Hélion

The evolution of painting through the ages is that of the optical sense
. . . Without discrimination of styles and epochs, the greater paintings of
the past are those where the artists, beyond the crust of their subjects,
found optical realities, strong elements of form and color. It is by increasing
the search for the reality of the painting in itself that the realism—which
is the reference to an outside reality—has been progressively eliminated.
The plastic elements of a subject cultivated by the painter, densified, opti-
fied, have been transformed beyond recognition, until the tradition of rep-
resentation or contact with a model has been broken. . . .

The point where representation stumbles over the optical reality
built out of it is clearly marked by Seurat and Cézanne, but the way to
abstraction is much clearer through Seurat.

Cézanne keeps on believing in the integrity of the model. It is by
his adoration of nature that he fulfills point by point its transformation
in a fully visible image. Thus he harms the integrity of the spot he is looking
at, but he devotedly follows the order of the usual appearance of it, and
allows no other deformation than that of translation of color and form
into surface. His work shows permanent efforts to increase or to get back
the resemblance with the model, such as emphasis upon the solidity of
volumes, the appearance of weight vertically, the density of coloration,
qualities which give his paintings an aspect quite compatible with that
of nature.

I cannot see such devotion to the subject in Seurat. He starts after
nature and also keeps its general order of normality, but once he has seized
the elements he is interested in, two anchors, a lamp-post, the sea, the
sky, the sails, the mast, the house, he starts manipulating them on his

Jean Hélion, "Seurat as a Predecessor," *The Burlington Magazine*, 69, July 1936, 4–14.
These excerpts, pp. 9, 10, 13, 14. By permission of *The Burlington Magazine*.

Jean Hélion (1904–) French painter. With Georges Vantongerloo and Auguste Herbin
he founded Abstraction-Création (1931), an organization which flourished for five years,
promoting non-objective art internationally in Europe through its exhibitions and publica-
tions. Stylistically, his own work derives from that of Léger and the Purists in the 1920's.

canvas without further respect for the spot. He does not seek at all, like Cézanne, that each point of his picture should correspond individually to each point of the subject. He makes a study of the spot to furnish him with general indications, materials of colour and form, but not to limit the reality of his picture.

Once he has seized the elements, he stylizes them beyond all resemblance, even to caricature, without consideration for taste, prettiness, normality. The appearance of his picture is never compatible with that of nature. Compared with figures by Courbet or even the deformed figures of Cézanne, Seurat's personages look like pictures of dummies full of straw. He did not care.

In a Seurat, every form is a unity that he keeps through all transformation. There is not, in his picture, as often in a Cézanne, a touch of the brush, that will start on a hat, for instance, and farther become part of the hair. A moustache by Seurat is a form, a foot is another, individual, integral.

In a large picture like *La Grand Jatte* [Fig. 15], people-elements are contained within their gesture. They exist entirely in sight, no more referring to any possible existence outside the picture. The pictorial image has trespassed beyond the mission to make visible certain scenery. But nevertheless it is not the result of a scene of love between a spot and a painter, as in the case of Cézanne, whose glances at the model are like fingers fingering amorously all over, with deforming but devoted passion.

Deformations by Cézanne are traces of grips, of huggings, of *coups d'œil,* chiefly physical, though not in any derogatory sense of the word. They are not freely taken decisions as are Seurat's deformations. Cézanne, by many corrections, shows he wished he could avoid them. His decisions result from the enthusiasm of the hand and of the eyes. The drawing fluctuates and disappears behind the touches, each touch of the picture being associated with a definite glance at a definite point of the model. By drawing, I mean the individuality of each element, which produces a clear and continuous separation between different elements. No. Cézanne's elements are bound by brush strokes. They could rarely be parted. They are members submitted to a mass, beyond their own personality, which is not completely defined. They melt into the whole. With Seurat, each part works without ever losing individuality; it is an action, not a submission.

In Seurat's *Grande Jatte,* the organization of the surface of the picture dominates all, fully, from edge to edge. Personages, monkeys, trees, spots of light, are each neatly shaped elements of the division of this surface. The division is complex but shows, when analyzed, clear progressions clearly rhythmed. The fat curve of an umbrella is perpendicular to its stick. The soft, curved tail of a dog sticks out of its mass, to divide a space between a sitting-with-an-umbrella-man-element, and a small dog. The shadows on the ground make a neat figure together in one plan. All sitting figures make one well-defined set. All standing figures, all trunks of trees, all hats, umbrellas, twisted tails, each taken as a character, simple or complex, fat or thin, oppose and combine their categories, with variations. Clear modulations everywhere, which can be perceived without strain, just by the process of looking. A high geometrical hat is grouped with a lady's

soft hat and a round cap. It is almost demonstrative. In the same way, some faces are up, others bent, some back, on one side, showing the other cheek.

All of this defines forms, and evolution of forms, so strongly that there are no dogs, no hats, no people left in Seurat's *Grande Jatte;* almost none. The reference to another world than the picture is fading away behind the optical activity of the forms and the colours. Very often I observe a Seurat without at all realizing it designates objects. In a Cézanne, I cannot forget that it is a question of certain objects, a certain place, a certain moment.

It is obvious that spaces-between-the-people-elements of the *Grande Jatte* are studied by Seurat separately, as objects. They are often clearer than the masses of the bodies. In the case of the sitting man with the top hat, on the left of the picture, the leg is what is left between one triangle of light and another, both tense, mechanically composed.

The existence of the painted surface as a whole, with no such things as holes left over—what is in nature the walkable space between objects—is most significant of the incomparable reality of painting, in itself. Representative or not, an ideal painting is a surface fully organized, according to all degrees, in all zones. A landscape by Cézanne is often a magnificent thing, but has many sides less developed than others. All the zones and points of the work are not always clearly organized together. The general structure is often—especially in the landscapes—confused, sometimes non-existent. Thus he is much nearer the Impressionists than Seurat.

The picture by Cézanne always points toward the model. A straight line does not exist on it, but a representation by bits of curves, and brush strokes of a straight line existing outside. In a Seurat, a straight direction is straight on the canvas. It was so in the model or it was not. It is not a designation. It is a realization, a fact, not any more a comment. Cézanne looks at the motif. Seurat looks at his canvas. Thus Cézanne deforms, while Seurat forms. Seurat builds, engineers his pictures. Cézanne is a mason, masoning, touch by touch, with no plans, only sketches. Great mason, certainly, and great sketches.

With Seurat, an absolute integrity of what is there, the minimum of hand-effect. No compromise, no dancing back and forth between clear and unclear, real or allusive, as is so typical of Picasso now. Seurat is equally obvious all through, equally abstract, equally representative, equally real, equally referring to intelligence through sight.

Seurat's systematization of decomposition of light puts him way out of the regular Impressionism. His pointillism, fully mechanized, is like the half-tone process of reproduction, and the nearest thing to an Ingres technique, with another palette. It keeps out of the drawing and is never used as an indication of form. It is something mastered, not empirical; like an alphabet with clear letters, clear rules, instead of a permanent improvisation. The small spots of colours that he uses are doses, almost homeopathic in size. They accomplish their function of synthesis of light, anonymously. . . .

Seurat may not have guessed that painting could come from another source than outside subjects, but his use of them is entirely nonrealistic. In the very precise picture of *Le Cirque* (1890–91) [Fig. 29], one of the last, the neck of the clown, in front, has been organized in lines and triangles, and the profile in a development of curves opposed to the straight lines of the neck, so much so that the whole thing becomes a caricature of reality. The same with the small people whose function is evidently to divide the tense bands of the benches, behind the principal scenes, in rhythmic segments.

By typifying each element formally, by opposing it so strongly to others, Seurat violates permanently the current notion of the appearance of the object. It is no enthusiasm of the hand as in Cézanne, nor awkwardness. Seurat's drawings or paintings of simple scenes show too well that he could draw and build classically if he wanted to. He had renounced this preoccupation for the search of tense relations. . . .

Seurat's courage in making deformations may have been very important, formerly. It is not so any more. It may also have been typical of a certain modulation of taste at a certain period, but now his importance lies definitely in his use of elements, in his widening the optical conception of painting.

SOME ASPECTS OF THE DEVELOPMENT OF SEURAT'S STYLE (1941)

Robert J. Goldwater

The fundamental pictures for the "final" style of Seurat are of course the *Parade* (1888–89) [Fig. 21], the *Chahut* (1890) [Fig. 27], and the *Cirque* (1890–91) [Fig. 29], the last of which was not altogether finished at the time of Seurat's death, although he considered it far enough advanced to exhibit. Essential also for our consideration of this style are the sketches made for these pictures. Great emphasis has been laid on the number and the nature of the sketches executed for the earlier canvases, and especially of course for the *Grande-Jatte*. The spatial layout, the detailing of the parts, the crayon drawings of the figures, the filling in of the space with these figures are correctly seen as leading to an understanding of Seurat's conception and purpose, and to a grasp of the method and manner of his transformation and integration of nature. But it has not been sufficiently noted that for these latter pictures, as large in conception as the *Grande-Jatte*, such sketches are almost entirely lacking. In Seurat's atelier at the time of his death there were found thirty-eight *croquetons* for the *Grande-Jatte;* for the *Chahut* and the *Cirque* there exist but one such sketch apiece.[1] For the *Grande-Jatte* there were twenty-three preparatory draw-

Robert J. Goldwater, "Some Aspects of the Development of Seurat's Style," *The Art Bulletin*, 23, June 1941, pp. 117–30. These excerpts, pp. 121–24, 126, 127, 128, 129, 130. By permission of *The Art Bulletin*.

Robert J. Goldwater (1907–1973) Professor of Fine Art at New York University and Director of the Museum of Primitive Art in New York. Known for his pioneering study *Primitivism in Modern Art* (1938) and for influential writings on Gauguin and Puvis de Chavannes as well as Seurat. Made the first major attempt (1941) to relate Seurat's development to broader patterns of style and taste in the 1880's.

[1] This enumeration is taken from Robert Rey, *La renaissance du sentiment classique*, Paris, Beaux-Arts, 1931, p. 144, who had access to it through Félix Fénéon, one of the executors. That the list may not be altogether accurate is indicated by the fact that Daniel Catton Rich *(Seurat and the Evolution of the Grande Jatte*, Chicago University Press, 1935, pp. 53–61) cites twenty-one drawings, twenty-six sketches and three studies "preparatory" to the *Grande Jatte*, and sixteen drawings and four sketches as "associated" works.

 The drawings have largely been studied from the facsimiles in Gustave Kahn, *Les dessins de Georges Seurat*, 2 vols., Paris, Bernheim-Jeune, n.d. Of the 149 items, only seven

ings in addition to the *croquetons;* for the *Chahut* there was only one, and for the *Cirque* but three. If further we take into account those pictures done immediately before and after the *Grande-Jatte,* we see that this is no sudden change: for the *Baignade* there were ten drawings and thirteen *croquetons;* for the *Poseuses* five drawings and four *croquetons;* for the *Parade* four drawings and three *croquetons.* These are significant figures, whose full import we will return to later; for the moment we may remark that they indicate something very different from an increasing mastery over a style.

How true this is becomes clear when we examine not alone the number, but also the character of the drawings. For the *Grande-Jatte* there are no line drawings. All the sketches, whether in conté-crayon or in color, are conceived in three-dimensional terms, either of the modeling of the individual figure, or of the organization of space.[2] For the linear organization, for the flat decorative pattern, there are no studies. But in these last paintings, Seurat's concern with this aspect of composition dominates the others. It is not simply that he makes outline drawings, as we have already seen him doing for the *Poseuses,* but that tensions and balances, whether in black and white or in color, as they exist upon the surface of the picture plane, become his almost exclusive concern. Take for example the conté-crayon study for *La Parade* (Kahn no. 123) [Fig. 20]. Here within the individual figures, there is no modeling, hardly even a contrast of flat planes; there is only the juxtaposition and contrast of the plane of the figure with the planes surrounding it.[3] The consciousness of the continuity of spatial recession, which, in spite of all emphasis on "measuring posts," exists from the very beginning of the three-dimensional conception of the *Grande-Jatte,* is here replaced by jumps from one parallel plane to the next, the distance between the planes being indicated by a variation in their values and a reduction in size of the figures they contain. Moreover the preparatory color study for *La Parade* (formerly in the Vildrac collection, Paris) is entirely a study in linear, decorative tensions [CdH 186]. The uniformity of stroke, which we have seen partly sacrificed before, here gives way entirely to modifications designed to indicate force and direction. The stroke of the foreground figures follows their contours; to emphasize their repetitive pattern the railing is done in long horizontal strokes; the gas-jets above are centers of light which radiate strong strokes of color towards each other and down into the picture. The shapes of the objects themselves, however, do not necessarily determine the lines of force: the windows at the right, vertical in shape, are nevertheless carried

are dated, and of these four are before 1878. —*Croqueton* is Seurat's word for his color studies in oil.

The dating of Seurat's early works stems originally from the inventory of his atelier taken at his death, and the catalogue of the 1900 exhibition of *La Revue Blanche.* See Lucie Cousturier, *Seurat,* 2nd ed., Paris, Crès, 1926, for reproductions (not very good) and generally accepted dates for most of the paintings. [This and all subsequent footnotes are the author's, renumbered for this printing. Footnote 1 has been expanded to include prior relevant citations.]

2 Cf. Rich, *op. cit., passim.*

3 This change is the reason why many preparatory conté drawings of individual figures cannot exist.

out in horizontal strokes, in order that the balance of horizontal and vertical, obviously one of the main decorative themes of the picture, may be preserved. (In the finished painting this horizontality is maintained by breaking the window into a light area above and dark area below, and by further emphasizing the row of lights that shine through from the room behind.) Even the legs of the trombone player are broken by horizontal touches, while his chest and arms are done in vertical lines. And finally, the distribution of these strokes is far from being even, as it is in the sketches for the *Grande-Jatte* and the *Poseuses,* so that density of area is likewise made to play its part in the distribution of the decorative pattern.

The studies for the *Cirque* show Seurat with the same predominant attitude, occupied with the same problems. The drawing of equestrienne and tumbler (Kahn no. 124) [CdH 707] is above all a surface design: the movement of the figures is entirely across the picture plane, with rider and clown spread out flat as they are in the finished painting, their actions conveyed entirely by linear contour. These figures are spots of light against the summarily indicated bands of the grandstand in the background, shown as strips of varying darkness with no interior detail. Spatial relations are reduced to a minimum; there is some distance suggested between the rider and the clown by variation in size, but little indication of the depth of the circus ring or the recession of the seats. The whole serves primarily as a decorative background with which to set off the jagged contours of the moving figures.[4] The colored *esquisse* for the *Cirque* (Paris, Louvre) [CdH 212] bears the same marks as those we have found in the *Parade*—the mood is of course a very different one, but this only serves to emphasize how much Seurat is now thinking in terms of total surface decoration conveyed by linear means.[5] Swirling lines replace the stolid horizontals and verticals, and the strokes follow these lines. Areas which are to be light are left entirely blank so that the horse and the head of the clown have become rather flat, reserved areas with no interior modeling. Similarly, by leaving large areas of the grandstand white they are brought further forward than in the finished composition; on the other hand the curves of the seats, shown in the sketch, are flattened to straight lines in the final painting.

The *Parade,* the *Chahut,* and the *Cirque* all exhibit certain stylistic characteristics which we have seen in milder form in the *Poseuses* and the *Poudreuse,* and they thus represent a new stage in Seurat's style. The *Parade* [Fig. 21] is a directly frontal composition, placed above the spectator's eye-level, and lacking in orthogonal lines.[6] A foreground plane

[4] A drawing for the clown of the lower foreground (Kahn no. 103, inscribed "Dernier dessin de G. Seurat") is again a study of angular contour and emphasizes its straight line contrasts considerably more than does the final version.

[5] A reproduction of this sketch is to be found in René Huyghe (ed.), *Histoire de l'art contemporain,* Paris, 1935. Chapter II, p. 27.

[6] Cf. Alfred Barr, ed., *The Museum of Modern Art, Catalogue of the First Loan Exhibition,* New York, 1929, p. 25, and Roger Fry, "Seurat's La Parade," *Burlington Magazine,* 55, 1929, pp. 289–93, for analyses of this picture. Barr here sees Seurat as "consciously or unconsciously . . . affected by Egyptian reliefs which he had seen at the Louvre."

(though we cannot be sure it is the same one) is established by the gas-jets above and the silhouetted heads below.[7] There are a great many planes indicated behind this first one, but the intervals between them are omitted, and their distance is only suggested by slight changes of clarity. The silhouetting of the figures against the lighter middle ground is very different from those three-dimensional silhouettes that characterize the earlier paintings; they lead the eye across from figure to figure rather than into the picture space. In the *Chahut* [Fig. 27] this spatial compression increases further. The foreground plane is again established by a figure looking in with his back turned to the spectator, but the effect of this figure is by no means to create a deep space. Rather the approximately parallel lines of flute, double-bass, and legs of the chorus are seen as on the same plane, so that the diminishing feet do not actually realize a recession in depth.[8] The upward glances of orchestra leader and spectator, each on a different plane, looking at the ballet which is on a third plane, are both directed across the picture and not at all at their actual object. The background plane, as in the *Parade,* is parallel to the picture plane, and though represented as rather far away (as we can see if we look at the spectators' heads below), appears to be rather close. The gas-jets to the left and above serve further to increase the surface pattern. The *Cirque* [Fig. 29] has the same foreground figure as have the two other pictures. But now the spectator is looking down into the circus ring so that a horizontal plane can be represented and thus give depth to the composition. In addition, the curve of the circus ring should lead the eye back into the space. In spite of this, the *Cirque* is effective largely as a surface design. This "poster-like" effect is in part due to the light and bright colors employed, colors in a strident key, almost all of the same intensity and with little suggestion either of modeling or of atmospheric perspective.[9] In part also it is due to the repetition of line and stripe patterns that cause the eye to play over the surface as a whole. But in large measure it is due to a multiple perspective that treats every part of the composition as if the spectator were at its own level. Thus we do not look down nearly enough upon the foreground clown, nor up enough at the spectators in the balcony, most of whom are drawn as silhouettes at eye level. We can see the belly and hind leg under the belly of the horse, even though the nearly horizontal and practically parallel lines of the upper balcony (in reality a section of a curve) indicate our eye-level is near the top of the picture. At the same time the supposed angle of vertical vision is many times too great, so that we of necessity flatten the picture by looking at it

[7] The frieze-like use of the gas-jets begins as early as 1885, according to Cousturier's dating of the drawing of the *Banquistes* (Cousturier, *op. cit.,* pl. 62; Kahn no. 102). Here the desire to flatten the composition is clearly evident from the profile posing of the figures, and the twisted shoulders of the clown, which suggest a relation to Egyptian relief that Barr *(loc. cit.)* has suggested for the *Parade.*

[8] What a change has taken place here since the *Grande-Jatte* may be suggested by a comparison of Rey's analysis of the *Chahut* (*op. cit.,* pp. 124–27), with the straight- and curved-line analysis Rich makes of the *Grande Jatte* (*op. cit.,* pp. 27, 29). Without subscribing to Rey's geometrical conclusions, we can observe how much more of the total effect of the picture is given by a linear analysis than in the case of the earlier work.

[9] Cf. Florent Fels, "Les dessins de Seurat," *L'amour de l'art,* 8, 1927, 43–46.

in separate parts. Thus the imagined relation of the foreground clown to the ring as it would continue forward under him is impossible to construct, and each row of spectators in the stands is seen as silhouettes looking straight out at the observer on their own level. To a lesser extent this "absolutizing" of the perspective is also to be found in the *Parade* and the *Chahut*. In the *Parade* the eye-level is even with the stand of the trombone player. In certain details this is taken into account: the end of the trombone is seen from below, the stand in front of the three musicians is in receding perspective. On the other hand, the ring master and the boy in profile are viewed from in front rather than from beneath, and the row of decorative gas-jets across the top is entirely outside the perspective of the picture. Indeed the arrangement of the whole is such that an abstraction of space seems to be made in favor of a decorative recession of planes that is as absolute for the position of the figures as it is immobile for their poses. In the *Chahut* the eye-level similarly moves up and down the picture at will: conductor and chorus man are each seen directly horizontally, the girls' heads are viewed from below, but not their left arms, and the lights to the left and at the top are once more decorative motives with no specific spatial relationship to the rest of the picture.

These three canvases are in effect the final stage in a gradual evolution of Seurat's vision. Seurat begins by seeing in the round, by seeing volume and space as a gradual transition from light to dark, by seeing in terms of modeling. In his last pictures he sees space in terms of parallel planes one behind the other with almost no modeling involved. This seems to carry with it, in the compositions we have just discussed, a flattening of the total space represented, but that it need not do so is shown by certain of the landscapes of these last three years.[10] It is only natural that the change should be somewhat less marked in the drawings than in the finished compositions, that to the end the drawings should remain rounder than the paintings. There is nevertheless a great difference in conception between such a drawing as the *Portrait of Signac* (1890; Cousturier, plate 53), and studies like the *Portrait of his Father* (1881; Kahn no. 46) or the *Woman Sewing* in the Museum of Modern Art (1883; Kahn no. 63); and within the limitations of the medium we can observe a tendency towards a flattening of planes parallel to that found in the paintings. The very fact that the conté-crayon drawings decrease so rapidly after about 1885 is indicative of this tendency, since the nature of the medium lends

[10] In this connection compare especially the *Chenal de Gravelines, un Soir* (1890; Cousturier, *op. cit.*, pl. 34) with *Marée Basse à Grandcamp* (1885; *ibid.*, pl. 15). The earlier canvas still preserves the impressionist desire for a continuity of atmospheric perspective as an essential element of recession. The later canvas conveys no less an effect of distance, but is composed in the separate bands of quay, water, and sea wall, each parallel to the picture plane, and each a distinct light and color area sharply separated from its neighbor. Thus the recession is given in jumps, rather than through a gradually changing continuum. Compare also *Le Hospice et le Phare à Honfleur* (1886) and *L'Entrée et le Port de Honfleur* (1886; formerly Goetz collection, Berlin) with *Le Crotoy: à val* (Edward G. Robinson collection, Beverly Hills) and *Le Crotoy: à mont* (both 1889) for a similar, though less marked change (reproductions in Cousturier, *op. cit.*, pl. 23, 21, 31, and 32, respectively).

itself to continuous, graduated modeling rather than to line, and it was for this peculiarity that Seurat had singled it out at the start. . . .

II

Our concern thus far has been with the direction of Seurat's art. Before turning our attention to the relation of his stylistic evolution to the painting of the time, we would do well to recall briefly the work of his contemporaries. . . . Of the younger generation—Seurat's real contemporaries—van Gogh was in Paris from 1886 to 1888, where he was friendly with Emile Bernard; Gauguin, whose disciple Bernard soon became, painted his Brittany pictures with flat colors and heavily outlined areas that were at the basis of the "synthetist" theories of his followers. Between 1885 and 1890 Lautrec developed his characteristic style, and in 1889 he and Bonnard did their first posters. During the same period Eugène Grasset, partly under the influence of English "Arts and Crafts," evolved his own influential "modern" manner of poster and decoration. And in 1889 *La Plume,* organ of the younger painters and writers, was founded. Thus in his last five years Seurat was the contemporary of various developing aspects of a new style—which, suddenly growing from such origins as these, flowered into that omniprevalant manner of poster, crafts, and architectural decoration of the decade 1890–1900 known as *art nouveau.* Seurat's own later work has close affinities with that of these other artists who were among the founders of *art nouveau.* . . .

Rey has pointed out that the theories of Charles Henry and Signac probably played a large part in Seurat's interest in linear expression.[11] He has also pointed to Seurat's study of the geometrical analyses of antique art that a certain M. D. Sutter published in *L'art* in 1880, though again we do not know exactly when Seurat first read them.[12] But little stress has been laid upon the fact that interest in this sort of theory, as well as the form that it takes in the paintings, is characteristic of the period in which Seurat was working (1885–91). This is the time of Gauguin and Emile Bernard and Paul Serusier in Brittany and Paris, the time of "synthetists" and "symbolists." [13] Maurice Denis (in 1885?) invents the terms "objective" and "subjective deformation" (stylizations of pattern, and of expression) and thus defines the intention of his art: "À chaque état de notre sensibilité devait correspondre une harmonie objective capable de le traduire." [14] In 1891 Paul Serusier published his *A B C de la peinture,* which like the theories of Sutter attempted to find laws of harmony, of construction, of proportion through an anlysis of the works of the

11 Rey, *op cit.,* pp. 103, 140. It should be noted that of Henry's three books, two (*Le repporteur esthétique,* and *La cercle chromatique*) were published in 1888.
12 *Ibid.,* pp. 127–29, 143.
13 On the subject of Gauguin and the synthetists, cf. Charles Chassé, *Gauguin et le groupe de Pont Aven,* Paris, Floury, 1921; and Anne Armstrong Wallis, *The Symbolist Painters of 1890,* New York University (Thesis), 1938.
14 Maurice Denis, "De Gauguin et de van Gogh au classicisme," *Théories: 1890–1910,* Paris, Rouart et Watelin, 1920, p. 267.

ancients.[15] Serusier finds his touchstone in the Pythagorean theory of numbers, and the proportions of the golden section, much as did Charles Henry. Sutter talks of "les lois de l'unité, de l'ordre, de l'harmonie," "quelque soit le degré d'élévation du sujet." [16] (Whatever terms such attempts to find laws of composition employ, they tend to eliminate the suggested third dimension from their paradigms, and to find their principles in two-dimensional relationships, so that Seurat's concern with this type of analysis was related to the tendency of his later works.) Thus not Seurat alone, but many others of his time, and more especially of his generation, were trying to find a wider basis for their art than the "nature seen through a temperament" that was the conscious theoretical justification of the impressionists. When Seurat studied the scientific treatises of Rood and Charles Henry, and when he proclaimed that "L'art c'est l'harmonie. L'harmonie, c'est l'analogie des contraires," he was seeking for some means other than his own taste, sensibility, and judgment by which to produce a good work of art, and to judge the work of art once it is produced. That is why he and the others of this time were interested in geometrical analyses of the ancients. By these means they hoped to arrive at objective and time-tested methods of composition which would be, as Serusier claimed for his number relationships (and as Seurat sought in his color relationships) those "sur lesquelles est construit le monde extérieur"; and moreover which were, just for this reason, significant and expressive of emotions and ideas.[17]

Now it is clear that there was nothing of the mystic about Seurat. He would certainly not have wanted to reëstablish the "preëminence of the imagination" that was the proud claim of the symbolists, he would not have wanted to "reach for the stars" with Albert Aurier, nor would he have wished to justify his art by metaphysical theories.[18] Yet in the light of his letter to Maurice Beaubourg, we may justly suppose that he would later have modified the well-known sentence quoted by Charles Angrand: "Certains critiques me font l'honneur de mettre de la poésie. Mais je peins d'après ma méthode, sans aucun autre souci." [19] We have seen that in his last years he was beginning to be concerned with the effects and significance of his method. Nor must we forget that the extreme concern of the synthetists with "subjective deformation" and the "centre mystérieux de la pensée" was extremely short-lived, and that they too, following Serusier, were soon concerned with the general laws of art. They quickly abandoned their interest in the naïve, and by 1895 both Bernard and Denis were looking for models and for laws in the art and the philosophy of the ancients.[20] To be sure, Seurat's art always remained less personally expressive, and he was always more interested in finding an "equivalent" for the mood of the object than in his personal reaction to it; yet his conscious and theoretical solution of his problem was in the

15 A second edition was issued in Paris by Floury, 1921.
16 Rey, *op. cit.*, p. 128.
17 Serusier, *op. cit.*, p. 2.
18 Denis, *op. cit.*, pp. 264, 268.
19 Quoted by Rey, *op. cit.*, p. 95
20 Wallis, *op. cit.*, p. 42.

spirit of his time. Akin to the symbolists, too, was his consciousness of the abstract surface pattern of his pictures, and his willingness to "deform" a naturalistic representation so that he might achieve this "certain order" of the arrangement of line and color.[21] We have seen that in his later pictures he is willing to abandon the fusions of pattern and representation that had existed in his earlier work; he now lets them exist side by side or lets the pattern dominate. Like the synthetists, during the same years when they were working—and for the first time in modern art—he, and they, substitute for the "illusion" of reality, the "suggestion" of the heavily laden reference to, and interpretation of, reality. Thus the desire for systematization and stylization connects Seurat closely with his younger contemporaries of 1880–90, and shows an affinity that grows as his style and theory develop, an affinity that must not be hidden by an initial adoption of an "impressionist" technique, or his initial alliance with an "Impressionist" exhibition. . . .

The affinity of Seurat's later style is in his use of line, line that may be called "symbolic" if we bear in mind the limitations of this adjective imposed by Seurat's theory. We have seen the process of stylization that took place in the formation of the *Poseuses,* not alone the introduction of line, but the elongation and the pointing of the forms, and especially the characteristic form of taut curves meeting in a point, found in the still-lives and in the hair. Here decorative area and expressive contour line are balanced as in many similar forms employed in Gauguin's pictures (where, however, they remain more flat and uniform in tone), where the same stylization with typifying repetitive intention has taken place.[22] The same characteristics are found in that curved group of silhouettes that makes up the right edge of the *Parade,* and in its frieze of gas-jets along the top. The mood this line is intended to convey in these pictures remains somewhat doubtful.[23] In *Port-en-Bessin, un Dimanche* (1888; Indépendants, 1890) [Fig. 23], where this decorative, and at the same time descriptive, line appears for the first time in all its force, there can be no question: the waving flags have been painted in a manner obviously at variance with the rest of the picture, and clearly motivated by theoretical and "symbolic" considerations; they are there to show the gaiety of this otherwise tranquil scene. Seurat's affinity with this side of *art nouveau* is strikingly evident in an amusing design of 1887, a study for the jacket of Victor Joze's novel, *L'homme à femmes* (Kahn no. 81) [Fig. 26]. Here, in spite of all pointillism, is a flat, decorative composition in two-dimensional bands of color that attempts the spirit and manner of Seurat's contemporaries and demonstrates just how far Seurat could go in this direction. (It is significant that Victor Joze also collaborated with other

21 Maurice Denis, "Définition du néo-traditionisme," *Théories: 1890–1910,* p. 1 (first published in *Art et critique,* August 23, 1890): "Se rappeler qu'un tableau—avant d'être un cheval de bataille, une femme nue, ou une quelconque anecdote—est essentiellement une surface plane recouverte de couleurs en un certain ordre assemblées."
22 Compare especially the use that Gauguin makes of the floral designs on the printed stuffs of native clothes, as in *Ia Orana Maria* and *Tahitian Women on the Beach.*
23 Barr, *op. cit.,* p. 26. "Of the seven great Seurats this [the *Parade*] is the most geometric in design as well as the most mysterious in sentiment."

painters of this time and style: for his *Reine de joie* Toulouse-Lautrec executed both jacket and poster, and also did the poster for his *Babylone d'Allemagne*, the jacket for which was done by Bonnard.) [24] The limitations suggested here—limitations as to mordant draughtsmanship and quickly caught anecdote that are the concomitants of the positive qualities of Seurat's art—have been accepted in the severe and typified stylization of the *Chahut* and the *Cirque*, yet these pictures belong to the style of their time no less for that. The use of bands, the half flame-like, half floral character of the repeated upward sweeping line, now carry out completely the details we have noted in earlier pictures. That style—the linear extreme of *art nouveau*—needs no lengthy description; in France alone it stretched from Grasset to Emile Bernard, from Gallé to the Rose Croix, in England it included Beardsley, and in America it was best known through the glass of Tiffany. [25] The line upon which it is based is derived from plant and animal motives, and it is essentially a decorative style in that it thinks in terms of the organization of a two-dimensional unit—that is perhaps why it found one of its most typical and popular expressions in the poster. Here we wish to do no more than point out Seurat's increasing affinity with this other aspect of the most progressive current of the art of his time. Would Seurat's connection have continued to grow? One of *art nouveau*'s most important and creative figures, Henry van de Velde, was for a brief time among his disciples. He carried on the direction of Seurat's work.

[24] Rey, *op. cit.*, pp. 140–41.

[25] On *art nouveau* cf. Ernst Michalski, "Die entwicklungsgeschichtliche Bedeutung des Jugendstils," *Repertorium für Kunstwissenschaft*, 46, 1925, pp. 133–49; and Fritz Schmalenbach, *Jugendstil*, Würzburg (Thesis), 1935.

THE TECHNIQUE OF IMPRESSIONISM: A REAPPRAISAL (1944)

J. Carson Webster

One of the most pleasing experiments in physics, for those interested in painting, consists of the demonstration that sunlight contains within it all the colors of the spectrum, into which it may be broken on passing through a prism; and that, conversely, white light may be formed by recombining these colors. This fact is taken as the basis for the explanation generally given of the technique of the Impressionist painters, offering an interesting and apparently scientific reason for their characteristic application of color. Since these painters—the argument runs—were seeking to attain the effect of bright outdoor light, what more logical and what more in keeping with scientific fact than to proceed according to this experiment and to place upon the canvas separate touches of pure colors, the "prismatic" colors, the elements of the light desired. These touches are then to "fuse in the eye" when viewed at "the proper distance," and thus result, we are told, in greater luminosity or even greater intensity than in mixing the colors "on the palette."

The prevalence of this theory may be inferred from its appearance in widely used texts of the present day.[1] In one of them we read,

> The juxtaposition of colors on the canvas for the eye to mix at a distance produces a more intense hue than the mixing of the same colors on the palette . . . The twelfth-century glassmakers used the same principle as the

J. Carson Webster, "The Technique of Impressionism: A Reappraisal," *The College Art Journal,* 4, November 1944, 3–22. These excerpts, pp. 3, 4, 5–8, 12, 13, 14, 16, 17–19, 20, 21–22. Reprinted from the *Art Journal,* by permission of J. Carson Webster and the College Art Association of America.

J. Carson Webster (1905–) American scholar and teacher, he is Professor of Art History at Northwestern University in Evanston, Illinois.

1 Helen Gardner, *Art Through the Ages,* New York, 1926, pp. 219, 371; and 2nd edition, 1936, pp. 319, 667-68. David M. Robb and J. J. Garrison, *Art in the Western World,* New York, 1935, p. 625; and 2nd edition, 1942, p. 797. Raymond S. Stites, *The Arts and Man,* New York, 1940, p. 726, col. 1. [This and all subsequent footnotes are the author's, but have been renumbered in this printing.]

French Impressionists of the nineteenth century who juxtaposed their red and blue pigment on the canvas for the eyeto mingle into purple from afar;

in another,

The science of color and light was studied [by the Impressionist painters] in the literature of physics. Practical methods were examined such as the division of color. Green mixed on the palette provided only dead solid color, but a bright green could be made by spotting the canvas with pure yellow and pure blue;

. . . The explanation is fascinating, but it becomes suspect when one examines Impressionist paintings carefully. Teachers, as well as students, might begin by checking the concrete examples of mixtures which are cited in such statements as those above. Thus, with regard to the persistent statement that green will result from separate touches of blue and yellow, I have yet to find green produced in this way (although students often assure me that it is so, bearing witness to the teaching of this theory). . . .

When we turn to the facts of color-mixture, our inability to find a case of green-from-blue-and-yellow-dots is confirmed. It is pretty generally known that the two methods of mixing color, the subtractive (as mixture of pigments) and the additive (mixture of light), do not always give similar results.[2] This fact, however, as the above quotations show, seems to be frequently forgotten in discussing Impressionism. Everyone knows that mixing a blue and a yellow pigment results in green. This means that on a color-circle the result is indicated on an outward curving line joining the points representing the two pigments mixed. There is no regular rule for all colors, but in the case of blue and yellow the line could curve out to about the circumference of the circle itself. Thus quite a saturated green can be made by mixing blue and yellow pigments. The mistake comes in assuming that the result would be the same if the same colors were mixed additively. This is not the case, for the result is then a grey of some kind, as is regularly demonstrated in the psychological laboratory by spinning a disk, part blue, part yellow, which then appears grey. On the color-circle (one should refer, of course, to a circle arranged for visual relationships, so as to bring visual, not pigment, complementaries across from one another, such as the Munsell or the Ostwald circles) additive mixtures of two colors are indicated along a straight line joining the points which represent the two colors mixed.[3] Thus the results of mixing blue

[2] Numerous books on color discuss this, and with ample emphasis on blue and yellow. I mention here only the early one by O. N. Rood, *Student's Text-book of Color, or Modern Chromatics*, New York, 1879, and later printings; the chapter on mixing colors might well be read by anyone interested in the "scientific" aspect of Impressionism, since it represents the scientific knowledge of the time, with which some of the artists were in contact. For the Munsell color-system, to which I shall refer for color relations, see A. H. Munsell, *A Color Notation*, 3rd ed., Boston, 1913, with color-atlas; later publications by the Munsell Color Laboratory, Baltimore, are available, e.g. *The Munsell Book of Color*, 1929.

[3] See Wilhelm Ostwald, *Colour Science* (translation by J. Scott Taylor), 2 vols., London, n.d. [1931, 1933], 2, pp. 32 ff., for a suggestive discussion of the two methods of mixture. For our present purpose a color-circle will be simply a mnemonic device for keeping the results of mixtures roughly in mind. Circles showing visual relationships will then differ

and yellow additively in Text Figure 1 would be found along a straight line drawn between points somewhere near the center of the sectors marked Blue and Yellow (depending on the particular colors used). If the amounts were such as to balance, the result would be indicated at the middle of the line, I would say around the point placed near the apex

Text Figure 1

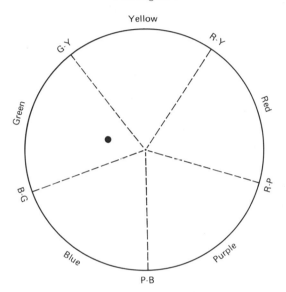

chiefly in the way in which the ordinary color-names are assigned to this circuit of the visible hues. Ostwald gives the name "Blue" to the region having the color of ultramarine; whereas in the Munsell circle this point approximately is given the name "Purple-Blue," the word "Blue" including colors farther along toward green (see Text Figure 1) which probably accords better with the ordinary meaning of the word. The Ostwald system, with its conscious adoption of psychological and mathematical principles (the Weber-Fechner Law, a color "equation") has a degree of symmetry and elegance that give it an aesthetic appeal of its own; whatever its shortcomings it should prove quite adequate for the field of art. (For an interesting distortion of the Ostwald circle, and a more rational notation, see Faber Birren, *Color Dimensions,* Chicago, 1934.) Our Text Figure 1 is based on the Munsell system, which is apparently the more accurate and complete for color specification; and its dimensions, hue, value, and chroma, correspond better with psychological and psycho-physical concepts of color. Those interested in a comparative analysis of the two systems may refer to "Color Order Systems, Munsell and Ostwald," by Milton E. Bond and Dorothy Nickerson, a part of a symposium, "Color in Art Education," published in the *Journal of the Optical Society of America,* 32 (1942), pp. 709–19. (More technical studies can be found in a coordinated series of articles on the Munsell system and in a symposium on the Ostwald system, both in the same journal, vol. 30 (1940), pp. 573–645, and vol. 34 (1944), pp. 353–99, respectively.) The subject of color is so complex that teachers of art might well find it profitable to read straightforward accounts of it in the principal fields outside their own, such as could be found in good text-books. For the physicist's approach see Arthur C. Hardy and Fred H. Perrin, *The Principles of Optics,* New York, 1932 (more useful for art teachers, I think, than the later text by Monk), and for the psychologist's, Albert G. Bills, *General Experimental Psychology,* New York, 1934. The latter contains a good summary of the Ladd-Franklin

of the sector marked Green in Text Figure 1—unless special hues of blue and yellow were intended and specified. This is very near the center of the circle, indicating the result is nearly neutral or grey. The ordinary names, "blue" and "yellow," could also refer to exact complementaries, resulting in a pure grey in that case.

To return to the situation in a painting of the Impressionist style, a moment's thought will show that in the case of touches of color set down side by side any mixture that occurred would be a predominantly additive mixture, that is the addition of the differently colored beams of light coming to the eye from the differently colored spots on the canvas (assuming that beams from differently colored spots fell simultaneously or in rapid enough succession on the same effective point of the retina). Therefore to obtain a green of any strength in this way would be impossible. Demonstration samples can easily be made if one wishes to approximate the conditions of a painting more closely than do the psychologist's disks. I have prepared such a sample in oil pigments, using regular spots of cobalt blue and cadmium yellow. (Monet, in a letter to Durand-Ruel of June 3, 1905, said that his colors were: cobalt blue, cadmium yellow, vermilion, deep madder (*garance*), emerald green, and white.) The areas are thus equal, which allows the yellow the greater weight; when spun the result is a rather dirty grey, faintly green-yellow. No one would call it green, yet the mixture of equal amounts of the same pigments on the palette produces a brilliant intense green by comparison. The result without spinning, when one retires to a sufficiently great distance, is apparently similar, although the exact effect is more difficult to see and judge.[4]

This error as to blue and yellow is sufficiently persistent and typical to justify this perhaps overlong discussion of it. In concluding it we may notice a statement which has perhaps influenced the texts quoted above and in which the process of the confusion can be rather clearly observed:

> Physicists have taught us that a ray of sunshine, passing through a prism, is decomposed into three pure colors, yellow, red and blue, which mingle at their confines and form three composite colors, violet, green, and orange. . . .

theory of the color sense. The modern physicist's diagram will unfortunately seem excessively abstract and mathematical to those in the field of art; the older diagram, as presented by Christine Ladd-Franklin, *Colour and Colour Theories*, New York, 1928, would offer the most vivid mnemonic device for the facts of color, but is discarded here as it is associated with the pure light-mixtures of the physicist, which do not occur in painting since a spot of the purest pigment reflects light of a number of hues. The most important coming event in the study of color will doubtless be the publication of the report on color now in preparation by the Colorimetry Committee of the Optical Society. Parts of the report have been published, and it gives promise of being a comprehensive and integrated presentation of the subject. Teachers of art interested in presenting color in relation to the modern body of knowledge on the subject should watch for the final publication of this report, more particularly as it is expected to contain an extensive introductory chapter, couched in less technical terms, which should increase the value of the report for a wider circle of readers.

4 A published demonstration in color, using small spots, ultramarine blue and zinc yellow in color, is found in a publication of the Munsell Color Laboratory, *Color News*, 1, No. 3 (September 1924), pp. 11 ff., and figs. 25–30; curves showing the luminous reflectances of the colors are given, and the text constitutes an unusually clear explanation of the

[The] method of the Impressionists consists in replacing that light, the splendour of which the painter cannot directly reproduce, by its constituent colors, the equivalents of which he has on his palette. . . . These colors cannot reproduce light unless they are combined, like the colors of the prism. The Impressionist painter leaves this process to the spectator; the eye reverses the process of the prism; it recomposes what the painter has decomposed.[5]

Here the confusion can be seen as it arises from the assumption that red, blue, and yellow, familiar as the artist's pigment-primaries, must be also the physicist's primaries for mixtures of light. (Physicists are far from teaching us this; in particular, green is just as "pure" a color as red or blue, and is, for them, a primary.) This confusion as to primaries leads easily to the further incorrect assumption that separate blue and yellow touches would fuse into green. A third incorrect assumption then follows, that the colored lights reflected from pigments will be as pure and brilliant as those issuing from a prism. A final assumption completes the theory, that the eye in viewing a painting accomplishes the same work as a prism —which requires further discussion and we shall return to it later. This pleasant theory explains the original appearance of the mistaken belief about mixtures of blue and yellow. The continual reappearance of this error is doubtless due as much to superficial observation of the pictures as to incomplete knowledge of the facts of color, since the pictures never confirm it. . . .

. . . Since retinal fusion is theoretically quite possible, even in painting, it cannot be disposed of so categorically as the belief in green-from-touches-of-blue-and-yellow. However, I think the notion that it exists as an effective means in painting has been greatly exaggerated, and I wish now to add some observations on retinal fusion.

. . . As all students know, and as even the vast public which today flows in and out of museums is aware, the Neo-Impressionists were more systematic or "scientific" in their procedures, and this special version of Impressionism should therefore offer a more favorable opportunity for utilizing retinal fusion.

It is perhaps worth emphasizing that this is not a question to be decided out of hand, by an appeal either to correct color-theory or even to the beliefs of the artists themselves. As to the first, retinal fusion is indeed a possible phenomenon; colors can be mixed in this way, so that a resultant color is produced from the spots of divided color, more especially *if the separate spots are sufficiently small.* An example is regularly found in the color-film *Dufaycolor,* which reproduces colors by additive mixture of light from small specks of three primary colors.[6] But it is important

facts involved, which result in a dark grey from the fusion of these colors. The sample published in an article on color in *Life,* July 3, 1944, p. 49, produces a lighter grey but uses very weak colors to do so, so that the demonstration is perhaps not very impressive.

[5] Louis Hourticq, *Art in France* [*Ars Una*], London, 1911, p. 402. Another often used text, Edith R. Abbott, *The Great Painters,* New York, 1927, pp. 396–97, repeats this statement in part.

[6] The three colors are of course additive primaries (red, green, and a purplish blue), not the subtractive primaries (yellow, magenta, and cyan blue). *Kodachrome* film works with the latter primaries using subtractive mixing. For explanation and color diagrams for

to note the size of these specks of color. They are not perceptible in the proper functioning of the process (as in the similar case of a printed illustration from a good half-tone screen), and it is only with a considerable degree of magnification that they can be separately seen. Here, then, is a real case of fusion; but painting differs markedly in that the separate spots are usually quite perceptible. In the color-film, color division is a scientific technique which actually produces resultant colors for the eye; but it is clear that it plays its part below the threshold of perception (and attention). Therefore, although "retinal" fusion is indeed among the phenomena possible in the visual world, the example of the color-film should prevent our concluding that it can operate effectively in any painting in which the touches are large enough to be present to perception and attention, and in which therefore the touches inevitably become a means of artistic effects (that is, they cannot escape serving other ends than the mechanical production of resultant colors by fusion).

As to the second point, that of the beliefs of the artists concerned, it is true that the representatives of the more systematic technique of Neo-Impressionism gave retinal fusion a place in their statements of their theory and method.[7] It would seem therefore that they believed it actually took place in their painting; that, as Signac put it, the touches, viewed at the proper distance, "reconstituted the color"; that is, a resultant color appeared to the eye rather than the colors actually touched upon the canvas. Here we can only suggest the contrary, that this rarely if ever happens, and that the artists were adopting a theory which they thought afforded a basis for and a justification of their practice, rather than describing what actually takes place in the pictures in normal intelligent experience of them. In Signac's work, in particular, because of the size of the touches they do not fuse, except at an abnormal and extreme distance. . . .

As a final possibility, Seurat's painting, *Sunday Afternoon on the Grande Jatte* [Fig. 15] in the Art Institute of Chicago, would seem to offer most clearly the conditions necessary for retinal fusion. Representing in its viewpoint the most rigorous naturalistic Neo-Impressionism, it also makes use of very small touches of paint, and the picture is so large, really outside the class of easel-paintings, that the normal viewing distance is unusually great. I find that I tend to take a position twelve to fourteen feet away for general viewing, and, despite the interesting information one may seek from distant views, one instinctively recognizes them as extreme and feels

the two processes see Julian E. Mack and Miles J. Martin, *The Photographic Process,* New York, 1939, pp. 372-73. Here, as often, the field of photography offers interesting comparative material for questions of art.

7 See Pissarro's letter to Durand-Ruel of November 6, 1886 (in Lionello Venturi, *Les Archives de l'Impressionnisme,* Paris and New York, 1939) and occasional remarks in his *Letters to His Son Lucien,* edited by John Rewald, New York, 1943, which also contains (p. 64) an English translation of the essential part of the above letter; Seurat's letter to Maurice Beaubourg published in facsimile by Robert Rey, *La peinture française à la fin du XIXᵉ siècle: La renaissance du sentiment classique,* Paris, n.d. [1931], and republished, with an English translation, by John Rewald, *Georges Seurat,* New York, 1943, pp. 60–62; and Paul Signac's *D'Eugène Delacroix au Néo-Impressionnisme,* Paris, 1921 (a reprinting of the text originally published in 1899), pp. 74–75 and elsewhere.

the need of returning within this "normal" distance. The size of the average strokes of pigment is slightly over one-eighth inch in width and varying slightly in length. The smallest touches, however, are roughly equivalent to a dot one-sixteenth inch in diameter. At the "normal" distance, for my eye and in a fairly well-lighted gallery, these smallest dots fuse, or at least disappear. But the dots of average size, as well as the larger ones, do not fuse, and we must conclude that retinal fusion, even in this painting, can at most be considered of only very limited importance. . . .

Thus it is not surprising that in the *Grande Jatte,* contrary to what the text-books would imply, the dominant color of the chief areas is obtained by pigment of that hue. Where fusion takes place it does not usually result in the creation of an important color of the picture. A special case, which I think is typical of the general situation, occurs when small dots of one color are found in an area of another. For instance orange dots are scattered sparsely over the green foreground, in the center, near the beginning of the sun-lit area. Whatever the artist's reason for putting them here, we may simply ask what their effect is. From a close view we see them as orange dots which enliven and give warmth to the area; they do not fuse. When one retires to a short distance they are no longer perceptible, but I believe we should simply say that they disappear, for they seem to have no effect on the area; they have merely dropped out. Since it is difficult to show in the picture itself what the effect would be if the orange dots were not present, I have prepared a sample of two emerald green areas, over one of which some reddish orange dots are scattered, but not over the other. When one retires to a distance at which one cannot see the dots separately the two areas have no perceptible difference. In such a case one must either view the picture at close enough range to see these dots, in which case there is no fusion; or one must retire to a distance at which "fusion" takes place, in which case they have no effect. . . .

In general, then, the color of areas of light in the *Grande Jatte* is given by pigment of the appropriate hue applied directly to the canvas and seen for that hue, as for instance in the green or the yellow green of the grass or the dark purple of the lady's dress at the right. Over this color are small touches of other colors, but unless there is some balance as to relative area it is chiefly the "ground" color that appears from a distance, as in the grass. In other areas there is an equal balance of spots and they in most cases are seen as separate, as in ordinary Impressionist painting. There are a few areas in which there is perhaps an important resultant color from fusion; for instance along the right (shaded) side of the central woman's skirt where there are approximately equal amounts of a red and a blue, perhaps producing a purple; or in the shadow on the ground under her dress. Incidentally, it is just in these two areas that, to my sensibility, the grating of the machinery becomes noticeable. I cannot help noticing, too, that the painting is more colorful from nearby than at the abnormal distance required for fusion in more important areas, such as the dress of the woman with the monkey. I take it that this is chiefly because additive (optical) mixtures are greyer than their constituent colors; being represented by straight lines across the color-circle, they thus lie nearer the center, representing a neutralizing or greying of the constituents. This

fact is often overlooked, as when it is said that Seurat used touches of green and violet to avoid the grey of palette-mixtures; for the additive mixture of these colors would produce a good deal of grey, being indicated in Text Figure 1 along a line running from about the center of the sector marked Green to some point in the P-B half of the sector marked Purple. If the end is to avoid grey, retinal fusion is thus not the means, and perhaps it is the avoidance of black rather than grey that is meant in such statements, since pigment mixtures of these colors would be quite dark.

If the size of the dots and the normal viewing distance prevent fusion in most of this picture, the only other basis for supposing it to be effective would be the phenomenon of the persistence of retinal sensations, which, for example, causes a burning coal on the end of a stick swung rapidly to appear to be a circle of fire. Seurat seems to have placed this phenomenon at the head of his ideas on technique, beginning that section in his letter to Beaubourg referred to above with the statement, "The persistence of retinal sensations being given." But it seems to me very questionable to assume that this phenomena will function satisfactorily in experiencing paintings. In particular, it seems to me that Seurat and others who have accepted the idea have overlooked the factors of context, purpose, and attention present in the situation of looking at a picture. It is true that sensations persist slightly on the retina and that this fact can be utilized in certain human purposes, as in the mixing of colors on the Maxwell disks or in producing movement in figures of a picture projected on a screen, in motion pictures. Here the context is one of expecting to see the transformation that takes place, the attention is orientated toward perceiving this effect, and the succession of stimuli is so fast as to leave no choice. But in viewing a painting the attention is not directed toward causing the fusion of dots which are separately perceptible when looked at steadily; it is orientated toward seeing the picture thoroughly, broadly at one moment, in detail at another, and the result is naturally to perceive, in so far as we can, what the painter has done on the canvas. Effective fusion from the persistence of retinal sensations would require movement of the eyes so that streams of light from two differently colored sets of dots would fall upon the same points of the retina in rapid succession, together with a set of the attention toward perceiving the resultant mixtures. The eyes can easily move that fast, but the attention, it seems to me, certainly blots out the intervening dots as the eye moves from one point of a picture to another; perhaps the colors of intervening spots enter the eye, but they can hardly constitute what we "see," and what happens in the course of the jumps which the eye makes can have no importance comparable to what is perceived in the moments of rest during which we take in the picture. In experiencing art the eye is merely an instrument in the service of conscious experience, and explanations which are based on its mere physical functioning (or, as sometimes is the case, on supposed defects of the eye) tend necessarily to be misleading if not fallacious. The idea that fusion in painting can be based on the persistence of retinal sensations is, therefore, not scientific, but pseudo-scientific, that is, an idea adopted from the findings of science but without sufficient

discrimination as to its relevance to the new situation in which it is to be used. . . .

Returning then to Impressionism in general, retinal fusion seems to have no place in it, but that does not mean that divided color is useless. It is important in that it allows a color, no matter how contrasting, to be introduced into an area of another color while still maintaining its own hue. Retinal fusion, as well as pigment mixing, would defeat this end. Thus the divided color is not a means to resultant colors; it is a means for recording colors in intimate association, in interpenetration, as it were, within a given area, while allowing each to be seen for what it is. This is a natural means to colorfulness of the picture, granted the naturalistic interest in light. In the Neo-Impressionist work the smallness of the touch allows more precise drawing of objects and a more careful "dosage" of the amounts of the respective colors; therein lies its value rather than in allowing a closer approach to retinal fusion.

Second, it is possible that in some paintings, though perhaps not so often in those we today call Impressionist, something in the way of a "delusive blend" of colors takes place, in which a few touches of color in an area seem to give a tinge of that color to the whole area.[8] This is probably due to processes of attention rather than to retinal fusion.

Third, it is possible that the concept of "luster," as used by Roland Rood, is pertinent here. This refers to a flickering or shimmering effect which one may be conscious of when two areas or sets of spots are presented to the attention simultaneously. An example affording a parallel to ordinary Impressionist painting would be that of small waves dancing in the sun on a moderately distant body of water, resulting in an apparent increase in active luminosity. This effect must, by the way, be distinguished from retinal fusion, and recalls rather the Talbot-Plateau Law,[9] which deals with the situation in which one experiences rapid repeats of a stimulus, say a light which flashes intermittently. When the repeats are only so fast as to cause the light to appear to flicker, it appears brighter than when the speed is increased enough to cause fusion so that it appears steady. What has been said above about viewing a painting indicates that we should be skeptical about a literal application of the idea, but I think it possible that the presence to the attention of these contrasting touches constitutes a means of suggesting, in representation, though not of duplicating, some of nature's effects related to the psychologist's experiment. The expression of the vibrating quality of light, included in the summary of the Impressionistic technique above, may be due in part to this factor. The variety of the surface of the painting gives the impression that it is more colorful and luminous than the pigments actually are.

Finally, as regards the over-all effect of color in a given area, it

[8] See Roland Rood, *Color and Light in Painting*, ed. by George L. Stout, New York, 1941, pp. 112 ff. This book, by a son of the O. N. Rood noted above, although not prepared for publication by the author, who died in 1927, and perhaps for that reason obscure in spots, contains a great amount of empirical observation of effects of light and color.

[9] E. G. Bills, *General Experimental Psychology*, pp. 35–36.

seems to me that what takes place when touches of one color are intro-
duced into an area of another color, or when touches of two colors are
set side by side, is not retinal fusion, but rather a kind of mental (not
visual) averaging, for the area involved, of the colors or their values. That
is, if some touches of ultramarine are introduced into an area of yellow,
we see both sets of touches, but we apprehend the area as having so much
blue in it, or as being so much darker in this case. This is a process of the
mind rather than of the retina, and this explanation would thus locate
the phenomenon in the realm of conscious attention, rather than in the
realm of mere sensation, which seems to me preferable since the touches
are quite perceptible to the attention. Psychological studies show that the
set of the attention is very important in determining the experience one
gets from a complex area, and in viewing Impressionist paintings our
attention does not neglect the richness and variety of color in the indi-
vidual touches. If divided color has its effect through mental processes,
it means, however, that divisionism does not depend on the peculiarities
of color relations and would apply to black and white as well. In fact,
Seurat's crayon drawings seem to me not only to surpass, for sheer quality,
his paintings, but to demonstrate with equal force the essentials of his
technique; they consist, in effect, of tiny touches of black and white which
create wonderfully rich and luminous areas. Their darks furnish many a
"sable silvered," and that phrase could stand as symbol for the whole
principle involved. (According to the theory of retinal fusion, the elder
Hamlet's beard should be called nothing but grey, but I think that term
would be less correct; the poet's phrase more completely as well as more
vividly renders a concrete visual effect.) As regards the average tone of an
area made up of black and white strokes or dots, we say it is grey, but
the concrete visual reality is: a sable silvered, a silver sabled—or, for colors,
a green empurpled, and the like.

The summary of the Impressionist technique given above can
therefore stand as essentially correct; retinal fusion would deprive this
technique of most of its value. Due to its apparent basis in science the
idea has had a persistent life, but it obscures rather than illuminates what
happens in the pictures. The only value of the theory has been the curious
practical one of helping to quiet the conventional mind, offended at first
by the roughness and broken color, with its message of good cheer: that
science is at work here, and that one should go off to a distance. Comforted
by this thought, the average man can continue his inspection from near
at hand. The theory's value has thus lain only in accomplishing its own
contradiction. By telling people they should stand back, it encouraged them
to stay up close—as they should.

Fig. 1 (Above)
SEURAT:
The Forest at Pontaubert
(oil on canvas), 1881–82
(London, Collection, Sir Kenneth Clark)

Fig. 2 (Below)
SEURAT:
The Seamstress
(conté crayon), July 18, 1882
(Fogg Art Museum, Harvard University, Cambridge, Mass., Grenville L. Winthrop Bequest)

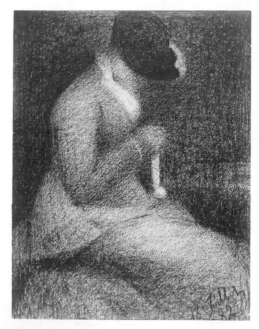

Fig. 3
SEURAT:
Place de la Concorde, Winter
(conté crayon and chalk), 1882–83
(The Solomon R. Guggenheim Museum, New York)

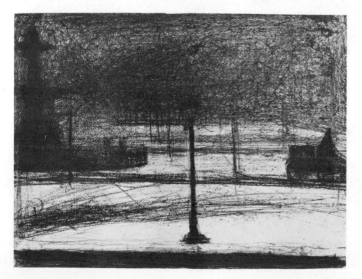

Fig. 4
SEURAT:
Man Dining (the Artist's Father)
(conté crayon), c. 1884
(Private collection)

Fig. 5
SEURAT:
Seated Boy with Straw Hat, Study for *Une Baignade*
(conté crayon), 1883–84
(Yale University Art Gallery, New Haven, Conn. Everett V. Meeks Fund)

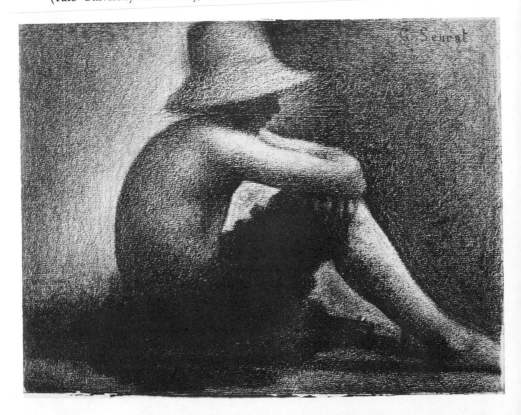

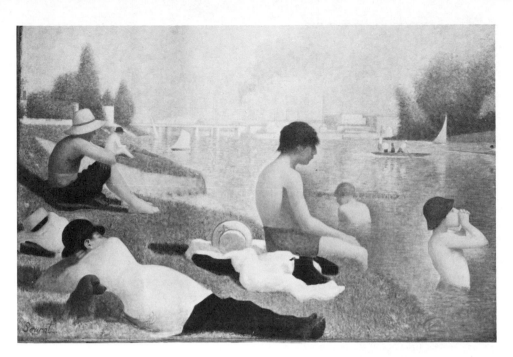

Fig. 6
SEURAT:
A Bathing Place, Asnières (Une Baignade, Asnières)
(oil on canvas), 1883–84
(National Gallery, London)
Reproduced by courtesy of the Trustees, The National Gallery

Fig. 7
SEURAT:
A Bathing Place. Asnières (detail), 1883–84
(National Gallery, London)
Reproduced by courtesy of the Trustees, The National Gallery

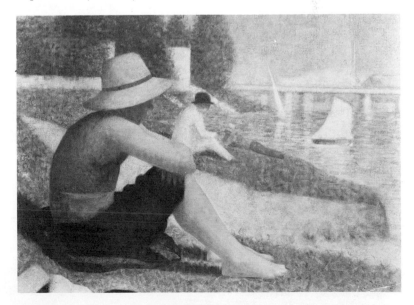

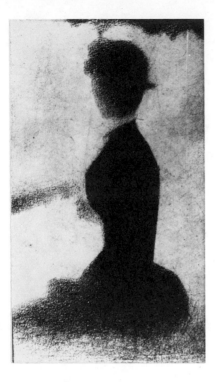

Fig. 8
SEURAT:
Woman Seated, Umbrella Raised, Study for the
Grande Jatte
(conté crayon), 1884–85
(Paris, Collection, A. Dunoyer de Segonzac)
Photograph, courtesy Galerie Charpentier, Paris

Fig. 9
SEURAT:
Three Women, Study for the *Grande Jatte*
(conté crayon), 1884–85
(Smith College Museum of Art, Northampton, Mass.)

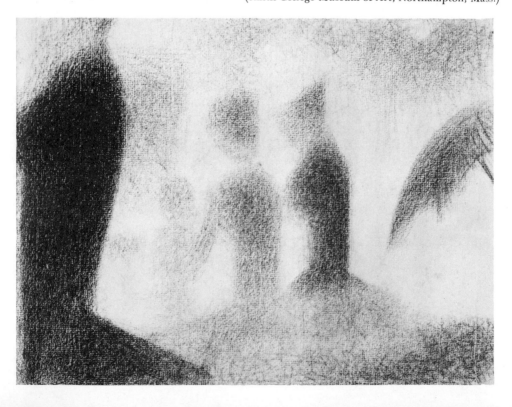

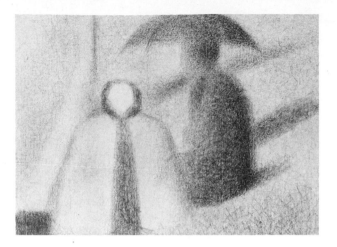

Fig. 10
SEURAT:
The Nurse, Study for the *Grande Jatte*
(conté crayon), 1884–85
(Albright-Knox Art Gallery, Buffalo, N.Y.
Gift of A. Conger Goodyear)

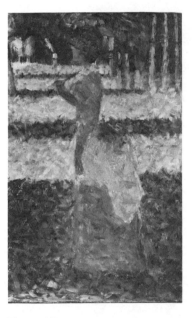

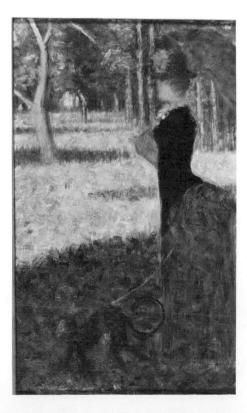

Fig. 11 (Above)
SEURAT:
Woman with Parasol,
Study for the *Grande Jatte*
(oil on wood), 1884–85
(Zurich, Private collection)

Fig. 12
SEURAT:
Woman with a Monkey,
Study for the *Grande Jatte*
(oil on wood), 1884–85
(Smith College Museum of Art,
Northampton, Mass.)

Fig. 13
SEURAT:
Island of La Grande Jatte
(oil on canvas), 1884
(New York, Collection, Mr. and Mrs. John Hay Whitney)
Photograph, courtesy Paul Rosenberg & Co.

Fig. 14
SEURAT:
Final Study of the *Grande Jatte*
(oil on canvas), 1884–85
(Metropolitan Museum of Art, New York. Bequest of Samuel A. Lewisohn, 1951)

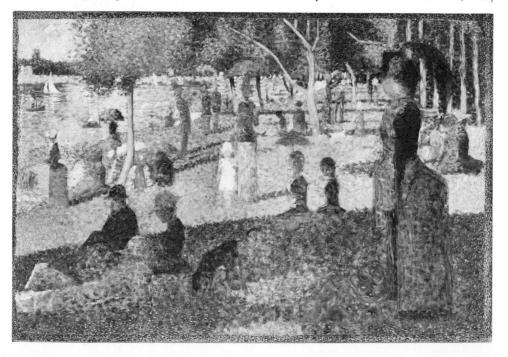

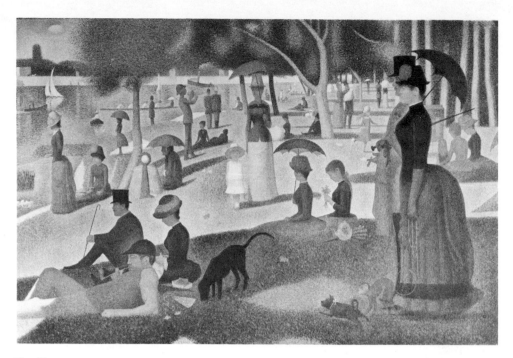

Fig. 15

SEURAT:

A Summer Sunday on the Island of La Grande Jatte
(Un Dimanche d'été à l'Ile de la Grande Jatte)
(oil on canvas), 1884–86
(The Art Institute of Chicago, Helen Birch Bartlett Memorial Collection)
Courtesy of The Art Institute of Chicago

Fig. 16

SEURAT:

The Bridge at Courbevoie
(oil on canvas), 1886–87
(Courtauld Institute Galleries, London)
Photograph, courtesy The Home House Trustees

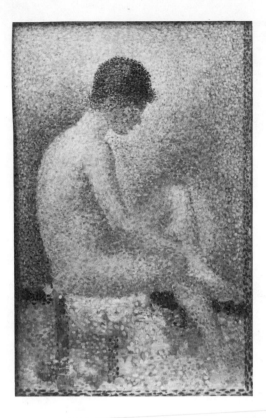

Fig. 17
SEURAT:
Seated Model in Profile,
Study for *Les Poseuses*
(oil on wood), 1886–87
(Louvre, Paris)
Photograph, courtesy Archives
photographiques

Fig. 18
SEURAT:
Standing Model,
Study for *Les Poseuses*
(oil on wood), 1886–87
(retouched in 1890)
(Louvre, Paris)
Photograph, courtesy Archives
photographiques

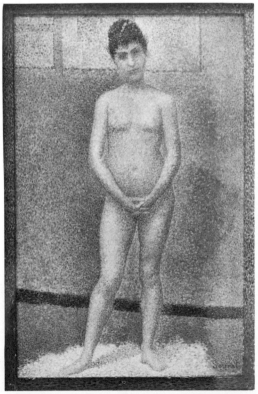

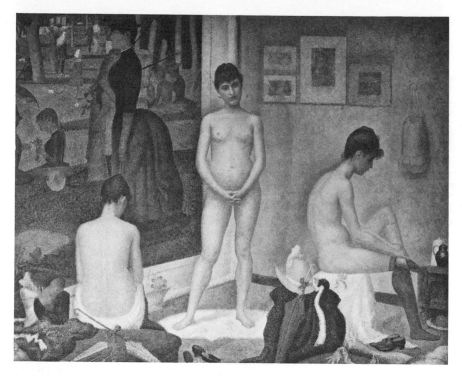

Fig. 19
SEURAT:
The Models (Les Poseuses)
(oil on canvas), 1886–88
(The Barnes Foundation, Merion Station, Pa.)
Photograph Copyright 1978 by The Barnes Foundation

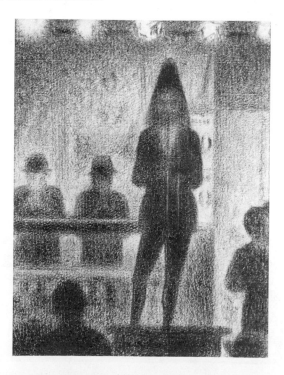

Fig. 20
SEURAT:
Trombone Player,
Study for *La Parade*
(conté crayon), 1887–88
(Philadelphia, Collection,
Henry P. McIlhenny)

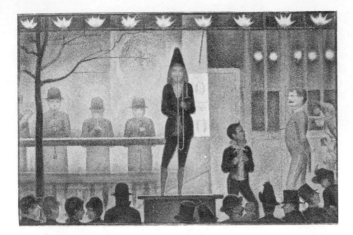

Fig. 21
SEURAT:
Invitation to the Side Show (La Parade)
(oil on canvas), 1887–88
(Metropolitan Museum of Art, New York. Bequest of Stephen C. Clark, 1960)

Fig. 22
SEURAT:
Seascape at Port-en-Bessin,
Normandy (Les Grues et la Percée)
(oil on canvas), 1888
(National Gallery of Art,
Washington, D.C.
Gift of the W. Averell Harriman
Foundation in memory of
Marie N. Harriman)

Fig. 23
SEURAT:
Sunday at Port-en-Bessin
(oil on canvas), 1888
(Rijksmuseum Kröller-Müller,
Otterlo, the Netherlands)

Fig. 24
SEURAT:
The Eiffel Tower
(oil on wood), 1889
(New York, Collection, Mr. and Mrs.
Germain Seligman)

Fig. 25
SEURAT:
Young Woman Powdering Herself
(Madeleine Knobloch)
(oil on canvas), 1889–90
(Courtauld Institute Galleries, London)
Photograph, courtesy The Home House Trustees

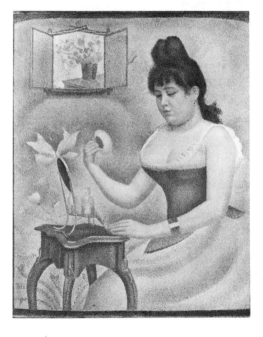

Fig. 26
SEURAT:
L'Homme à Femmes
(pen drawing on paper,
design for a book cover), 1889
Basel, Collection, Robert von Hirsch

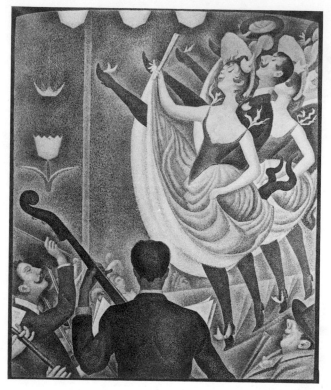

Fig. 27
SEURAT:
Le Chahut
(oil on canvas), 1889–90
(Rijksmuseum Kröller-Müller,
Otterlo, the Netherlands)

Fig. 28
SEURAT:
Le Chahut
(As analyzed by
Robert Rey)

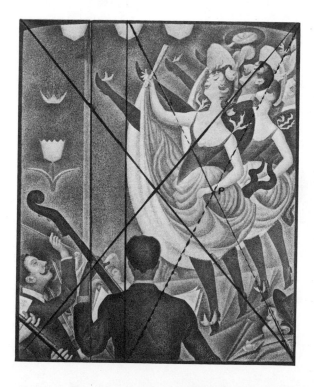

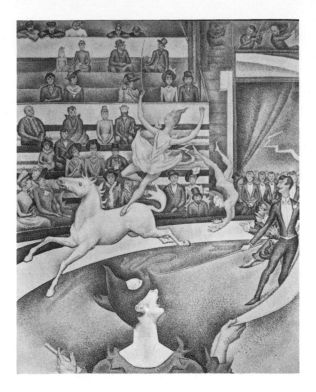

Fig. 29
SEURAT:
The Circus (Le Cirque)
(oil on canvas), 1890–91
(Louvre, Paris)
Photograph, courtesy
Archives photographiques

Fig. 30
SEURAT:
The Circus
(Compositional network)
Photograph, courtesy
Henri Dorra

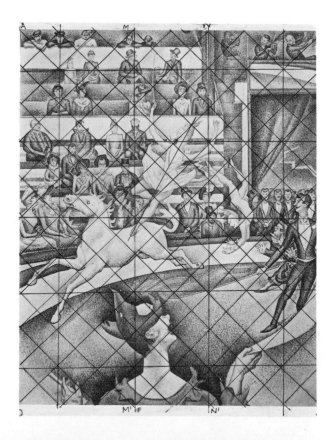

Fig. 31
WORMS:
The Bachelor (detail [2 x 1½″] of
facsimile in chromotypogravure)
(From *L'Illustration,* December 5,
 1885)

Fig. 32
JULES CHÉRET:
Folies Bergère, Les Girard, 1877
(Bibliothèque Nationale, Paris)
© by S.P.A.D.E.M., Paris, 1978

Fig. 33
JULES CHÉRET:
L'Amant des Danseuses, 1888
(Bibliothèque Nationale, Paris)
© by S.P.A.D.E.M., Paris, 1978

Fig. 34
JULES CHÉRET:
Title page for A. Sylvestre, F. Thomé,
and Chéret, *La fée au rocher,* Paris, n.d.
© by S.P.A.D.E.M., Paris, 1978

Fig. 35
JULES CHÉRET:
Spectacle-Promenade de l'Horloge (detail), ca, 1880
(From E. Maindron,
Les affiches illustrées,
Paris, 1886, p. 122)

Fig. 37
JULES CHÉRET:
Hippodrome, 1884
(Bibliothèque Nationale, Paris)
© by S.P.A.D.E.M., Paris, 1978

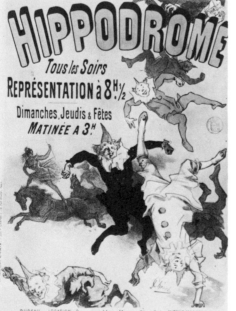

Fig. 36
JULES CHÉRET:
L'Horloge, Les Frères Léopold, 1877
(Bibliothèque Nationale, Paris)
© by S.P.A.D.E.M., Paris, 1978

ARTISTS' QUARRELS[*] (INCLUDING LETTERS BY PISSARRO, SIGNAC, SEURAT, AND HAYET, 1887-1890) [1948]

John Rewald

Seurat's bitterness toward the "old" Impressionists was great. He resented the impertinence of Degas and the coldness of Monet. He was irritated especially by the fact that Gauguin and Guillaumin treated him with a certain condescension, for he could see in them only more or less skillful imitators of the real Impressionists. Pissarro remained the only one of the "old school" to join with the scientific Impressionists, and his efforts to rally his students Gauguin and Guillaumin to the new cause were in vain. . . .

Seurat himself grew weary of seeing each of his works become the center of discussions that quickly deteriorated into an exchange of reproaches and suspicions, arguments running aground in seas of prejudice or complacency. On the other hand, he watched, not without concern, as the camp of his friends and followers swelled with new converts, and he observed, not without regrets, the efforts made by these new recruits to appropriate his theories and techniques for themselves. When he wanted

John Rewald, "Querelles d'Artistes," *Georges Seurat* (Paris: Éditions Albin Michel, 1948), pp. 111–16. This excerpt, pp. 112–16, includes material not available to Mr. Rewald for the earlier, American editions of his book in 1943 and 1946. The chapter in question appears only in the 1948 French edition and has never been translated in its entirety, although some of the documents have appeared in English in Rewald's *Post-Impressionism, from van Gogh to Gauguin*, New York, 1956, 1962, pp. 112, 114. A substantial portion of the chapter is presented here, in the editor's translation, by permission of John Rewald.

John Rewald (1912–) Art historian, educated in Germany and at the Sorbonne; Professor of Art History at the Graduate Center of the City University of New York; former Professor of Art History at the University of Chicago. He has gathered the basic facts and documents for the study of late 19th-century French painting. His pioneering and still indispensable works include *The History of Impressionism* (1946) and *Post-Impressionism from van Gogh to Gauguin* (1956). He is also the author of a series of authoritative biographical monographs on Seurat (1943, 1946, 1948) and co-author of a *catalogue raisonné* of Seurat's paintings.

* All of the documents quoted in this chapter are unpublished and have been provided by Mme. Charles Cachin-Signac and M. Rodo Pissarro. [Author's note]

to go so far as to stop exhibiting his work so that no one could copy him, Pissarro wrote to his son Lucien in February of 1887: "He is so cautious. But we, or rather I, can see no disadvantages in it, since I consider nothing *secret* in painting beyond the artist's own artistic personality which is not easily swiped! ! !"

The question of caution naturally became an even more delicate one when it involved explaining the new theory to friendly critics, to whom Seurat sometimes opposed complete silence. In April of 1887, Pissarro wrote to Signac:

> I was a bit embarrassed by M. Félix Fénéon's request for information on our working methods and analyses of color. It isn't easy—on the one hand, not wanting to draw the curtain of mystery too far aside, and, on the other, not being able to refuse M. Fénéon, who has been such a friend to us. I wanted to say only what the public could understand. I was terribly inadequate. . . What I regret most is the advice I gave him to generalize as much as possible about the artist's personality, except for one thing that I thought it necessary to emphasize—and that was not to fail to give first place to Seurat as the initiator of the scientific movement.

. . . In all of his letters and actions, there is apparent Pissarro's almost touching desire to avoid offending Seurat. Thus, on the 16th of June, 1887, he wrote to Signac:

> Yesterday I visited Seurat's studio. His large canvas [the *Poseuses*] is coming along. It is already charming in its harmony. It is clearly going to be a very beautiful thing, but what will be most surprising is the execution of the frame. I have seen a beginning of it. It is indispensable, inevitable, my dear Signac. We will be forced to do likewise. The painting is just not the same with white or anything else around it. By means of this indispensable complement can be conveyed the idea of sunshine or cloudiness. I, for my part, am going to try it; but I will not exhibit it, you understand, until after our friend Seurat has established the priority of his idea, which is only fair!

But despite all of these precautions, Seurat's sensitivity was never entirely appeased. He knew well enough how to keep silent when necessary, but he forgot nothing . . . His friends, well aware of his touchiness, ended almost by fearing him; for even the most well-intentioned among them could not always avoid awkward incidents. In 1886, for example, a journalist had said of Seurat that he was "a new-comer, a student of Pissarro," and the young painter had never been able to pardon this comment, even though he well knew that Pissarro had had nothing to do with it. After that he set himself to demonstrate to the art critics in his circle that it was *he* who had been followed by Pissarro, a fact the older artist had always readily confirmed. But the results of this campaign soon exceeded its original aim.

On August 13, 1888, Arsène Alexandre published an article on the movement in his journal *Paris,* concluding that a bit of science is not injurious to art but that too much may be. Having thus formulated his reservations, Alexandre stated:

The artists who use the small touch of pigment are full of convictions, and several have great talent. It is sufficient, for example, to cite Pissarro *père*, who rallied to the new school and still manages to do fine things; or, better still, Seurat, the true apostle of the lentil, he who has planted it and watched it grow, Seurat, that man of prodigious efforts, who almost sees his paternity of the theory contested by misinformed critics and unscrupulous comrades.

Signac naturally became indignant over this last phrase, which, as he wrote to Pissarro, "questions our honesty and which I cannot let pass. I am writing to Seurat to ask if it was he who suggested this phrase to Arsène. I expect a *frank* reply. In any case, you will admit that if Seurat had not been crying on Arsène's shoulder, that man would have known nothing of our excellent comrade's petty jealousies."

Seurat's reply was not long in coming. It is dated Sunday, August 26, 1888:

> My dear Signac,
>
> I am acquainted only with the phrase of that article quoted in your letter. Had M. Alexandre told me: "I am going to write that," I would have replied: but you are going to offend either Signac or Pissarro or Angrand or Dubois. I do not wish to offend anyone. I have told him nothing but what I have always thought: the more of us there are, the less originality we will have, and the day when everyone practices this technique, it will no longer have any value and people will look for something new as is already happening.
>
> It is my right to think this and to say it, since I paint in this way only to find a new approach which is my own.
>
> That is all I may have told him. As for the beginning of the phrase, that must refer to an article in *Le Matin* in which I was treated as Pissarro's student . . . Now I do not admit to that, since it is false. I must have indicated that to him.
>
> This is a regrettable business for which I am not responsible. M. Alexandre came to me more than a year ago. I exhibited with you in a special room, which I would certainly not have done had I the thoughts about my *comrades* that you attribute to me.
>
> I look not at personalities, but at facts.
>
> Cordially, SEURAT

In the margin of the letter, these words appear: "Anyway, I do not talk much." To this is added, on a little scrap of paper: "I have (1) never called anyone 'unscrupulous comrade.' (2) I still consider Fénéon's pamphlet [1] as the exposition of my ideas on painting."

Seurat's explanations did not immediately succeed in calming Signac's indignation, but Pissarro judged the incident more philosophically:

> Really, if Seurat is the instigator of the article you describe, then I would have to believe that he has lost his head . . . Was it not enough to have taken the greatest precautions from the very first, telling Fénéon, Durand-

[1] *Les impressionnistes en 1886.* For excerpts, see "From *The Impressionists in 1886*," by Félix Fénéon in this volume. [Editor's note]

Ruel,[2] and everyone concerned with the new painting that to Seurat belonged the glory for having been the first in France to have the idea of applying science to painting? Today he wants to be the sole proprietor! . . . It's absurd! . . . But, my dear Signac, we should give Seurat a patentholder's title, if that will flatter his vanity . . . In short, all of art is not contained in scientific theory. If Seurat had only that, I tell you that he would interest me only moderately. Cannot one create masterpieces with black and white alone? And you, my dear Signac, do you believe that this is the whole foundation of your talent? Fortunately, no

This is disturbing though from another point of view. For the future of our "Impressionist" art, it is essential that we keep absolutely aloof of Seurat's École [des Beaux-Arts] influence. You yourself have foreseen it. *Seurat is of the École des Beaux-Arts,* he is impregnated with it . . . Let us take care then for there is the danger. This is not a question of technique or science, it is a question of our tradition; we must safeguard it.

Make use then of the science that belongs to everyone, but retain your gift to perceive as an *artist of a free race,* and leave Seurat to resolve problems that will have their evident utility. That will be his lot. But to create is something higher. . . .

These disputes and grudges were nevertheless quickly forgotten by the friends as soon as Seurat showed them his new works. If they were sometimes wounded by the manners of the man, they remained faithful to their admiration for the artist. Pissarro and Signac in particular could always regain, before Seurat's canvases, their respect for the man whose unyielding rigidity perhaps concealed a singular timidity, which manifested itself as vanity. They forgave, or better still, they understood, and could not deny Seurat their affection for very long. But other members of the little Neo-Impressionist group could not always rise above questions of self-esteem. While they struggled with the rigors of Seurat's method, they suffered from the scorn that Seurat felt for those who followed him without making an original contribution. Thus, instead of being sustained by his advice, in the end they felt themselves surrounded by a hardly veiled hostility. It was thus that Hayet,[3] the young friend of Lucien Pissarro, wrote early in 1890 to Signac:

When I found myself becoming involved with the [Neo-]Impressionist movement, I thought I saw there a group of intelligent beings, assisting each other mutually in their research, with no other ambition: pure art, and I believed in that for five years. But then one day, the slights got the best of me and made me think. I thought about the past and about this group that I had taken for a select group of seekers. I had seen it divided into two camps, one seeking, the other debating and sowing discord (perhaps unintentionally), with but one goal in mind, the steeplechase . . . And these reflections made

2 For Pissarro's letter of 6 November 1886 to his dealer, Durand-Ruel, see Lionello Venturi, *Les Archives de l'Impressionnisme,* 2 (Paris–New York: Durand-Ruel Éditeurs, 1939), II, 24–25. [Editor's note]

3 Louis Hayet (1864–1940). For examples of his work and further bibliography, see Robert L. Herbert, *Neo-Impressionism* (New York: The Solomon R. Guggenheim Museum, 1968), pp. 61–65. [Editor's note]

me lose all confidence. Unable to live in doubt and unwilling to suffer eternal torment, I decided to isolate myself. . . .

In the midst of these quarrels, controversies, and misunderstandings, Seurat seemed unshakable. But although he refused to modify his attitude, he nevertheless came to understand that it was his duty to formulate his ideas clearly. Pissarro was right, there are no secrets in art; it would be best if he himself were to provide the necessary clarifications, establishing once and for all his uncontestable priority. Thus, in the summer of 1890, after reflecting at great length and drawing up several drafts, Seurat finally put down on paper the principles of his esthetic.[4]

4 See Seurat's letter to Maurice Beaubourg, 28 August 1890, which is translated in Part One of this volume. [Editor's note]

PIERO DELLA FRANCESCA - SEURAT - GRIS (1953)

Lionello Venturi

The director of the National Gallery in London told me recently that the most popular pictures in his museum are Piero della Francesca's *Baptism of Christ* and *Nativity,* and it is common knowledge that art-lovers sensitive to the present trends of taste nowadays go to Arezzo to see the frescoes in the Church of St. Francis rather than to Rome for the sake of Raphael's Loggias or Michelangelo's ceiling of the Sistine Chapel. . . .

It should be realised, however, that the critics are not responsible for the enthusiastic public interest in Piero today, or, where they are, only to a very limited extent. The interest of art-lovers in Arezzo is attributable to the passion for the abstract which has possessed the greatest artists throughout the world in their work during the last seventy years.

Mr. Berenson considers Cézanne the cause of this development, but I do not think he is right. The Italian primitives who came back into favour with the contemporary public as a result of Cézanne's influence were Giotto and Masaccio. There is very little abstraction in Cézanne, who is closely attached to life (*pace* the critics who still maintain the opposite view today).

Of the great painters of the late nineteenth century, Georges Seurat bears most resemblance to Piero della Francesca. "Painting is only a demonstration of surfaces and bodies with increasing or diminishing bounds." It is a demonstration of perspective, designed to give a scientific knowledge of the essence of natural objects apart from transient phenomena. The same applies to Seurat; the method he uses to achieve "the art of penetrating a surface" is thoroughly scientific. Seurat said on another occasion:

Lionello Venturi, "Piero della Francesca—Seurat—Gris," *Diogenes* (a quarterly publication of the International Council for Philosophy and Humanistic Studies), 2, Spring 1953, 19–23. These excerpts, pp. 19, 20, 21, 22, 23. By permission of the *Revue Diogene.*

Lionello Venturi (1885–1961) Italian art historian and noted author of books on both Renaissance and Modern painting. Publications include *Les Archives de l'Impressionnisme* (1939) and two important *catalogues raisonnés: Cézanne, son art, son œuvre* (1936) and *Pissa. ro. son art, son œuvre* (1939).

"Art is harmony. Harmony is the analogy of opposites, the analogy of counterparts of tone and colour and line." [1]

Neither Seurat nor Piero has said anything about his experience of nature, although each was intensely aware of it. Piero owes his experience to his immediate predecessors, the Florentine painters (above all, Masaccio) and the artists of Bruges (first and foremost, Jan van Eyck).[2] Seurat gained his from the Impressionists, particularly Pissarro. Both artists show the same double 'development in their work, moving, firstly, from the concrete to the abstract or from nature to harmony and, secondly, from the abstract to the concrete or from perspective geometry to the image. The art of both masters is a combination of these two trends.

Immobility, impassivity, impersonality, the view of the world *sub specie aeternitatis,* all follow from the double development to which I have referred; all our experience of the natural world is in fact moulded by the absolute, impassive, transcendency of geometrical form, and no harmony of line and colour, even though it be fixed for all eternity, is devoid of the vibrant quality of life.

The kinship between the two painters is not confined to the principles they followed, but also extends to their artistic qualities; their sense of stability and their love of absolute proportion, their passion for the monumental, the fine balance of light and colour, make their art similar in spite of the centuries which lie between them and their different environment.

Yet it was not Seurat who sent art-lovers flocking to Arezzo. It was Cubism. . . .

. . . we can see that same rigorous precision and objective detachment in Juan Gris. Mr. Kahnweiler tells us that, long after the painter's death, Picasso remarked, in speaking of one of Gris's pictures, "It's good to see a painter who knows what he's doing." Gris knew so well what he was doing that he was able to evolve a very clear theory.[3] "Painters have always worked inductively. They have given a pictorial representation of something proper to a specific reality; they have taken a picture from a subject. My method is just the opposite. It is deductive. The picture X comes to coincide with my picture. . . . Pictorial mathematics brings me to representative physics. The quality or dimensions of a form or a colour suggest to me the denomination or the adjective describing an object" (p. 278). "There is no doubt that a purely scientific discovery, which is merely capable of application to the technique of painting, like the Italian discovery of perspective, has influenced all aesthetics since the Renaissance" (p. 281). "The only methods which are constant in painting are those which are purely architectural. I would go so far as to say that the only possible technique in painting is a sort of architecture of colour on

[1] Cf. John Rewald, *Seurat* (Paris: Albin Michel, 1948). [Author's note]
[2] Cf. Piero della Francesca's treatise, *De Prospectiva Pingendi,* ed. G. Nicco Fasola (Florence, 1942); and *De Corporibus Regolaribus,* Memoria de G. Mancini (Rome: Accademia dei Lincei, 1915). [Author's note]
[3] Daniel-Henry Kahnweiler, *Juan Gris* (Paris: Gallimard, 1946). [Author's note]

one plane" (p. 282). "I am well aware that, at the outset, Cubism was a form of analysis, no more constituting painting than a description of physical phenomena constitutes physics. But now that all the elements of so-called Cubist aesthetics are judged by the technique of picture-painting, now that the analysis of yesterday has become a synthesis, by setting forth the relationships between the objects themselves, this reproach can no longer be levelled at it. Regarded as only an aspect of style, what was called Cubism is no more; regarded as a theory of art, it has become an integral part of painting" (p. 290).

In the view of Piero della Francesca, perspective was not a method of painting; it was an ideal, an artistic tenet, the prime source of all formal creation. His method was thus very similar in essence to that of Juan Gris, who has the modern man's awareness of the distinction between the empirical and the mathematical, the inductive and the deductive way of proceeding. Gris regards his own method as akin to the Italian use of perspective; in his opinion, the ideal is Cubist abstraction, proceeding from the mathematical to the physical. Admittedly, the ascendancy of the purely physical element is much less obvious in his work than in that of Piero or Seurat. The important thing is the ultimate destination, the result of creative activity—in this case, an *idealised architecture*. That is the common bond between Piero della Francesca, Georges Seurat, and Juan Gris.

SEURAT AND JULES CHÉRET (1958)

Robert L. Herbert

In the space of a few short years, Georges Seurat's style changed from the rather ponderous rhythms and heavy, opaque forms of the *Baignade* [Fig. 6] to the sprightly, light and transparent movements of the *Circus* [Fig. 29]. He had just turned twenty-four when the *Baignade* was completed in 1884 and was only thirty-one when he died, leaving the unfinished *Circus* as the last monument to his creative activity. In those seven years he moved rapidly away from his early style, an evolution that has been most thoroughly analyzed by Robert Goldwater.[1]

His new style was the result of a conscious search on his part, involving elaborate theories of linear directions, geometric proportions, and a modification of his earlier color theory.[2] Basing his researches largely on the work of his friend Charles Henry, a brilliant young mathematician and aesthetician, Seurat believed that certain emotions could be expressed by linear directions—gaiety by lines above the horizon, for example. In fact, gaiety and upward-swinging lines are the chief characteristics of the *Circus,* as opposed to the calm stolidity of the *Baignade*.

But an examination in detail of Seurat's new theories could not explain a change in style that involved a fundamental modification of his

Robert L. Herbert, "Seurat and Jules Chéret," *The Art Bulletin*, 40, 1958, 156–58. By permission of *The Art Bulletin* and Robert L. Herbert.

Robert L. Herbert (1929–) Professor of Art History at Yale University, he is an authority on Seurat and Neo-Impressionism. Major writings include *Seurat's Drawings* (1962), *Neo-Impressionism* (1968), *Barbizon Revisited* (1962), *David: Brutus* (1972), and *Jean-François Millet* (1975).

1 "Some Aspects of the Development of Seurat's Style," ART BULLETIN, 33, 1941, pp. 117–130. [This and all subsequent footnotes are the author's.]

2 John Rewald (in his *Post-Impressionism, from van Gogh to Gauguin*, New York, 1956, pp. 99f., 141 and *passim*) has indicated the influence on Seurat of Charles Henry's aesthetic theories. My unpublished thesis of 1954 was devoted to the same subject, but both of these studies have been supplemented by the discovery of a number of important documents clarifying Seurat's later theories. Permission to publish these manuscripts has not yet been obtained, although I hope to be able to include them in my forthcoming monograph.

whole outlook. Details of the *Circus* possess a wittiness, an element of sprightly caricature that would have been unthinkable for the Seurat of 1884.[3] If the earlier painting was beholden to the young painter's love of antique sculpture, Ingres, and Puvis de Chavannes, the linear arabesques of the *Circus* had their chief inspiration in the posters of Jules Chéret.[4]

An admiration for Chéret's colorful lithographs was quite logical in view of Seurat's early interest in popular art. One of his first drawings (Paris, collection Mme. Ginette Cachin-Signac) is a copy after or an imitation of a Cham-like caricature, and among his effects were found sixty *images populaires,* rather primitive colored broadsides of the mid-nineteenth century.[5] It is not surprising, therefore, to learn that he collected Chéret's posters and even induced his mother to obtain some.[6]

Seurat's friends were conscious of his debt to Chéret. Emile Verhaeren wrote that "The poster artist Chéret, whose genius he adored, charmed him by the joy and gaiety of his compositions. He studied them, hoping to decipher Chéret's expressive methods and to ferret out his aesthetic secrets."[7]

Jules Chéret was born in 1836, and at an early age began working in typography and printing. After a brief stay in England, where he did some monochrome posters, he returned to Paris and by the middle of the 1870's was using three colors in his lithographs and had developed a style

[3] Most writers interested in Seurat have noted the contrast between the lonely paintings of the Channel coast that he did each summer and the lively vaudeville scenes of his more ambitious winter canvases. To conclude that one or the other kind of painting represents the "true" Seurat ignores the complexity of his artistic personality. This note attempts only to show that some of his late works of urban theme, especially the *Circus,* are indebted to one particular artist and that their bubbling gaiety should serve as a caution against considering Seurat always a detached, impersonal observer.

[4] Rewald (*op. cit.,* p. 145, and *Georges Seurat,* Paris, 1948, pp. 99 and 134) has cited comparisons between Seurat and Chéret made by their contemporaries. The most important body of information on Chéret is in the Cabinet des Estampes, Bibliothèque Nationale, Paris, which has four volumes of newspaper and magazine clippings concerning Chéret, covering the years 1885–1937 and, thanks to the *dépôt légal,* original copies of most of his posters. These posters are accurately dated and prove that there are many errors in Ernest Maindron's two books, the most important published sources for Chéret's work: *Les affiches illustrées,* Paris, 1886, and another work of the same title published ten years later. The only modern study of importance is the excellent article by Robert Goldwater, "L'Affiche Moderne," *Gazette des Beaux-Arts,* ser. 6, 23, 1942, pp. 173–182. A study of unpublished posters shows that Chéret is a more original artist than Mr. Goldwater concludes.

[5] This important collection forms part of a large gathering of original drawings, clippings, and reproductions not known to previous students of Seurat, but as yet unavailable for publication.

[6] Information from unpublished correspondence between Seurat's common-law wife, Madeleine Knobloch, and Paul Signac. I am deeply indebted to Mme. Ginette Cachin-Signac for permission to consult Signac's very rich and important correspondence. Her friendship and her help made possible my work on Seurat.

[7] "Georges Seurat," *La société nouvelle,* 7, 1891, p. 434, cited by Rewald, *Georges Seurat,* Paris, 1948, p. 99. Five other articles briefly comparing the two artists appeared in the years 1889–1892, the most important being Verhaeren's "Chronique artistique: les XX," *La société nouvelle,* 7, 1891, pp. 248–254. One article even suggested that Chéret had profited from the work of Chevreul, Rood, and Seurat: Edmond Cousturier, "L'art aux murs," *L'endehors,* 2, 62, July 10, 1892, n. p.

that was often remarkably free and daring, as in *Folies-Bergère, Les Girard* of 1877 [Fig. 32]. Inspired in part by Japanese prints, Chéret's work foretold the style of Toulouse-Lautrec, Bonnard, and Art Nouveau, and preceded by a decade the incursion of English influences that were instrumental in the development of Art Nouveau in France. By the late 1880's he had reached the height of success, universally admired by critics, artists, and public, decorated by the government, and awarded an important one-man show.[8]

This was the very time when Seurat turned to Chéret. Concerned with the gaiety and sparkle of modern life in his later work, he could have found no better model. Chéret was a poet of bubbling imagination, who had at his fingertips a natural gift for bright color and movement. An effervescent *charmeur,* the very epitome of all that was graceful and joyful in modern life, he remains today one of the best interpreters of Paris in her most charming *fin-de-siècle* moments. Seurat's *Chahut* of 1889–1890 [Fig. 27] has certain features in common with *Les Girard* of a decade earlier. In each case the dancing figures are hardly modeled at all, and their willful flatness is complemented on the surface by such angular linear motifs as the flying coattails which dart out from the buoyantly vertical forms like tongues of flame. In each composition the faces of the figures are caricatured and their elongated arms and legs are raised high in the air, while some of the men hold hats over their heads.

Seurat made only one excursion into the poster artist's field, a cover for the novel *L'Homme à femmes* [Fig. 26] which he did in 1890.[9] In this, he betrayed his debt to Chéret, particularly to such posters as *L'Amant des Danseuses* [Fig. 33] of 1888. Each composition depends upon a central foreground figure standing in front of a group of people (the furthermost only summarily indicated) who are peering out at the observer. The two male figures in dark clothing are especially close. Each wears an English dandy's costume (a prominent fad of the day) and their bodies sway gracefully in the same rhythm. They have given their moustaches a debonair upward twist to suit the gay mood of their pointed feet and slyly cocked heads.

The dancing woman in *L'Amant des Danseuses* is so like the circus girl in Seurat's last painting [Fig. 29] that one wonders if it is not a case of direct inspiration. Their hair flies upward to a point; their waists come down from their shoulders to form triangles; their skirts flair outward and upward and have flashing ribbons darting out into space; their legs are in the same relative positions. The very outlines of their bent legs are the same: inward-bending curve below angular knee, slight bulge at the shin, with the heel peeping out the other side of the straight leg.

In a more general sense, Seurat's circus girl, the most lithe and winsome of all his female types, recalls an equally charming personage that appears in some ten or twelve of Chéret's posters and in a book that he

[8] Including posters, drawings, pastels, and gouaches, the exhibition ran from December 1889 to March 1890. The catalogue was written by Roger Marx.

[9] The novel was by his friend Victor Joze, who wrote articles on Neo-Impressionism in the Polish review *Przeglad-Tygosmowy* in 1887 and 1888.

illustrated, *La fée au rocher.* The title-page of this book [Fig. 34] presents this figure, as usual, in the same bright yellow that Seurat chose for his *écuyère.* These two young ladies are as light as the wind and as gay as yellow butterflies, their floating forms freed from a sense of weight and solidity by their witty, flashing outlines.

Another type that Chéret used over and over again is the handstanding clown that is shown in *Spectacle-Promenade de l'Horloge* [Fig. 35] of about 1880. That Seurat's flying clown in his *Circus* [Fig. 29] is indebted to Chéret seems hard to deny. They are alike in nearly every detail, from their flying top-knots to their projecting torsos and angular hips. The use of lightsome, upward-moving rhythms extends to all of the details of Seurat's last painting, and for most of these details prototypes can be found in Chéret's work. The foreground clown in his *L'Horloge, Les Frères Léopold* [Fig. 36] of 1877 foretold the form of Seurat's clown [Fig. 29], not only in pose and position in the composition, but also in the darting lines and the brilliant combination of orange-red and white.

Chéret's contribution to Seurat's late style must not, however, be measured only by comparing a few specific figures. Seurat was interested in Chéret because he found in him a kindred spirit who dealt with the very subjects to which he himself had turned—those artificial homes of vertiginous pleasures, the cabarets, vaudeville theaters, and circuses of late nineteenth-century Paris[10]—and because Chéret's decorative poster style confirmed his own evolution toward surface pattern.[11] If one selects at random from Chéret's work, he cannot help but be struck by the profound stylistic similarities with Seurat's late work. When, for instance, they treat the same subject, as in Chéret's *Hippodrome* [Fig. 37] of 1884, and the two clowns in the middle ground of the *Circus* [Fig. 29], they seem naturally to depend upon similar devices. Their individual figures are rather flat, partly because of the virtual absence of modeling, partly also because by its very nature, the jaunty whiplash line of which they were so fond is a surface element that does not readily suggest solid, well-rounded forms. Because of the use of such decorative surface movements, their forms tend to float upward on the plane of the picture rather than back into illusionary space, an effect abetted, of course, by the fact that the figures are supposed to be tumbling through space. The principal characteristic which the two artists share is their exploitation of sharply curving and angular rhythms, as full of animation and liveliness as a child playing hopscotch.

Seurat entered the world of painting with his *Biagnade* of 1883–1884, and announced himself as an eminently serious artist whose solemn and quiet forms reflected his scholarly interest in antiquity and the nineteenth century classicizing tradition. His outlines were calm, gently curving and clear, his forms modeled as smoothly as severe style Greek sculpture. His

10 After 1886, the year the *Grande Jatte* (The Art Institute, Chicago) was exhibited, Seurat devoted only two or three months of each year to landscape. Except for the *Poseuses* (Barnes Foundation, Merion) his major paintings and most of his drawings were concerned with urban entertainments.

11 See note 1.

figures were placed out-of-doors in the Impressionist tradition and his composition had the pictorial depth of Renaissance painting. His outlook was that of a detached, nearly impersonal observer. In his last work, on the contrary, his forms are bright and gay, his outlines quick and darting. Instead of looking toward the past, he left behind his early interest in the academic tradition and dealt with contemporary subject matter in a style that had its roots more firmly in contemporary art. The calm detachment that marked his early paintings of rural and suburban scenes was giving way before a new devotion to the city, a twinkling and satirical probing of the amusements of his fellow men. To this new outlook corresponds the humor and sparkle of his lighter colors and his lively arabesques. Along this new path, Seurat's cicerone was Jules Chéret.

NOTES ON SEURAT'S PALETTE (1959)

William I. Homer

Owing to the scientific basis of Neo-Impressionist colour theory, there has always been considerable speculation about the arrangement of Seurat's palette. In the studies devoted to his technique that have appeared since 1886, the initial year of Neo-Impressionism, reliable remarks about the type of palette he used have been extremely rare. One man—Paul Signac —who could have given a precise description of it in his writings did not do so, but he was certainly familiar with his friend's palette as a result of their close collaboration from 1884 to 1891.[1] And, more important, it actually came into his possession after Seurat's death. That palette is still preserved, among other unpublished Seurat documents, in the collection of Mme. Ginette Cachin-Signac, Paul Signac's daughter. Through her kindness, the present writer was able to examine it during the summer of 1957.

The arrangement of this palette confirms most of the remarks on it made by M. Robert Rey in his excellent essay on Seurat, published in 1931.[2] However, owing to the brevity of his discussion, a number of points

William I. Homer, "Notes on Seurat's Palette," *The Burlington Magazine,* 101, May 1959, 192–93. By permission of *The Burlington Magazine* and William Innes Homer.

William Innes Homer (1929–) Professor of Art History at the University of Delaware. Author of many articles on Seurat as well as a major book *Seurat and the Science of Painting* (1964). Also known for his work on early 20th-century American art, including *Alfred Stieglitz and the American Avant-Garde.*

[1] In his *D'Eugène Delacroix au Néo-Impressionnisme,* Paris [1939], pp. 73–4, Paul Signac described Neo-Impressionists' palette in the following way: "Les néo-impressionnistes, comme les impressionnistes, n'ont sur leur palette que des couleurs pures. Mais ils re-pudient absolument tout mélange sur la palette, sauf, bien entendu, le mélange de cou-leurs contiguës sur le cercle chromatique. Celles-ci, dégradées entre elles et éclaircies avec du blanc, tendront à restituer la variété des teintes du spectre solaire et tous leurs tons. Un orangé se mélangeant avec un jaune et un rouge, un violet se dégradant vers le rouge et vers le bleu, un vert passant du bleu au jaune, sont, avec le blanc, les seuls éléments dont ils disposent. Mais par le mélange optique de ces quelques couleurs pures, en variant leur proportion, ils obtiennent une quantité infinie de teintes, depuis les plus intenses jusqu'aux plus grises." [This and all subsequent footnotes are the author's.]

[2] Robert Rey: *La Renaissance du sentiment classique,* Paris [1931], p. 114.

Text Figure 1 Seurat's palette

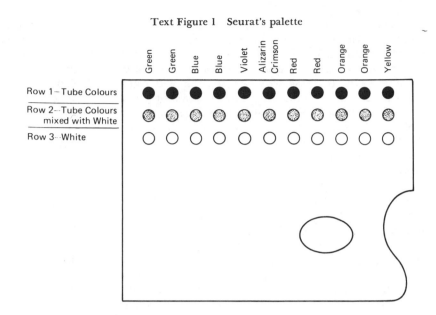

	Green	Green	Blue	Blue	Violet	Alizarin Crimson	Red	Red	Orange	Orange	Yellow

Row 1 – Tube Colours

Row 2 – Tube Colours mixed with White

Row 3 – White

about its exact composition remain unclear. With due respect for his findings, a more complete description of the palette is offered here. On the long side of a conventional rectangular wooden support, Seurat first squeezed from his tubes eleven small mounds of paint, which were arranged one after another in a straight line [Text Figure 1]. A second row, parallel to this, was composed of mixtures of these colours with white, providing a series of tones similar in hue to the first row, but of higher value. A third and last row, parallel to the other two, consisted of an equal number of small mounds of white paint. As one would expect from a reading of Neo-Impressionist sources, the colours of the first row approximated those of the solar spectrum; that is, they included neither earth colours nor black.[3]

It is possible to make two further observations here on Seurat's colour arrangement, which, although considered in some previous studies, seem to have carried insufficient weight in the popular understanding of

3 One must assume that Seurat's palette varied somewhat from his early essays in painting to the conclusion of his career in 1891. A clear line of demarcation may be established, however, in 1886, when he perfected his technique of divided colour, which remained substantially the same until his death. The supposition that this palette belongs to his mature period (1886–91) is confirmed on several levels. Félix Fénéon's general description of it in *L'Art Moderne* [27th October 1889], p. 339, corresponds closely to the palette here under discussion: '*A la confection des tableaux de MM. Signac et Seurat ne participent que les couleurs prismatiques. C'est dire que, supposées les couleurs fournies par les tubes échelonnées sur la palette dans l'ordre du prisme, on n'unira jamais que les couleurs consécutives: et la bande spectrale, ainsi restituable sans solution de continuité, sera, sur tout son parcours, susceptible de s'élargir par l'intervention du blanc, de façon à constituer un rectangle chromatique qui serait au cercle chromatique ce qu'est un planisphère à une mappemonde.*' Also it is logical to assume that the palette which Seurat left would reflect his most advanced theories of colour arrangement, since in the process of its revision all traces of earlier systems would be obliterated.

Neo-Impressionism. First, as one can see in Text Figure 1, his palette was not limited to a few simple primary and secondary colours (*e.g.*, red, yellow, blue; orange, green, and violet) ; on the contrary, he used eleven different colours ranging in gradual steps from green on one end to yellow on the other.[4] One may ask why he used this wider gamut of colours when he surely knew that, according to the laws of subtractive mixture, he could approximate all of the hues of the spectrum from varying combinations of the three primary pigments; red, yellow, and blue. The answer lies in the fact that he realized, probably as a result of reading scientific sources, that mixtures derived exclusively from red, yellow, and blue were not equal in intensity to the colours already prepared in powdered or tube form, which could be purchased in hues that were equivalent to the short-interval steps from one colour to the next in the solar spectrum. Secondly, while it is sometimes still maintained that he applied only dots of pure, unaltered pigment from the tube to the canvas, which were then supposed to create a luminous effect by mixing in the eye, an examination of this palette indicates that he often modified these spectral hues by the addition of white. Indeed, it is precisely this problem—the orderly introduction of white—that appears to be among the chief considerations that determined the way in which he set up the second two rows of the palette.

Although interesting in themselves, these facts take on additional significance when viewed as part of Seurat's total creative process. It must be realized, in the first place, that his mature art was postulated on the creation of luminous, vibrating images, whether of indoor or outdoor subjects. Precisely how and why he chose the colours he did has never been explained adequately, but the palette he left behind can help to shed some light on this question. After the completion of *A Sunday Afternoon on the Island of La Grande Jatte* (1884–6) [Fig. 15], the great trial-piece of Neo-Impressionism, Seurat's method was almost always synthetic; that is, by varying the hue, value, and intensity of his coloured dots, he was able to create an infinite variety of chromatic effects, provided that the observer was willing to stand far enough away from the picture to permit the phenomenon of optical mixture to take place. In believing that the canvas should operate according to the scientific laws of light and colour, Seurat was forced to abandon black, since black, as defined by the physicists he read, was non-light. Also forbidden, as Signac was fond of pointing out, was the mixture on the palette of complementary colours—such as green and red—since such a practice would violate their belief in the purity of the component prismatic hues of white light. As a result of this kind of thinking, light and shadow, for the Neo-Impressionists, had to be transposed onto the canvas solely by means of spectral colours. Thus, when

4 Because of the limitations of colour terminology and notation, it is difficult to give a precise verbal description of these hues. Where there is a duplication of terms in the identification of colours on Text Figure 1, such as red, orange, green, and blue, it should be understood that these refer to different shades of the same basic hue, in each case. Also, as in some of Seurat's paintings, the pigments that remain on the palette have lost some of their original intensity.

Seurat was called upon to represent shadows, he was obliged to do it without having recourse to the conventional muddy colours used by painters of the academic tradition. The only alternative—and a scientifically valid one —was to determine the colours which, when mixed optically, would approximate the desired effect in nature. For deep shadow tones, however, he was often able to omit white, since, in order to achieve sombre low values, he had to use his component colours at full intensity. But when it was a question of representing middle values and highlights, white was essential.

Although scientists such as Helmholtz and Maxwell had demonstrated that all of the colours of the solar spectrum, as well as white light, could be recreated by the additive mixture of the primaries of light (red, green, and blue-violet), the Neo-Impressionists realized that artists' pigments could not equal these in brilliance. Therefore, when lighter areas were called for in their paintings, white had to be added to their hues in order to raise their value sufficiently. When transcribing the effects of outdoor illumination, particularly where strong local colours were modified by the effect of distance, Seurat relied frequently on less intense, pastel tones of this type. The arrangement of the palette under discussion provided him with a consistent basis for mixing these tones without violating the chromatic composition of the remainder of the picture.

Another reason for the rather delicate gradations from one hue to the next on the first row of the palette can be found in Seurat's practice of building up areas of the canvas from a number of such intimately related colours; like Delacroix, he wished to avoid dull, flat surfaces. When confronted with a green area in nature, for example, instead of painting it with a single tone, mixed on the palette, he would compose it of several different shades of green, as well as touches of blue and yellow, which were set down side by side on the canvas. This palette permitted Seurat to visualize at a glance the contiguous colour groupings necessary for the production of any desired tone.

We may be tempted to speculate on the purpose served by the now unused area of the palette. As M. Rey has suggested,[5] it probably afforded the necessary space for Seurat to compound additional, and more refined, mixtures of his basic hues with white; here, too, he could prepare even more delicate combinations of neighbouring hues, when necessary.

Some readers may be surprised to find that this palette was not set up according to some esoteric mathematical formula, such as those professed by Seurat's influential friend, the scientist and aesthetician Charles Henry. But in surveying the palette, there is very little internal evidence to suggest that an *a priori* number system was used. A vigorous affirmation of Seurat's painterly approach had already been suggested in the year of the debut of *La Grande Jatte* by his most important critic, Félix Fénéon. In an article he wrote for *L'Art Moderne,* Fénéon pointed out that science was merely an aid to the sensitive eye of the Neo-Impressionist painter,

[5] R. Rey, *loc. cit.*

and that the study of physics texts, alone, could never be responsible for the artist's creation of a masterpiece.[6] Sentiments similar to this were expressed intermittently during Seurat's lifetime by several other writers who knew him personally. Thus, the Seurat palette discussed here may be interpreted as one more piece of evidence which may help demolish the myth that he was a mysterious savant, able to produce paintings simply by consulting a collection of ponderous text-books and colour charts. His palette is, above all, a device that encourages the artist's *eye* to respond to colour relationships.

[6] Félix Fénéon: "L'Impressionnisme aux Tuileries," *L'Art Moderne* [19 September 1886], p. 302.

THE EVOLUTION OF SEURAT'S STYLE (1959)

Henri Dorra

Seurat's last work, the unfinished *Cirque* [Fig. 29], carries a step further the development of the previous years. The dots are mostly dashes, often applied so as to form streams in the direction of the main outlines. They are larger and less crowded than in previous works. The outlines themselves are stronger.

The color contrasts are not as pronounced as they were in earlier works, and it seems that Seurat was intent on creating an overall light golden glow. There are four dominant colors in the painting: red, sulphur, cyanide blue (for the shadows) and orange tinted with yellow (for sunlight). They are fairly evenly spread around the color circle and created an overall effect which is harmonious. Seurat seems to have simplified his color schemes in his later works, and *Le Cirque* may well mark the culmination of this trend—although one cannot ignore the fact that the artist died before he could finish the picture, and that he might have intended to use additional hues fairly extensively.

The figures are quite shallow, and the background, for all the careful perspective rendering of the curvature, is deliberately flattened into a decorative backdrop, a colorful mosaic meant to set off the movement of the main protagonists.[1]

The outlines of the figures are more stylized than ever. They seem to be made up of straight lines and carefully rounded curves. It appears that Seurat paid much less attention to the accurate rendering of physical

Henri Dorra, "The Evolution of Seurat's Style," in Henri Dorra and John Rewald, *Seurat* (Paris: Les Beaux-Arts, 1959), pp. lxxix–cvii. This excerpt, pp. ciii–cvii. By permission of Henri Dorra and Les Beaux-Arts. Revised for this volume by Henri Dorra.

Henri Dorra (1924–) Professor of Art History at the University of California at Santa Barbara; formerly Assistant Director of the Corcoran Gallery (1954–61) and the Philadelphia Museum of Art (1961–62). Author of several major studies on Gauguin and co-author of the 1959 *catalogue raisonné* of Seurat's paintings.

1 As in the case of *La Parade* and *Le Chahut,* various parts of the painting are seen from different eye positions. There are therefore several perspective points. See Goldwater: *Op. cit.,* p. 122, 123. [This and all subsequent footnotes are the author's.]

forms in *Le Chahut* [Fig. 27] and *Le Cirque* than in earlier works. Significantly he did much fewer studies from nature for his later than for his earlier large canvases.

Because *Le Cirque* is incomplete, one can still see the network of lines Seurat drew to set up the composition. They are in pale blue and can be observed over most of the surface of the picture (they even appear in a preparatory drawing [D.R. 210 f]. This network was retraced onto a photograph [Fig. 30].

The following deductions can be made from an analysis of the network of *Le Cirque*.

The height of the painting was determined by Seurat so as to be equal to twice the length, AN, NN' being a « golden section » of AB.[2]

The whole surface of the picture was covered by horizontal and vertical lines, as shown, forming squares the length of which is equal to the distance MN—the distance between the two « golden sections » along the width. To these were added diagonals going through the intersections, and those going through the middle of the sides.

In *Le Cirque,* as in *Jeune femme se poudrant* [Fig. 25] and *Le Chahut,* Seurat followed the network quite loosely. It is significant, however, that « golden section » NN' [Fig. 30] divides the architecture in two parts, separating the stairs and stage from the spectators' seats, and that it sets apart the dancer on horseback and the bulk of the clown in the foreground from the other figures in the ring. In addition, the psychological fulcrum of the scene, the point where the foot of the dancer rests on the horse, is on « golden section » MM'. It becomes obvious that Seurat has not only endeavored to give each of his outlines swift, graceful, harmonious rhythms, but that he has striven to create an overall pattern of elements parallel and perpendicular to one another. This he has done by giving all the limbs directions approximately parallel to either set of diagonals. Thus the legs of the tumbler are in a direction almost perpendicular to the left arm of the dancer on horseback, his forearms in a direction roughly perpendicular to the horse's hind legs. The hands of the clown in the foreground are each in directions approximately perpendicular to those of the fore and hind legs of the horse respectively, as if to suggest that they were receiving the thrust of the horse's motion.

Other elements in the composition are at 30° and 60° to the horizontal, notably the tangent to the edge of the parapet at the extreme left, which is at 30° to the horizontal, and the axis of the body of the dancer (added on Fig. 30) which is at 60° to the horizontal. According to Henry's theories, 30° and 60° angles are pleasing, as are the 45° and 90° angles of the network, and it must be assumed that Seurat was again following Henry's rules.[3]

[2] The dimensions indicated on the back of the watercolor study for *Le Cirque* at the Louvre [D.-R. 210e] may well have been those of the original stretcher (1 m. 85 × 1 m. 76). If so, Seurat selected smaller dimensions for his linear construction. The dimensions of the portions of the canvas bent over the present stretcher bear out this assumption.

[3] The basic assumption is stated by Charles Henry in his *Cercle chromatique, éléments d'une théorie générale de la dynamogénie*, Paris, 1888, p. 15: "The human being can

The only vertical element in the design of the moving figures is the wand held by the dancer on horseback, symbolizing, perhaps, the triumph of discipline and natural balance.

The dualism between object and subject, between the world of sensations and the world of aesthetic experience is less pronounced than in the earlier large compositions. *Le Cirque* is perhaps the least objective of Seurat's paintings. Gone is the scrupulous, detailed study of light effects that characterized *Une Baignade, La Grande-Jatte,* and their numerous preliminary studies; gone the intimate naturalism of *Les Poseuses.* Here it seems that the artist has started out not so much from his direct observations of a real circus, as from some kind of conceptual circus—one is tempted to say a poster-painter's idea of a circus.[4] The combination of warm colors, rising lines, light bodies prancing over the ring, all convey with extraordinary lyricism the intense, childlike joy that the word circus awakens even in an adult.

In conclusion, it can be said that Seurat's stylistic evolution was gradual and systematic—just as what we know of his thoughtful, methodical, conscientious personality would lead us to expect. This evolution, however, was quite broad in every respect.

He abandoned the criss-cross hatchings of his early works for dots and then for dashes; the conventional late Renaissance space of *Une Baignade* [Fig. 6] for the flattened-out space of his late works; the blurred delineations of his early field scenes for the strong, decorative outlines of his late paintings; and he discarded the apparently haphazard composition of the impressionists for consciously and elaborately organized constructions that are almost mechanistic. He developed first the empirical principles of the impressionists into a system of color theories with the assistance of treatises on optics, but this faithfulness, in itself, conceals a paradox: in the beginning, Seurat's scientific approach was meant to curb the "temperament" through which, as Zola put it, the naturalist painters were seeing nature. Thus Seurat's theories were meant to improve upon the objectivity of the

only describe circumferences. His mechanics do not go beyond those of the compass. He is therefore impeded from accomplishing with continuity changes in direction determinating on the circumference arcs expressed by numbers that are not of the form 2^n, $2^n + 1$ prime number, or 2^n multiplied by one or more prime numbers of the form $2^n + 1$." It will readily be seen that arcs of $30°$, $60°$, $45°$ and $90°$ fulfil these conditions. One may wonder to what extent the *Rapporteur Esthétique*, devised by Charles Henry, was used by Seurat to obtain harmonious outlines. The *Rapporteur* is a protractor graduated in degrees and in a gradation conceived by Henry to determine easily whether or not an angle fulfils the above conditions. To determine whether an outline is harmonious, the outline is broken up into a polygonal line, and the test is applied to each angle of the line. A simple compilation with the aid of tables supplied by Henry gives the answer. Henry devised a similar test for the lengths of the sides of polygonal lines, and a *décimètre esthétique* to apply it. The *Rapporteur* was mentioned in *La Vogue* as early as 1886 and the instrument was available commercially in 1889. It may be that the proliferation of straight lines and angles in *Le Cirque* was meant to facilitate the use of the *Rapporteur*.

4 The influence of Chéret's posters in *Le Cirque* are discussed by HERBERT: Seurat and Chéret, *Art Bulletin*, June 1958, p. 157. The subjective elements in *Le Cirque*, needless to say, are due to many factors, among which the influence of Chéret is minor. The principal factor was a change in the artistic climate.

impressionists. As time went by, however, the artist applied increasingly both his color theories and the theories of linear composition he developed later to expressive ends—while his subjects became ever more removed from nature. The magnitude of the change was such that his last large paintings could be dubbed, in the words of Apollinaire, "ballets full of grace, lyricism and common sense." Inevitably the harmonies of color and line expressed his own delicate poetry, thus re-emphasizing the "temperament" he had wanted to submerge in the first place.

Le Cirque marks the culmination of this evolution. It is significant that it is around the same time that several other great artists were rejecting the tenets of impressionism and turning increasingly subjective in their art. Seurat unquestionably played an important role in this development, and it is particularly tragic that he died at the dawn of a new artistic era to which he had contributed so much, and to which he would undoubtedly have contributed even more.

SEURAT'S DRAWINGS (1962)

Robert L. Herbert

I THE DEVELOPMENT OF SEURAT'S MATURE DRAWING STYLE

In just a little over a year after his return to Paris [from a year of military service in Brest] in November 1880, Seurat developed the distinctive drawing style which has placed him among the greatest masters of black and white. By 1882 he fully realized the rich, velvety drawings in conté crayon which are so superb in every sense that they are a serious challenge to the pre-eminence of his painting. The rapidity of his maturity (and he was only twenty-two in 1882) is bewildering. In spite of his precocious competence, no drawing before 1881 can begin to compare with the quality of his first mature work. . . .

. . . Fortunately, among the many drawings of this period are a few which can be dated, stylistic anchors for the frail bark of analysis. The Brest notebook [November 1879–November 1880] establishes a *terminus a quo; Harvester* [CdH 456] and *Orange Vendor* [CdH 450] were signed and dated 1881; *Peasant Hoeing* [CdH 557] was done late in 1881 or early 1882; and, finally, *The Seamstress* [Fig. 2] is inscribed July 1882, providing the *terminus ad quem*. The task will be to see how a style which denies the existence of separate lines grew out of its apparent opposite, an earlier dependence upon the autonomy of clearly stated line.

There are three stages observable in this development: pure line drawings, compositions based upon cross-hatching and closely packed parallel lines and the fully mature drawings which vary considerably, but have in common a subtle interplay of velvety shades to which any line still visible is entirely subordinate. This is not necessarily a strictly chronological evolution. All through his career he occasionally resorted to pure line, and the three stages certainly existed side by side. In spite of overlapping, however, the three groups are very roughly in sequence so that a

Robert L. Herbert, *Seurat's Drawings* (New York: Shorewood Publishers, Inc., 1962). These excerpts, pp. 35, 36, 38, 44–47, 87, 88, 96, 98, 99, 101–7, 110, 113–15. By permission of Shorewood Publishers, Inc. and Robert L. Herbert.

typical drawing from each of the periods 1880, mid-1881 and late 1881 through 1882, would fit the corresponding stage. . . .

EARLY MATURE DRAWINGS

Seurat's mature drawing style was formulated probably by late 1881, and for a certainty by 1882. After 1884 a change is observable, hence the third stage of the early independent [1] drawings encompasses the years from late 1881 until 1884. The rich body of drawings from these years is impossible to organize chronologically, so little fundamental variation do they show, and it is best to group them by subject matter and stylistic type. Considered from the latter standpoint, Seurat's most familiar style paradoxically involves the smallest number of drawings, those carefully modelled with a sense of heavy, rounded mass. The portrait of his mother [CdH 582], *The Black Bow* [CdH 511] and the studies [Fig. 5] for his first major painting *Une Baignade* (National Gallery, London) [Fig. 6] are among the best known of this type. The initial soft lines which sketched in the outline of the figures have disappeared, completing the remarkable transformation from linear to tonal technique. . . .

In the completed, mature drawings, Seurat's crayon catches the tiny tufts of the heavy-textured paper, producing a smoothly modulated surface with a soft, cloth-like texture. No incidental lines or movements along the surface break up the evenly molded masses. With only two or three exceptions, he used conté crayon on Michallet paper for his mature drawings. An enlarged detail of one of his drawings exhibits the qualities of this combination. Conté is a medium hard and greasy crayon which has certain advantages over charcoal. It is easier to handle, since it does not crumble or smudge, and the degree of darkness is directly proportionate to the pressure used. It is nonetheless soft enough to leave its mark no matter how lightly applied. In the original its more opaque and lustrous blacks distinguish it from the matte and chalky blacks of charcoal. Michallet was the particular brand of "Ingres paper" (so named because it was favored by that great master of drawing) Seurat always used. It is a thick rag paper, milk-white when fresh but a creamy off-white after exposure to the air. Under a microscope its myriad tufts can be seen to project from the surface in little comma-shaped hooks. When Seurat lightly stroked its surface, the hooks caught the crayon here and there, leaving the valleys between them untouched. As a result, his greys are truly three-dimensional, with the white showing between the touches of dark. . . .

II THE RELATION BETWEEN SEURAT'S DRAWINGS AND PAINTINGS

During Seurat's school days, drawing had quite naturally taken precedence over painting. For generations academic practice insisted upon

[1] "Independent" drawings henceforth will mean those which bear no direct relation to Seurat's paintings, but were drawn purely for their own sake. [This and all subsequent footnotes are the author's.]

the mastery of drawing as a prelude to any serious attempts at painting. Color anyway was rather suspect—the Ingres versus Delacroix dispute had only reinforced the Beaux-Arts disdain for color—and until 1881 Seurat did relatively little painting. From that time on he devoted about equal time to the two media,[2] but his work in oils was more experimental in character while his drawings were finished compositions. In 1883 he turned to his first major painting, the *Baignade,* whose studies and related paintings absorbed so much of his energies that drawing took a secondary place for the first time in his career. Independent drawings become still fewer in 1884 and 1885, the period devoted to the *Grande Jatte* [Fig. 15] and its innumerable studies, and to a summer of painting in Grandcamp on the Channel coast. Through these years drawing as a technique, however, continued to be of the utmost importance, for work in black and white lay behind Seurat's painting. The definitive forms for the *Baignade* and the *Grande Jatte* were established not so much by the oil studies, devoted to the analysis of color and light, as by the separate conté drawings. And yet, even his early independent drawings are the work of a painter, much as they can stand on their own merits. The shift from a linear to a tonal style parallels the increasing importance of painting in his work.

PAINTING AND DRAWING BEFORE THE "GRANDE JATTE"

Some connoisseurs of drawing would think of Seurat as a painter's draftsman who handled his whites, greys and blacks as though he were working in oils, and would reserve the highest place for artists like Degas or Matisse who more often exploited the special characteristics of pure line. While there is no need to take a position on the relative merits of linear *versus* tonal drawing, it is clear that in Seurat's case there was a constant flow back and forth between drawing and painting. This remains true even though he experimented only briefly with drawing directly in color, and even though most of his drawings were done for their own sake. The essence of his unique style in black and white is his conception of drawing as a fluid medium, in which the several greys, for example, have the subtle qualities of colored pigments in painting. Not only did he avoid its opposite, the use of isolated dark lines on light paper, he also took care to subordinate what line is visible to the viscous unity of velvety tone. The confrontation of drawings with paintings is a convenient way of seeing Seurat as the whole artist he was, both draftsman and painter. . . .

Yet despite the common style shared by both painting and drawing, it is essential also to take into account their differences, even when we compare a drawing with the painting for which it is a study [Figs. 5 and 6]. The *Baignade* [Fig. 6] of 1883–84 was the first of his canvases of large, almost mural scale. Given Seurat's early maturity in drawing, and the Beaux-Arts insistence that form be established first in black and white, it is no surprise to see that in the oil sketches, in which he worked out

[2] It has generally been considered that Seurat devoted most of his time to drawing until the beginning of the *Baignade* in 1883, but about 60 small panels, 23 small and 2 large canvases, can be dated before the *Baignade* studies of 1883.

the colors and the general composition, the figures have only a rough approximation. Their forms were determined in separate drawings done in the studio. Many observers have pointed to the combination of two disparate strains in the *Baignade,* its Impressionistic landscape and its classicizing figures. Although the landscape was, in fact, artfully synthesized and is far from a direct impression, the contrast is justified by the brushwork alone, which is quite free in the landscape, but smooth and heavy in the figures. Together with the still-life in the center, the several human forms retain a studio feeling and the separateness from one another and from the landscape remains evident. The extreme case is provided by the straw hat which in the painting is cocked up in the air without support; in the studio drawing (Mrs. Culver Orswell; CdH 593) it was leaning against the wall. When the seated boy was transferred to the canvas, his self-sufficiency was maintained; he is the same pensive figure who looks as though he could have descended from a Severe style Greek relief. But there are subtle changes since color, in the hands of a sensitive artist, will always alter black and white form. The most noticeable amendment is the separation of the individual parts of the figure which brings about a greater emphasis upon flat surface pattern. The boy is seated upon an orange cloth that contrasts sharply with his dark blue trousers, instead of merging with them as in the drawing. He now wears a coral sash which makes a new shape at his waistline, and a sleeveless shirt in lavender and green separates his back and torso from his shoulder. These new shapes and demarcations are due largely to color and only slightly to a shift in the pattern of light and dark. A black and white reproduction of the painted figure will seem much closer to the drawing, for the contrasting hues, say flesh color and green, are of the same degree of darkness and cannot be readily distinguished by our eye.

In Seurat's hands, therefore, drawing serves painting by determining the essential structure of the forms, but the two remain separate. His studies are rather unusual in the history of art because they were, with very few exceptions, complete in themselves. *Seated Boy with Straw Hat* [Fig. 5] makes no concessions to the final painting. By such devices as the willful darkening of the background on the right as it meets the edges of the figure, and its lightening on the left, the artist has endowed the boy with his own self-contained environment in black and white. Some of the halos and umbrae are retained in the painting (not easily seen except at close range), compounded by the use of complementary colors. In other words, "irradiation," a concept developed first in his drawing, was applied to painting.

The relation of Seurat's drawing and painting on the eve of the *Grande Jatte* could be summarized in this manner:

1. Most of his drawings were entirely independent of his paintings and were granted equal importance.

2. Studies in black and white for his paintings were also complete works in their own right.

3. Color was entirely separate from drawing, and its demands altered somewhat the initial black and white forms.

4. Seurat's development of a fluid, tonal style of drawing reflected the concern for light and nuanced modelling typical of a painter.

5. Drawings formed the substructure of his figure compositions and some qualities peculiar to black and white, such as irradiation, were carried over into painting.

6. The same principles underlie both drawing and painting: a harmony of opposites, a predilection for flat surface pattern of geometric contour, a relative autonomy and at times an isolation of the parts.

DRAWINGS FOR THE "GRANDE JATTE"

Once again, as for the *Baignade,* the structure of the forms was fixed in separate drawings. The most marked change is the geometric tightening of the individual forms, and frequently the use of a sharp silhouette against the untouched background. *Woman Seated, Umbrella Raised* [Fig. 8] is one of the many in which the form is placed against the light paper, which emphasizes all the more its hard edges. Gone is the careful adjustment of figure to enveloping light and shadow, and within the contours the form is scarcely modelled at all. This seated figure is a study for the woman just to the right of center, who is outlined against the sun-struck grass which is approximated by the glare of the untouched paper in the drawing. *The Nurse* [Fig. 10] and *Young Women* [Fig. 9] have forms that are partly shaded and are more complex, therefore the lighting is softer and the edges slightly rounded. But even so, the same change from the *Baignade* is there, if less apparent. The individual shapes are wafer-thin and lack the sculptural feeling of the *Baignade* studies; they are drastically condensed and can be circumscribed by the simplest geometric movements. The nurse, seen from behind, is as chunky as a boulder. Only her cap and ribbon, flattened into the vertical plane, make us sure she is indeed a seated woman. The detached character of the forms in both drawings is aided by the careful and smooth way in which the greys and blacks were laid down; they have none of the scumbled lines and occasional wispy edges found in earlier drawings.

III "CITY VERSUS COUNTRY"—
SEURAT AND HIS SUBJECTS

In essence Seurat straddled two generations, drawing and painting both rural and city life. Millet's peasants had had radical overtones in their day, but by the early 1880's such subjects were acceptable to all levels of society and common in the academic salons. The homely industrial suburbs, on the other hand, did not win a prominent place even in literature until the 1870's. Seurat has the distinction of being the first major visual artist in France to deal importantly with them. This dilemma of the city versus the country appears over and over again in nineteenth-century art. Millet like Ruskin fought the modern city, despised its industrial products, and fled to the rural, pre-industrial past. Daumier portrayed the city and

its people, but hardly touched upon the growing industrialization of the belt around Paris. Of the Impressionists—the most progressive artists of Seurat's youth—Pissarro painted peasants and landscapes. Monet, largely landscapes, Renoir, landscapes, portraits and scenes of middle-class pleasure groups. Manet and Degas concentrated upon urban subjects, especially middle- and upper-class entertainments, but shunned the industrial suburbs.

Seurat stands out by contrast not just because he drew and painted factories, drawbridges or railroads, but also because of the emotional eyeglasses through which he looked at them. He agreed with Huysmans that "essentially, the beauty of a landscape is made of melancholy," and felt deeply "this pitiable charm which is born of a desolate corner of a large city, a balding hillock, a silly stream which weeps its way between two skinny trees. . . ." [3]

A drawing by Seurat is, then, two things: an arrangement of certain flat forms and a number of illusionary realities which those forms suggest. In the twentieth century, dominated by formalistic considerations, the former has assumed such prominence that our view of the latter has been prejudiced. We delight in investigating the abstract components of art, and too often give a secondary place to the artist's ties with the tangible world. Because Seurat did not deal in anecdote, because he seldom showed the features of his subjects, he is too readily presumed to have been interested only in form for its own sake. But can it be an accident that such a definite pattern emerges from his early drawings, a pattern which indicates specific non-formal ideals? Peasants are not, in his eyes, mere pretexts for formal study, nor are they the quaint rustics of Salon genre. They are simple people of immense dignity, always at work. His city folk are not chosen indiscriminately, they are the humble urban dwellers: market porters, nurses, boot-blacks, street vendors, vagabonds. And beyond the humanitarian ideal they expose is a tacit expression of social criticism: in the wake of Millet and Daumier, Seurat is saying that the little people of the world are more important than the nymphs and Venuses preferred still by the bourgeoisie, who would like to ignore the lower echelons of society on which they build their well-being. What has happened by his day is simply that in both literature (the naturalists had the same sympathy for ordinary people) and in the visual arts, the overt moralizing of Daumier and Millet is no longer a viable attitude for most artists, who assume instead the position of a more neutral spectator, deliberately suppressing their sympathies. Seurat's choice of the forlorn manufacturing district north of Paris is consistent with his humanitarian concern. He does not draw landscape in the spirit of escape from the ugliness of the city, he draws the ugliness itself. Landscape rose to preëminence in the nineteenth century in opposition to the changing cities of the industrial revolution. The bourgeoisie could escape into healthy, untouched nature and forget the disfiguring scars and social misery that hung like a pall of

[3] "Paysages, La Bièvre," *Croquis Parisiens* (1880), *Oeuvres,* 8 (Paris, 1929), pp. 105ff.

smoke over their consciences. To remind them of it was a radical act. . . .[4]

In one type of drawing, his twilight views of the city, there is a more direct and far more intimate visualization of his emotional proclivities. Paris is called the "city of light." We think of its wide avenues, its many small squares and its parks, the flower-bedecked Tuileries, the Seine curving gracefully through its heart. Yet Seurat drew none of these. *Rain* [CdH 519] is instead a moody vision of a woman whose indistinct form is nearly lost in the gloom of a rainy day. We can hardly read any natural forms, our eyes strain in the effort of following the swirling lines which slash energetically across the paper, crossing and recrossing to form deep blacks and lugubrious greys. Even the glow of the sky is violent, as though murkiness were the natural state and had to be forcibly ripped apart to expose the light. More quiescent but equally powerful is *Place de la Concorde, Winter* [Fig. 3], among Seurat's greatest compositions and one of the outstanding drawings of the nineteenth century. Steeped in the brew of historical memory, from the time of Louis XV, for whom it was first named, through the Terror, when the guillotine there claimed its due, the Concorde is seen with a light covering of snow whose purity has been sullied by the soiled tracks of carts and carriages. The gas lamps, which might have shed a warming glow, have not yet been lit; only their stems show, the potential sources of light swallowed up by the leaden obscurity. When these drawings are turned over, the depressions made in the paper by Seurat's crayon are visible. They are so heavy it is almost certain that at times he held his crayon in his clenched fist rather than between his thumb and forefinger, a mute testimony to the depth of his feelings.

IV SEURAT AND "PRIMITIVE" ART

There are other sources for the *Grande Jatte*, which is a veritable syndrome of different tendencies having in common a planar emphasis and a measured simplicity. At the opposite pole from antique art, the popular broadsides which Seurat had collected were already of some significance in his earliest paintings and drawings. This was especially true in his views of rural architecture of 1881 and 1882, whose flat horizontal planes have a stark simplicity found nowhere else in contemporary painting. Contact with Impressionism about 1882 seems to have led him away from this early, rather primitive style towards more complex spatial compositions, but in the *Grande Jatte* he reaffirmed his love of flat and toy-like forms. The pair of cadets in the background of the Chicago painting are the most obvious, not the only instance of his fondness for popular art. They are close to the sheets of toy soldiers he had in his studio, and throughout

[4] A natural outgrowth of his early orientation was his later sympathy for the Anarchist movement. See John Rewald, *Seurat* (Paris, 1948), p. 94, and Robert L. and Eugenia W. Herbert, "Artists and Anarchism," *The Burlington Magazine* 102 (November 1960), pp. 473–82.

the *Grande Jatte* and its drawings there are echoes of the doll-like figures of colored broadsides. This is such a striking feature of the painting that Seurat's contemporaries immediately drew attention to it.[5] His fondness for caricature, allied to the same tradition, is given away by *The Bustle* [CdH 615], a delightful travesty of the current fashion.

Quattrocento painting, another art then considered primitive, may also have been of special interest to Seurat at the time of the *Grande Jatte.* Several of his friends compared his painting to early Renaissance Art. Although they do not mention Piero della Francesca, copies of whose frescoes were in the Ecole des Beaux-Arts when Seurat was a student there, he has more recently been considered a possible influence.[6] Unfortunately there is only stylistic evidence on which to base such a claim, but it is convincing. *Woman Seated, Umbrella Raised* [Fig. 8] has the crisp outlines, strong contrast with the background, profile position and the aloof monumentality found in Piero's murals. The final painting, in scale and style allied to mural art, has the solemn rhythms of the Arezzo frescoes. Of all artists of the past, Piero is certainly the closest in style and spirit to the Seurat of the *Grande Jatte.*

Did Seurat also look carefully at Egyptian art? His friend Kahn said that he did,[7] and a number of his contemporaries found in the *Grande Jatte* echoes of Egyptian style.[8] Archeological investigations of the ancient Near East had long since drawn attention to the art of Egypt, Mesopotamia and Anatolia; the Louvre was very rich in Egyptian sculpture, and the museum of the Ecole des Beaux-Arts which Seurat must have known thoroughly had a large selection of copies of Egyptian statues and reliefs. In the *Grande Jatte* the nearest parallels are found in the seated nurse, whose blocky form approximates that of the familiar seated scribes of the Old Kingdom, and the tall woman in the center who recalls the rounded form of the standing Empire priestess which exists in many similar versions, including two in the Louvre [9] which assume the identical pose of Seurat's figure, the right arm down tight against the body, the left bent upward (holding the insignia of office instead of an umbrella). In general the forms have a hieratic calmness and processional dignity that suggest Egypt as much as the more supple art of Phidias. It is tempting to think that Seurat shared the views of his Symbolist friends, who found

5 For example, the *Grande Jatte* was compared with broadsides in *Le Gaulois* (May 16, 1886) and with Kate Greenaway's illustrations in *La République Française* (May 17, 1886), articles pasted in a scrapbook by Signac, Signac Archives.

6 Daniel Catton Rich, *Seurat and the Evolution of "La Grande Jatte"* (Chicago, 1935), p. 46; Roberto Longhi, *Piero della Francesca* (Florence, 1946), p. 158, and "Un disegno per la Grande-Jatte e la cultura formale di Seurat," *Paragone* (1, 1950), pp. 40–43; Lionello Venturi, "Piero della Francesca—Seurat—Gris," *Diogenes* (2, Spring, 1953), pp. 10–23.

7 "Seurat," *L'Art Moderne* (11, 1891), p. 109.

8 For example, Maurice Hermel in *La France Libre* (May 28, 1886), and an anonymous critic in *The Bat*, London (May 25, 1886), both cited by Fénéon, "Les Impressionnistes," *La Vogue* (I, 8, 1886), p. 273; Octave Mirbeau in *La France* (May 20, 1886), an article pasted in the Signac album; Paul Adam, "Les Impressionnistes à l'Exposition des Indépendants," *La Vie Moderne* (10, April 15, 1888), p. 229.

9 Known as "Lady Nai," a wooden statuette of the XVIII dynasty, and "The Priestess Toui," also in wood, of the XVIII or XIX dynasty.

Egyptian art more congenial than classical art, and that would be entirely logical in view of the fact that a great many artists were discovering its virtues at about the same time.[10] The most overt references to Egypt were made slightly later by Gauguin and the Nabis. Gauguin, who took with him to the South Seas a photograph of a Theban fresco,[11] frequently borrowed from Egyptian sources, and the Nabis, especially Paul Sérusier, went so far as to study Egyptian mathematical proportions. Seurat would therefore stand, as he does in many other respects, at the very beginning of an important facet of the style of the 1890's. Even if the parallels with Egyptian style in the *Grande Jatte* are only accidental, his contemporaries singled them out and helped make the canvas a prime source for those interested in pre-Greek art.

An indefatigable seeker of support for his style and his theories, Seurat turned to at least one other so-called primitive art about 1886. He copied a Turkish or Persian painter's manual that Gauguin had lent him, and underscored key phrases (which Gauguin had not emphasized) which give away his interest in hieratic silhouettes:

> Everything in your work should breathe the calm and peace of the soul. You should also avoid *poses in movement*. Each of your figures ought to be in a *static* position.

> When Oumra represented the execution of Okrai, he did not raise the sword of the executioner, nor give to the Kha-Khan a menacing gesture, nor twist the victim's mother in convulsions: the sultan, seated on his throne, wrinkles his brow in anger; the executioner looks at Okrai as on a prey who inspires him with pity; the mother, leaning against a pillar, confesses her hopeless anguish in the sagging of her strength and her body.

> Thus *one can spend an hour before this scene, more tragic in its calm* than if, the first moment passed, attitudes difficult to maintain had made us smile in disdain.

> Apply yourself to the *silhouette* of each object; clarity of outline is the attribute of the hand that no hesitation of the will can enfeeble.[12]

Beyond the general similarity of flat silhouettes and static poses, Turkish and Persian miniatures have little to do with the style of the

10 Lucien Pissarro, later a disciple of Seurat, wrote to his father in 1883 that he preferred Egyptian to Greek art: letter dated London, October 22, 1883, in *Camille Pissarro: Lettres, op. cit.,* p. 71.

11 Bernard Dorival, "Sources of the art of Gauguin from Java, Egypt and ancient Greece," *Burlington Magazine* (93, April, 1951), pp. 118–23.

12 The copy, in Seurat's hand, is in the Signac Archives. Mme. Signac, relying upon a faulty translation, thought she had identified the author as Vehbi Zunbul-Zadé and I so published it in "Seurat in Chicago and New York," *Burlington Magazine* (100, May, 1958), pp. 146–53. Mr. Samuel Wagstaff kindly informs me that an accurate translation of the Zunbul-Zadé manuscript in the Bibliothèque Nationale proves that it is not at all the original copied by Gauguin and in turn, by Seurat. Kahn, "Au temps du pointillisme," *Mercure de France* (171, May, 1924), p. 16, said that Seurat had copied an oriental text lent him by Gauguin; it appears in *The Intimate Journals of Paul Gauguin,* trans. Van Wyck Brooks, (London, 1931), pp. 49–53. Since Seurat was on poor terms with Gauguin after May, 1886, one can guess that he obtained the manuscript sometime the preceding winter.

Grande Jatte, but the document is one more proof that Seurat was looking beyond the classical tradition from which he had sprung. The assimilation in one painting of an admiration for Greek and various "primitive" styles is the first major statement of a shift in taste fortified a few years later by Gauguin, who also combined an interest in classical art with a more deliberate study of ancient Mediterranean and non-European styles. First Seurat, then Gauguin, broke the academic camp's monopoly of antique art, reinterpreting it in the light of their fascination with the non-classical (making, as it were, a primitive art of the classical) and thereby showing Matisse and other modern artists a way toward the reintegration of the once decadent classicizing tradition into the mainstream of progressive art.

SEURAT AND THE SCIENCE OF PAINTING (1964)

William Innes Homer

"ASPECTS OF SEURAT'S CHROMO-LUMINARIST TECHNIQUE AND METHOD: *LES POSEUSES* AND *LA PARADE*"

Although Seurat's friends and critics observed that *La Grande Jatte* embodied the main tenets of Neo-Impressionism, it was in many respects an experimental painting in which new discoveries were incorporated only gradually between 1884 and 1886. Henry van de Velde was aware of this when he wrote that the canvas was "incomplete and inevitably suffering from the haste of arriving first and from the poorly estimated intake of breath for the first bugle 'call to arms' of the new formulae." [1] A careful examination of the picture will reveal several vestiges of the earlier stages of Seurat's artistic evolution. The most noticeable of these elements are the *balayé* and short horizontal brushstrokes that serve as an underbody for the multitude of small dots that were added relatively late in the development of the painting. But in the canvases executed shortly after the completion of *La Grande Jatte*—a series of landscapes and seascapes of Honfleur—it is evident that the experimental phase had passed and that Seurat had finally consolidated the discoveries made in *La Grande Jatte* into a consistent artistic credo. As Fénéon wrote in his second definitive article on the Neo-Impressionists, published in September, 1886: "The first efforts in this direction date from less than two years ago: the period of hesitation is over; from picture to picture these painters have consolidated their style, increased their observations, and clarified their science." [2] In such paint-

William Innes Homer, *Seurat and the Science of Painting* (Cambridge, Mass.: The M.I.T. Press, 1964), pp. 164–79 and 235–49. By permission of the author.

[1] Henry van de Velde, "Notes sur l'art—'Chahut,'" *La Wallonie*, 5, 1890, 122. [This and all subsequent footnotes are the author's.—Ed.]
[2] Félix Fénéon, "L'Impressionnisme aux Tuileries," *L'Art moderne*, September 19, 1886, p. 301.

ings as *Honfleur, un soir, embouchure de la Seine* (D.-R. 171), executed during the summer of 1886, the small dot appears for the first time as a dominant structural element rather than as an afterthought. As a result of the growing uniformity of Seurat's pointillist technique, optical mixture could take place much more easily, and thus his paintings tended increasingly to operate as luminous screens that emit colored light.

The first major picture to embody Seurat's fully developed, perfected Neo-Impressionist technique was *Les Poseuses* [Fig. 19; Barnes Foundation, Merion, Pa.], the third of his seven large paintings. He started work on it in the fall of 1886, and it was completed in time to be shown at the fourth exhibition of the Indépendants, which opened on March 22, 1888. A second, smaller version of this painting was executed in 1888 as a *"petite réplique,"* (D.-R. 179)[3] and although similar in treatment to the earlier version, the brushstrokes were made proportionally larger in relation to the dimensions of the canvas. Because it incorporates some improvements over the painting in the Barnes Foundation and is far easier to study, we shall discuss the second version rather than the earlier canvas.

"LES POSEUSES": SYSTEM OF MODELING

Unlike *La Grande Jatte, Les Poseuses* (D.-R. 179) was executed almost entirely in small dots, which give the picture a uniform, tapestrylike surface. This technique enabled Seurat to record with unusual subtlety the variations of color in his subject. The merits of this method were, as we might expect, observed by Fénéon, who wrote: "On a very small area, the numerical proportions of colored specks, being capable of infinite variety, the most delicate transitions of relief, the most subtle gradations of hue can be exactly translated."[4] In order to illustrate the appropriateness of Fénéon's remarks, let us consider Seurat's method of executing *Les Poseuses*—a method that serves not only as a means of making delicate adjustments of color but also of recording the chromatic changes in the modeling of three-dimensional forms. In the torso and arms of the central model, for example, we find that the local color in the shadow is pink; as we turn from the shadow toward the fully illuminated areas of flesh, this tone becomes increasingly lighter, through the addition of white, until the highlights are reached. Thus Seurat first modeled the figure monochromatically merely by taking the basic local color and adding white to it in order to obtain the necessary effect of three-dimensionality through variations of light and shade. But following the theory and methods developed in *La Grande Jatte,* the artist believed that the local color should be modified by the color of the illuminating light (in this case, yellow-orange) and that the complementary of this light, blue, should influence the hue of the shadows. Like the local color of the flesh, these modifying hues—yellow-orange and blue—also participate in the general modeling of the figure by being used at almost full intensity in the shadow and gradually moving up

[3] Often considered a preparatory study, the small version of *Les Poseuses* was identified as a small replica of the large canvas by Fénéon in the catalogue he prepared for the Seurat exhibition held at the Bernheim-Jeune Galleries in 1908–1909.

[4] Fénéon, "Le Néo-impressionnisme," *L'Art moderne,* May 1, 1887, p. 139.

the value scale to white as the form turns from the shadow into the light. The yellow-orange, of course, dominates the lights, and blue is restricted chiefly to the shadows. But as the body is modeled from light into shadow, dosages of these two complementary colors intermingle, creating in the half-lights a luminous optical gray. If the observer looks either toward the lights or the shadows, this neutral gray will become tinged slightly with orange or with blue, depending on the direction in which his eye moves around the form. Color and chiaroscuro were thus inseparably welded together by a method that respected the color data supplied by nature— as did the Impressionists—but also retained the solidity of mass character- istic of the Renaissance tradition in Western painting.

In employing such devices, Seurat was gradually abandoning the kind of "divisionism" used in *La Grande Jatte,* where the local color and the illuminating light were kept distinct and separate, and where optical mixture was used chiefly as a means of adding various extraneous elements to large areas of local color. In that painting, the underlying hues were rarely modified so much that they lost their identity, except in infre- quent cases where neutrals were produced intentionally through the optical mixture of complementaries. In *Les Poseuses,* however, the local color in many areas is all but lost and is replaced by synthetic resultant tones cre- ated by the optical mixture of a multitude of specks of different hues. In certain parts of the painting Seurat seems to have predicted in advance the desired resultant color and then simply juxtaposed the necessary com- ponents in small dots to produce this hue. In the rear wall, for instance, he applied almost equal dosages of purple and green, which are comple- mentary to each other and hence mix optically to produce a cool, luminous neutral tone; then throughout this area were scattered spots of blue and yellow-orange, which express the action of light and shadow, respectively, and serve to neutralize further the underlying color. When viewed at a distance, the wall appears as a flickering light neutral tone, swinging some- times to coolness and at other times toward warmth of color. What is most remarkable about this effect is that when the individual dots are scrutinized closely they are found to be quite intense in color and relatively low on the value scale; but when seen at a distance they lose their identity through optical mixture and blend into a resultant tone that is considerably lighter in value than any of its components.

It should be observed here that Seurat's reason for using optical mixture in *Les Poseuses* was not to create resultant colors that were nec- essarily more *intense* than their individual components but rather to duplicate the qualities of transparency and luminosity in half-tones and shadows experienced so frequently in nature. Were nature composed en- tirely of intense, pure colors, then Seurat probably would have found a way to match them; but only a small proportion of the hues we perceive are found at full saturation. More often the artist is confronted with the problem of representing the perplexingly difficult warm and cool neutrals that occur especially in shadows.

In order to succeed at the task he set for himself in painting *Les Poseuses,* Seurat was forced to make certain adjustments in the representa- tion of the visual data presented to his eye. It is obvious, of course, that

human flesh is not spotted with myriad colored dots—covered with "colored fleas," as one critic put it.[5] The dots have very little to do with the surface texture of the objects represented, but instead are components of an impartial screen of colored pigments which, through different combinations, represents the seen image. In *Les Poseuses* it is as if we have been presented with the colors of the subject before they were completely synthesized. That is to say, when the painting is seen close up, the architecture of the intended color experience is all too evident. Only when we move back will it begin to resemble the subject matter as we are accustomed to seeing it. At a distance, the roughly dotted surface disappears; as Fénéon observed: "Take a few steps back and all the multicolored specks melt into undulant, luminous masses. The technique, one may say, vanishes: the eye is no longer attracted by anything but that which is essentially painting." [6]

Why, then, did Seurat insist on breaking up the colors into their components and allow them to synthesize in the eye of the observer? The following answer must be proposed: in no other way could the inherent luminosity of his subject be duplicated with artists' pigments. We should remember that the intensity of light is far greater than that of the pigments at the painter's disposal; Seurat thus had to resort to every device known to the science of his day in order to equal nature's brightness. For this reason, he insisted on using pigments at full intensity or else mixed only with white. By juxtaposing them as uniformly sized small dots—a technique that is most conducive to optical mixture—he was almost able to compose, as it were, with colored light, following Rood's advice that paint handled in this way could be made to obey rules governing the mixture of light, not pigments.

In *Les Poseuses,* then, we find Seurat beginning to create luminous images in a much more abstract way than he had in *La Grande Jatte.* The principle of optical mixture had been employed in the latter picture in an effort to record the extraneous hues that influenced the local colors, and in that canvas Seurat pursued an essentially analytical approach to nature. In *Les Poseuses,* on the other hand, he discovered synthetic methods by which he could predict whatever effects of color he desired, largely through obeying Rood's suggestion that, with the appropriate theory and technique, artists could make pigments behave like colored light.

"LES POSEUSES": VIEWING DISTANCE AND FUSION

Many arguments between writers on Neo-Impressionism have occurred because some of them—Fénéon and Signac, for instance—saw Seurat's paintings as being much more luminous than those of the Impressionists, while others found them dull and gray. Two examples of the latter opinion should suffice here. The critic Émile Hennequin wrote: "One could hardly imagine anything dustier or more dull than his *La*

[5] J. K. Huysmans, "Chronique d'art—Les Indépendants," *Le Revue indépendante,* April 1887, p. 54.
[6] Fénéon, "Le Néo-impressionnisme," *L'Art moderne,* May 1, 1887, p. 139.

Grande Jatte, which represents promenaders placed in the half-shadow cast by a full sun." [7] George Moore, too, shared Hennequin's reaction: "They [the Neo-Impressionists' pictures] fail most conspicuously at the very point where it was their mission to succeed. Instead of excelling in brilliancy of colour the pictures painted in the ordinary way, they present the most complete spectacle of discoloration possible to imagine." [8] There is a reasonable explanation for this curious disagreement: the characteristic luminosity of Seurat's paintings may be experienced only by standing at the proper distance from them. If one moves too close or too far away, the desired effect is lost. Unfortunately, Seurat, as far as we know, wrote nothing about the appropriate distance from which his canvases should be viewed; but he undoubtedly gave Fénéon instructions about where to stand, because in the critic's estimates of his friend's pictures he consistently praised their luminosity. A significant hint about Seurat's intentions was supplied by Fénéon in his article "Les Impressionnistes," quoted earlier, where he mentioned the importance for the artist of Dove's theory, which stated that when one perceives the separate colored elements and their resultant optical mixture in rapid succession, effects of "lustre" are produced. In the light of Fénéon's observations, let us examine the various color effects brought about by viewing *Les Poseuses* at different distances.

At a distance of fifteen feet, certain parts of the painting (the flesh, the rear wall, and the floor) do in fact appear desaturated and neutral in tone. But areas such as the red-orange, blue, and green articles of clothing do not become grayish, owing to the intrinsic intensity of their hues. It is, then, only in the portions of the painting where less intense colors have been used that grayness becomes a problem. To find out when these areas become more colorful and luminous, the observer must move closer to the canvas. Upon arriving at a distance of nine feet from it, the individual colored elements become more discernible, and the areas that originally appeared flat and dull now reveal some of their component hues. Although individual colors cannot yet be named, one can detect an alternation between warm and cool tones that was not evident at the fifteen-foot distance.

Moving to a distance of six feet from the painting, the effects of lustre described by Fénéon become pronounced. At this point the whole surface vibrates with color, and a lustrous atmospheric veil seems to hover over the picture. Yet considerable fusion is still found: if, for example, one attempts to separate the individual spots of yellow-orange, representing sunlight, from the local color (green) of the grass in *La Grande Jatte* (seen in the background of *Les Poseuses*), one will find that it cannot be done. As hard as one tries, at a distance of six feet most of the colors can neither be made to fuse completely nor can they be seen individually. One's eye is simply caught between the horns of a visual dilemma.

Moving to a position three feet from the painting, the point of greatest lustre has been passed. With a few exceptions, the hues of the individual dots are now discernible, but they do not blend into a uniform

[7] Émile Hennequin, "Notes d'art—L'Exposition des Artistes Indépendants," *La Vie moderne,* September 11, 1886, p. 581.
[8] George Moore, *Modern Painting,* London, n.d., p. 94.

value as they did at the distant view. Instead, there are abrupt transitions in many places, particularly in the flesh of the models. Also, because the different hues of the dots can be detected, the effect is rather spotty, whereas three feet farther back partial fusion would have occurred. One now sees separately the components that comprise the final resultant tones, and because they are disparate colors in many cases, they tend to struggle against each other. This is particularly noticeable when complementaries (such as yellow-orange and blue) appear in a given area, where, instead of neutralizing each other (as they would at a distant viewpoint), they tend mutually to intensify one another.

It is the critical change of viewing distance from six to three feet, then, that destroys the beneficial effects of optical fusion and reveals instead the component colors of the painting. Yet it would be incorrect to say that at three feet all of the colors can be seen individually. There is still some fusion at this distance, particularly in those portions of the painting where Seurat used extremely small dots (as, for example, in the face of the central figure). Our conclusion, at this juncture, must be that effects of fusion work by degrees, moving from grayness to lustre, and then to the point where separate elements can be discerned, still without being able to rule out fusion entirely. The final step is to close in on the canvas until no evidence of fusion can be detected, that is, until the individual colored elements reveal themselves with perfect clarity.

Thus if one stands too far away, the painting will indeed seem neutral in color, an effect that disturbed many contemporary writers. Or, if one stands so close that the individual colors may be discerned, then the picture will appear rough and spotty, and none of the intended qualities of modeling and luminosity will be evident to the observer. However, if one assumes a station point between five and seven feet from *Les Poseuses,* most of the individual spots of color discernible at the close view fuse into a variety of indefinable tones that sparkle with a subtle warmth; atmosphere seems to permeate the picture; and the abrupt contrasts of value and color seen at the close view give way to smooth transitions in modeling in which effects of chiaroscuro are reinforced by warm lights and luminous, transparent half-tones and shadows.[9]

Such effects of luminosity and lustre were described eloquently by Fénéon, as we saw in an excerpt from one of his articles cited in our dis-

[9] In his *Recent Ideals of American Art* (New York, c. 1890, p. 160), George W. Sheldon reported the results of an interview with Camille Pissarro, in which the following instructions about viewing distance were given: "A painting should be seen, as Nature is seen, at a distance sufficient to allow its colors to blend; or, generally speaking, at a distance as long as three times its diagonal." While Sheldon believed that he was recounting the tenets of Impressionism—and indeed he had received information from one of the former practitioners of that style—at the time of the interview Pissarro had been influenced heavily by the Neo-Impressionists and was undoubtedly echoing their theories, not those of the original Impressionist group. We thus have one piece of fairly reliable evidence concerning the viewing distance advocated by the Neo-Impressionists. Significantly, the distance of five to seven feet that the present writer recommends for viewing the small version of *Les Poseuses,* which is based on actual experience and trial and error, is confirmed by Pissarro's instructions: the length of the diagonal of *Les Poseuses* (small version) is 24.5 inches; when multiplied by three the result is 6.12 feet.

cussion of lustre in *La Grande Jatte*. Closely related in content to Fénéon's observations and especially significant in the light of Seurat's perfected chromo-luminarist technique in *Les Poseuses* is Rood's discussion of partial fusion of color through optical mixture. The following passage, quoted previously, is particularly relevant to this picture:

> If the coloured lines or dots are quite distant from the eye, the mixture is of course perfect, and presents nothing remarkable in its appearance; but before this distance is reached there is a stage in which the colours are blended, though somewhat imperfectly, so that the surface seems to flicker or glimmer —an effect that no doubt arises from a faint perception from time to time of its constituents. This communicates a soft and peculiar brilliancy to the surface, and gives it a certain appearance of transparency; we seem to see into it and below it.[10]

Thus Rood and Fénéon give us the necessary hints concerning the distance from which we should view Seurat's paintings. It is reasonable to assume, in view of the foregoing discussion, that Seurat sought just such effects as those described by the American scientist; and we have seen that these effects can be perceived only if one stands in the appropriate viewing range. Hence the arguments among Seurat's critics between the group who felt that his pictures were truly luminous, and those who thought they were dull, gray, and colorless, must be resolved in favor of the former group. The latter evidently stood too far away from the paintings to experience the beneficial effects of partial fusion and lustre.[11]

If *Les Poseuses* was Seurat's first major painting that exemplified his fully developed chromo-luminarist technique, in his next important picture, *La Parade*, this language was employed in solving an even more difficult artistic problem. In many ways, *La Parade* represents the ultimate conclusion of Seurat's interest in depicting light, and for this reason a brief discussion of several aspects of the technique and method used in this picture will occupy us in the following pages.

LIGHT AND COLOR IN "LA PARADE"

Seurat obtained a degree of luminosity in *La Parade* (1887–1888; Fig. 21) surpassing that of any of his previous major paintings. This is due, in large part, to the character of the subject—a nocturnal scene illuminated by gas jets—which lends itself to effects of mysterious, shimmering light. The method by which Seurat created such effects is of particular interest to us here. As far as this writer can determine, the basic system governing the color technique of *La Parade* is the same as that used in *La Grande Jatte* and *Les Poseuses*, the theoretical basis of which has already been discussed. But in *La Parade* Seurat derived every possible advantage from this system to create effects of muted, glowing light emanating from the picture. While orange and yellow-orange dots, corre-

[10] Ogden N. Rood, *Students' Textbook of Color,* New York, 1881, p. 280.
[11] An excellent discussion of the phenomenon of lustre in painting appears in Roland Rood, *Color and Light in Painting,* ed. George L. Stout, New York, 1941, pp. 118–43.

sponding to the color of the gaslight, and blue dots for the shadow color were used to model the forms, these colors were also scattered freely throughout *La Parade,* irrespective of any function they might have in modeling. Since, in any given area, these hues usually intermingle, they tend to neutralize one another by optical mixture, thus creating an effect of light-charged atmosphere that permeates the whole canvas. Often, in fact, underlying local colors are almost nonexistent, as in the open space behind the musicians at the left; here Seurat simply inundated the area with yellow-orange, orange, and blue dots that, through their optical mixture, convey a sense of impalpable, luminous shadow.

The local colors become somewhat more pronounced in the foreground, especially in the two-fifths of the painting at the right. However, almost all of the local colors are selected from a narrow range of hues in the violet and yellow-green sectors of the chromatic circle (violet and yellow-green, for example, are the dominant colors, respectively, of the upper and lower portions of the background at the right). It should be noted that in some instances the local colors do not appear alone, but are modified by the application of a few dots corresponding to their complementary, which tend to neutralize them. Thus in any given area of the picture the component colors will ordinarily be the following: the local color; a small quantity of its complementary; yellow-orange and orange, representing light; and blue, for shadow. What is unusual, as already suggested, is the fact that Seurat often allowed the last-mentioned pair to dominate the local colors, as frequently happens in the left-hand side of the painting.

The methods Seurat used in painting *La Parade* are admirably suited to the creation of neutral color effects. When viewed at a distance of thirty feet, only a few areas of the picture, such as the yellow-green background at the right and the red and orange surrounding the central trombone player, appear as intense colors; the remaining parts would best be described as warm and cool neutrals. It is extremely difficult to identify some of these tones specifically, particularly in the upper-left quarter of the picture, because their components have almost completely neutralized each other. In such areas as the jacket of the stage manager at the right, for example, four major hues—purple, green, yellow-orange, and blue—have been used in almost equal doses, and the result is an indescribable neutral tone that, as one follows the modeling of the form, shifts back and forth between warm and cool. (For a diagram of the color relationships in *La Parade* see Text Figure 1.) Thus, Seurat once more used the division of tone and optical mixture not only as a means of obtaining greater intensity of color but also to create a wide range of luminous neutrals that appear frequently in our experience of nature and which are, of course, even more pronounced in such a nocturnal setting.

When compared to *Les Poseuses* and *La Grande Jatte,* the surface of *La Parade* is even more abstract in relation to the subject matter depicted in the painting. As before, the pigments are applied in small, almost uniform dots, and the brushwork is completely unrelated to the actual texture of the objects represented. But for the first time in a major picture the canvas sometimes shows through the paint layer, again suggesting that

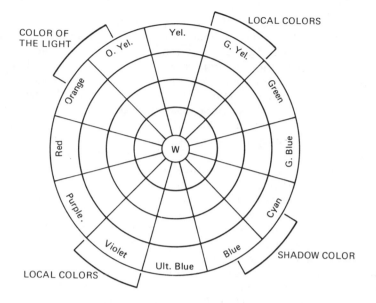

Text Figure 1. Diagram of Color Relationships in
La Parade de cirque.

Seurat was not thinking of the surface as a means of conveying the tactile reality of things but rather as an undifferentiated screen that yields the desired resultant color only when one is far enough away from it that the execution is invisible. The small spots of white canvas in *La Parade* play a very important role here: as in the conté crayon drawings, they reinforce the effects of lustre when one steps back from the painting and views it at a distance of thirteen to fifteen feet. That is, speaking in terms of the optical mixture of *values,* as well as of color, partial mixture takes place, which makes the surface seem to sparkle with light.

While Seurat carried his technique of chromo-luminarism to its ultimate conclusion in *La Parade,* in his last two major paintings, *Le Chahut* and *Le Cirque* [Figs. 27 and 29], his interest in equaling nature's luminosity waned in favor of achieving emotional expression through different configurations of formal elements. Although Seurat continued to use a similar color technique in these later pictures, his esthetic theories and their mode of application changed considerably.

"SEURAT AND SCIENCE"

The Neo-Impressionist style Seurat created in 1884–1886 was not, as some writers have assumed, the result of slavishly following scientific treatises at the expense of the visual perception of nature . . . his optical sensibilities were highly developed and . . . such texts served primarily to guide him in making his pictures operate according to the laws governing light and color in the physical world. Because Seurat distrusted the instinctive, "romantic" elements of the Impressionists' approach, he turned for assist-

ance to scientific studies of the very phenomena these painters had examined perceptually. The scientists, of course, did not confine themselves exclusively to observation but attempted to arrive at general laws, the validity of which they demonstrated through controlled laboratory experiments. In this connection, one of the most perplexing questions facing contemporary critics of Seurat's work concerned the degree to which he subordinated art to science. As a result of exhibiting *La Grande Jatte* [Fig. 15] before the public in 1886 and 1887, he was attacked by many writers for relying unduly on scientific formulae in the conception and execution of the painting. This was certainly an understandable reaction, if one considers the apparent mechanical quality of his technique and the aura of scientific certitude about his theories, as publicized by Fénéon's articles and his booklet *Les Impressionnistes en 1886*. Indeed, we discovered in our analysis of *La Grande Jatte*—not to mention *Une Baignade* [Fig. 6]—that the artist did in fact rely, to a considerable degree, on scientific and semiscientific sources at this time. Thus the following central question must be posed: what was the relationship between scientific theories, vision, and intuition in Seurat's creative process during the first, or chromoluminarist, phase of Neo-Impressionism?

From writings by his close friends, especially Fénéon, we hear repeatedly that science was used primarily as a means of guiding and controlling his highly developed optical sensibilities. In the course of this study, too, it has been found that, rather than closeting himself in his studio and working according to some mathematical or chemical formula, Seurat often painted out of doors and recorded his sensations spontaneously almost in an Impressionist manner in 1884–1885. And from . . . witness accounts, we know that the artist was capable of acute perception of nature's phenomena. Further evidence of his optical sensitivity to the world surrounding him may be found in several of his letters to Signac.

From Honfleur, where he had gone to paint during the summer of 1886, Seurat wrote the following to Signac on June 25: "If you find Les Andelys colored, I see the Seine—gray water, almost undefinable, even in brightest sun with blue sky, at least during the last few days." [12] This brief excerpt certainly hints at his consciousness of the character of light and color as perceived in nature and suggests, too, that he was aware of changes in the weather. At the beginning of the summer at Honfleur, Seurat appears to have worked freely from nature in order to acquaint himself with his subject, inasmuch as he stated in the same letter: "The weather has been good for five days. . . . Up to now I have only done [oil] sketches in order to acclimatize myself." [13] On July 5, 1886, he wrote again to Signac: "The wind and consequently the clouds have bothered me these last few days. The stability of the first days surely ought to return." [14] To anyone familiar with the letters of Monet and Pissarro of the late seventies and early eighties, this complaint about the troublesome instability of the weather may sound as though it could have been written

[12] This letter was published in Dorra and Rewald, *Seurat, Paris,* 1959, pp. l–li.
[13] *Loc. cit.*
[14] This letter was published in Dorra and Rewald, *op. cit.,* pp. li–lii.

by either of these Impressionist painters; it is certainly not the statement of a "scientific" artist who evolved his style only by consulting treatises on physics and optics. And in closing this same letter Seurat wrote: "Let's go get drunk on light *once more, it's consoling.*" [15] In this enthusiastic outburst we have in concise form Seurat's dominating interest at this time—to go outside and become immersed in light.

In these excerpts, there is considerable evidence testifying to Seurat's well-developed optical sensibilities, the importance of which his friend Fénéon pointed out in his remarks on the Neo-Impressionists' method:

> These painters are accused of subordinating art to science. They only make use of scientific facts to direct and perfect the education of their eye and to control the exactness of their vision. Professor O. N. Rood has furnished them with precious discoveries. . . . But Mr. X can read optical treatises forever and he will never paint *La Grande Jatte.* Between his courses at Columbia College, Mr. Rood, whose artistic acumen and erudition seem nil to us, paints: it must be wretched. The truth of the matter is that the Neo-Impressionist method demands an exceptionally delicate eye: all those clever people, who hide their visual incompetency with dexterous niceties, will flee, frightened, from its dangerous integrity. This kind of painting is accessible only to *painters.*[16]

In the same vein, Seurat's friend Émile Verhaeren wrote: "Seurat is depicted as a scholar, an alchemist, etc., and what more I wonder? However, he only makes use of scientific experiments for controlling his vision. Once the painting is finished, one does the proof, as for a problem. What's wrong with this?" [17] Here again we have a statement to the effect that the artist was not being carried away by scientific theories, but that they were used merely to guide his vision. And on the Neo-Impressionists' derivation of principles of color from Chevreul and Rood, Signac observed: "There is indeed a science of color, easy and simple, which all should learn and the knowledge of which would do away with so many foolish judgments. . . . These laws of color can be learned in several hours. They are contained in a few pages by Chevreul and Rood. The eye, guided by them, has only to perfect itself." [18] Although he underestimated the extent of Seurat's debt to Chevreul and Rood, Signac, like Fénéon and Verhaeren, regarded scientific laws of color as a means perfecting the artist's vision, not as a substitute for optical sensibility.

During the first, or chromo-luminarist, phase of Neo-Impressionism Seurat and his friends believed that if they studied the laws governing the behavior of color proposed by modern physics and at the same time observed their subject closely, they could produce pictures that actually duplicated nature's mode of operation and would thus automatically sur-

[15] *Loc. cit.*
[16] Félix Fénéon, "L'Impressionnisme aux Tuileries," *L'Art moderne,* September 19, 1886, p. 302.
[17] Émile Verhaeren, "Le Salon des *Vingt* à Bruxelles," *La Vie moderne,* February 26, 1887, p. 138.
[18] Paul Signac, *D'Eugène Delacroix au néo-impressionnisme,* Paris, 1899; 4th ed., Paris, Librairie Floury, 1939, pp. 120–21.

pass the Impressionists at their avowed purpose. But between 1887 and 1891, Seurat became much less concerned with naturalistic values and turned increasingly to the problem of conveying emotions through more abstract pictorial means. At this time, . . . the artist directed his interest to theoretical sources dealing with questions of harmony, rhythm, and expression, and had succeeded in incorporating ideas derived from them in such paintings as *Le Chahut* and *Le Cirque* [Figs. 27 and 29]. This brings us to a second question: to what extent was Seurat ruled by [these] theoretical texts . . . and to what degree did he transcend them?

Some critics who did not know him well complained that he went too far in regulating his later works through didactic "scientific" formulae. However, several friends of the artist who had discussed with him the role he thought scientific theories (especially those of Henry) should play provide a more reasonable answer to this question. Apropos of the influence of Henry's ideas on Seurat, Kahn wrote: "This furnished Seurat with only the basis, the exact and demonstrated basis that he needed, permitting him to arrive at his final synthesis, which became apparent from his Crotoy marines and was affirmed in his canvases *Le Chahut* and *Le Cirque*." [19] The notion that Henry's scientific theories of expression were not followed slavishly by the artist was also echoed by Fénéon: "Seurat, who was acquainted with the works of Charles Henry, took pleasure in formulating a philosophy of concordances between the character of tones (dark, light . . .), of hues (cool, warm . . .), and of lines (descending, ascending . . .); and his theories were always subject to the finest painterly genius." [20] The same writer, in an important article about Signac, discussed the impact of Henry's ideas in terms that might apply equally well to Seurat, considering the congruity of the artistic aims of the two painters between 1886 and 1891:

> From the start he has subordinated each of his compositions to the character of a dominant direction and accentuates the supremacy of the latter by the contrast of accessory lines: more by intuition than by principle. Having collaborated on [Henry's] *L'Éducation du sens des formes* (in press), *L'Éducation du sens des couleurs* (in press), he is certainly acquainted with the flourishing theory of living reactions, and knows, as everyone does, the close bond which unites angles and rhythmic measurements to the numbers 2^n, to the prime numbers of the form $2^n + 1$, and to the products of these numbers. But he has not become slave to these engaging mathematics; he knows well that a work of art is inextricable. Moreover, nowhere did Henry claim to furnish artists with the means of mechanically creating a somewhat complex beauty. He said: every direction is symbolic.[21]

In this passage we find, again, that the mathematical formulae and theory of linear directions proposed by Henry cannot produce beauty by themselves; they serve merely as the "basis" through which the artist can insure

[19] Gustave Kahn, "Seurat," *L'Art moderne*, April 5, 1891, p. 109.
[20] Fénéon, "Au Pavillon de la ville de Paris," *Le Chat noir*, April 2, 1892, p. 1932.
[21] Fénéon, "Paul Signac," *La Plume*, September 1, 1891, p. 299.

the expression of certain specific emotional states or create pictorial harmony.

Furthermore, if Henry's ideas about esthetics and Seurat's letter to Beaubourg are examined, both will readily be seen to be couched in the most general terms: they deal essentially with *principles* of expression and harmony rather than with any concrete and specific instructions about producing works of art. Even Henry's most mathematical pronouncements are geared to the measurement of intervals between lines and colors on an abstract level; he provided no instructions about the way in which these principles should be applied in paintings. The same may be said about the contents of Seurat's letter to Beaubourg: it merely deals with the raw materials, so to speak, of pictorial expression and harmony; no specific rules for the actual construction of the work of art are proposed.

Seurat's later theory of painting . . . was followed in determining the resultant emotional tone of *La Parade, Le Chahut,* and, to some degree, *Le Cirque.* At the same time, under Henry's influence, he also designed the compositional framework of these paintings according to the golden section ratio and arrived at rhythmic relationships between linear directions in *Le Chahut* and *Le Cirque* by measuring their angles with the *rapporteur esthétique.* But a glance at the diagrams made by the present writer to illustrate these elements will show that, taken by themselves, they are not works of art: they merely act, in Kahn's words, as "the exact and demonstrated basis" to ensure a specific expressive result or to guarantee pictorial harmony.

Fortunately, we have several important contemporary accounts of Seurat's personality and aims that shed further light on his attitude toward the role of theory in art. One of the most perceptive reports on the interaction between artistic intuition and scientific theory in his creative process was furnished by his friend Gustave Kahn, who wrote:

> If he believed that a scientific esthetic cannot be entirely imposed upon a painter because there are intimate questions of art and even of artistic technique which the painter alone can evoke and resolve, he experienced the absolute need to found his theories on scientific truths. His intellect was not absolutely that of a born painter, a painter like Corot, happy to place pretty tones on a canvas. He had a mathematical and philosophic bent of mind, adapted to conceiving art in a form other than painting. I will explain myself more clearly in saying that if certain painters and even good painters give the impression that they could be nothing but painters, Seurat was of those who give the impression, in short, of a more developed aptitude which leads them to devote themselves to the plastic arts, other cycles of human intelligence being reabsorbed in their faculties.[22]

In a similar vein, the Belgian poet Émile Verhaeren, who knew Seurat personally, wrote the following recollections shortly after the artist's death: "To hear Seurat explaining his work, confessing in front of his yearly exhibitions, was to follow a person of sincerity and to allow oneself to be won over by his persuasiveness. Calmly, with cautious ges-

[22] Kahn, "Seurat," pp. 108–9.

tures, his gaze never leaving you and his slow and uniform voice searching for slightly preceptorial words, he pointed out the results obtained, the clear certainties, what he called 'the basis.' " [23] Here the underlying foundation of Seurat's art is again referred to, recalling the term used by Kahn, as the "basis"—"*la base.*" Continuing on this subject, Verhaeren remarked:

> Not only did he never begin his paintings without knowing where he was going, but his concern went even beyond their success as individual works. They had no great meaning for him if they did not prove some rule, some truth of art, or some conquest of the unknown. . . . Perhaps he thought that the scientific and positivist spirit of his time demanded within the realm of the imagination a more clear and solid tactic for the conquest of beauty. He wanted to inscribe this tactic point by point at the bottom of each of his paintings, and he often succeeded. And that is why each year a great work appeared, more theoretical perhaps than simply beautiful, but magnificent in truth sought out and victorious will! [24]

It is interesting to note that Seurat's conception of method, or theoretical "basis," described in Verhaeren's account was one that could be reduced to terms so simple that they might be inscribed at the bottom of each canvas, again confirming our hypothesis that Seurat's "science" involved the application of general guiding principles, not elaborate formulae governing the total creative process.

Finally, on a more personal level, de Wyzewa's recollections provide a picture of the artist's temperament close to that found in the accounts just quoted:

> From the first evening I met him, I discovered that his soul was also one of times past. . . . He believed in the power of theories, in the absolute value of methods, and in the continuance of revolutions. I was very happy to find in a corner of Montmartre such an admirable example of a race which I had supposed extinct, a race of painter-theorists who combine idea and practice, unconscious fantasy and deliberate effort. Yes, I very clearly felt Seurat's kinship with the Leonardos, the Dürers, the Poussins. . . . I add that his research dealt with the same matters, in my opinion, that can occupy an artist. He wanted to make a more logical art out of painting, more systematic, where less room would be left for chance effect. Just as there are rules of technique, he also wanted there to be [rules] for the conception, composition, and expression of subjects, understanding well that personal inspiration would suffer no more from these rules than from others.[25]

De Wyzewa understood better than most of his contemporaries the image in which Seurat probably saw himself: that of a painter-theorist like Leonardo da Vinci or Poussin—both of whom, significantly, played major roles as progenitors of the academic tradition in France, and whose achievements were admired by several of the authors Seurat read. And, like these two

23 Verhaeren, "Georges Seurat," *La Société nouvelle*, April 1891, p. 434.
24 *Ibid.*, p. 436.
25 Teodor de Wyzewa, "Georges Seurat," *L'Art dans les deux mondes*, April 18, 1891, p, 263.

masters, he relied on carefully formulated theories to guide his artistic imagination.

Seurat's allegiance to the academic tradition, as manifested in the early nineteenth century by Ingres, was also observed by Verhaeren: "As he appeared to us, he most often brought Ingres to mind. He had already molded certain of his ideas into axioms, he theorized willingly and loved doctrines, fixed precepts, and sure and indisputable means. But he was colder and more austere than the author of the *Odalisque*.[26] The connection established here between Seurat and Ingres on the basis of their devotion to rational laws and theories in art is all the more significant when we consider that at the École des Beaux-Arts Seurat had been a devoted admirer of Ingres and had studied under one of the master's pupils, Heinrich Lehmann. Indeed, it may be that Seurat's devotion to an approach in painting that owes much to the academic point of view prompted his friend Pissarro to write: "Seurat is of the École des Beaux-Arts; he is impregnated by it." [27]

During the last three or four years of his life, Seurat did, in fact, revive some of the tenets of the academic tradition against which he had rebelled between 1880 and 1886. In resurrecting these tenets he turned, as Sutter had urged,[28] to some of the sources that remained undefiled by the corrupt teachings of the École des Beaux-Arts. But, in addition to following the original academic conception of the role of discipline and law in painting, Seurat also took advantage in a nonacademic way of many of the discoveries made by his contemporaries in the physics of light and color, visual perception, and the psychology of the affective value of color, tone, and line. In realizing that it was imperative to turn to the science of his own day rather than merely imitating the methods inherited from the distant past, he probably saw his own position, as de Wyzewa suggested, as being analogous to that of the painter-theorists of the Renaissance and Baroque periods who used—or occasionally originated—the most advanced "science" of their time.

The observations that we have made concerning Seurat's application of scientific and semiscientific laws and principles to his paintings, along with the foregoing remarks by his friends, bring us to the conclusion that instinct and intuition, on one hand, and a highly rationalized theory of art on the other, were balanced in his creative process from 1886 to 1891, the year of his death. Significantly, just such a relationship was advocated by Sutter, Blanc, and Delacroix, who, in different ways, believed in regulating instinct through proven theories but who, at the same time, favored the independence of the artist's imagination and creative genius. Even Henry, the most scientific of all the writers read by Seurat, admitted the limitations of his own discipline and in the concluding paragraph of his *Rapporteur esthétique* stated: "It is not to be asserted that I wish to substitute the mechanism of an instrument for the creation of the artist. Genius is inimitable, for it is expressed not only by visible

26 Verhaeren, *Sensations*, Paris, 1927, p .203.
27 Letter published in Rewald, *Georges Seurat*, Paris, 1948, p. 115.
28 David Sutter, "Les Phénomènes de la vision," *L'Art*, 20, 1880, p. 269.

rhythms but by an infinite number of more or less invisible rhythms. . . ." [29]

• • •

In the course of this study we have seen that Seurat conceived of science in several different ways and that he continually sought to improve it, with the result that he turned to a number of different texts at various stages in his development. It will be appropriate, therefore, to conclude with a summary of his changing conceptions of science and their sources. At the beginning of his career, he studied carefully Charles Blanc's *Grammaire des arts du dessin* and Chevreul's *De la loi du contraste simultané*, both of which dealt with the problems of obtaining harmony through contrast and analogy, and demonstrated ways in which colors could be made to appear more intense by juxtaposition to their complementaries. Blanc also enunciated two principles that were to be of paramount importance for Seurat's art: gradation and optical mixture. His "science," however, was based mainly on his knowledge of Delacroix, Chevreul, and the "oriental" rules of coloring that had been handed down by artists and craftsmen from generation to generation. In short, though Blanc's book was published in 1867, it was based more on painters' recipes than on recent developments in physics and optics.

Unlike Blanc, Chevreul was trained as a chemist and was generally respected in scientific circles. But though he lived until 1889, his *De la loi du contraste simultané*, which was published early in his career—in 1839 —was never revised by its author. From the standpoint of new developments in physics in the 1860s and 1870s, Chevreul's book was antiquated as a scientific treatise; yet he was still hailed widely in the 1880s for discovering a number of important principles governing color behavior. It should be kept in mind, too, that the book was not conceived as a contribution to the discipline of physics or chemistry, but rather was designed as a manual for painters, designers, and decorators.

The systems of color harmony advocated by Chevreul and Blanc, while proposed as general laws, cannot be regarded as entirely scientific in origin, in the sense of being derived exclusively from the disciplines of physics or optics . . . both authors shared the idea that complementary colors, as well as those close to each other on the chromatic circle (analogous colors), were harmonious. This concept of harmony, however, had been understood instinctively by artists since the Renaissance. In the nineteenth century, as Blanc pointed out, Delacroix brought this system to a high point of development, first by studying the principles of coloring utilized by "oriental" artists and then by following Chevreul's precepts. Thus the laws of color harmony proposed by Chevreul and Blanc, while rigorous in nature, tend to be codifications of principles already discovered independently by painters and decorators. Moreover, neither Chevreul nor Blanc used the scientific instruments available in their day to investigate the phenomena of color and light, but instead relied on empirical observation—called the "experimental method" by Chevreul—in arriving at

[29] Charles Henry, *Rapporteur esthétique*, Paris, 1888, p. 15.

their conclusions. There is, particularly in Chevreul's system of arranging colors, a predetermined, "classical" quality that may be seen in the regularity of subdivisions of the chromatic circle and its radii that resulted from a dogmatic and overly arbitrary approach to the problem of color on the author's part.

While Seurat based much of his early color technique on the principles set forth by Blanc and Chevreul, their errors were pointed out in the writings of Rood and Henry. Chevreul, in particular, came under attack by Rood for arranging colors in an *a priori* fashion rather than placing them carefully on the color circle on the basis of data provided by physicists' instruments of measurement. Henry, too, insisted that the angular relationships between the radii of the color circle be determined with great care. Moreover, Rood and Henry demonstrated the incorrectness of Chevreul's and Blanc's conception of the mixture of colored light and countered with a definition of the difference between additive and subtractive mixture based on the experiments of Helmholtz and Maxwell —a definition that in its essentials is still accepted by color scientists today. Seurat understood these principles of additive mixture of colored light as a result of studying Rood's *Théorie scientifique des couleurs* and applied them rigorously in *La Grande Jatte, Les Poseuses,* and *La Parade.*

With his discovery of Rood's book, Seurat's theory took on an increasingly scientific character. The American scientist approached many of the same matters discussed by Chevreul and Blanc—division of color, optical mixture, contrast, gradation, and color harmony—but based his conclusions on the rigorous measurements of color phenomena with instruments developed by the disciplines of physics and optics. Thus, while Chevreul and Blanc proposed a number of general principles of color behavior, Rood gave more specific instructions to artists about how color should be handled, particularly with the aim of achieving a high degree of luminosity. And in addition to basing his book on color theories current in his day, he performed a valuable service for Seurat in demonstrating precisely how modern physics could—and should—be applied in the art of painting.

We have also seen that Rood was concerned with the question of color harmony and that in *Une Baignade* and *La Grande Jatte* Seurat followed some of his recommendations. But in this matter Rood was far less scientific in approach than he was elsewhere in his *Text-Book of Color.* The chapter on color combinations, for example, is comprised largely of a summary of agreeable arrangements proposed by Chevreul and the Viennese physiologist Ernst Wilhelm von Brücke (the latter's suggestions, in turn, were not based on any system of physical measurement, but again on personal choice). Rood's own suggestions for harmony stem from his observation of nature and an analysis of colors used by the old masters. Thus as one of the major influences on Seurat between 1883 and 1886, Rood advocated a system of color harmony based on esthetic judgments that he and several other writers had formulated in a rather arbitrary fashion. This point is mentioned here in order to underline our conclusion that, while many aspects of Seurat's technique were grounded

in modern physics, his conception of harmony can hardly be called scientific, in the strict sense of the word, stemming as it does from a wide variety of traditional artistic and theoretical sources. In one respect, however, Rood's advice on the subject of color harmony may be regarded as scientific: he provided Seurat with a contrast-diagram [Text Figure 2] on which the placement of complementary colors that harmonized with each other had been determined by controlled laboratory experiments.

So far we have found that two rather different types of "science" were studied by the artist: the first, as exemplified by Chevreul's work, was a result of abstracting general laws from a large number of experiences of color behavior as observed in nature and in the composition of tapestries; Blanc's writings, too, fall in this category, with the difference that through personal contact with Delacroix he had based some of his theories on color recipes that the artist had pointed out to him. While Chevreul and Blanc exerted a strong influence on Seurat's early work, he entered a second, more rigorously scientific phase in his painting and theory between 1884 and 1886, largely through the application of the principles presented in Rood's *Théorie scientifique des couleurs*. This book, as we have indicated, was a compendium of most of the important recent developments in the physics of light and color, and it provided Seurat with a theoretical and technical foundation for the style that is best described as "chromo-luminarism."

Between 1887 and 1891, however, he adopted another type of

Text Figure 2. Seurat's Copy of Rood's Contrast-Diagram, Mme. Ginette Signac Collection, Paris.

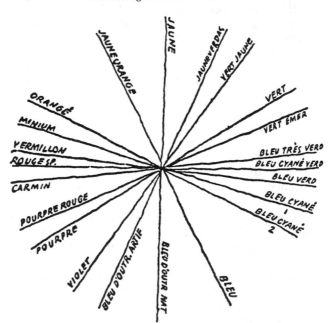

science, partly as a result of his contact with Charles Henry. While the latter's writings indicate that he was conversant with most of the sources on which Seurat's theory of chromo-luminarism was based, Henry's major contribution was in stimulating the artist's interest in the expressive possibilities of color and line. Henry's theories, in turn, were based on several different scientific disciplines. First, he attempted to prove his hypothesis that different sensations produce measurable physiological reactions in a human organism by citing experiments conducted by such pioneers in psychology as Féré, Wundt, Fechner, and Helmholtz. Second, he relied on Rood and Helmholtz, among others, for their discoveries relating to the physical laws of color and light. Equally important, however, was Henry's use of algebra and geometry: he recommended the use of a formula based on Gauss's theory, and the golden section, as devices that would enable artists to guarantee harmonious results in any given visual configuration. Thus, experimental psychology, physiology, mathematics, and physics were all drawn upon by Henry's encyclopedic mind in creating a universal system of harmony based on the achievements of modern science.

. . . in the matter of expression through formal elements, Seurat's theory and practice were heavily influenced by Henry, whose writings synthesized the four disciplines just enumerated; but as far as we can determine, Seurat did not, except in the case of physics, turn directly to the sources upon which Henry based his theories. Thus, the scientist undoubtedly opened new horizons for the artist, particularly by embodying in his books and demonstrations the discoveries made by the nascent discipline of experimental psychology, which proved scientifically the propositions that Seurat had studied in the less rigorous theories of expression formulated by Humbert de Superville, Blanc, and Sutter. These three writers, however, did provide valuable lessons for Seurat and contributed in part to his esthetic, as stated in his letter to Beaubourg. This third type of "science"—geared to the expression of specific feelings through configurations of color, value, and line—may thus be added to the two already mentioned. It should be kept in mind that the first and second phases of Seurat's use of science, which resulted in his chromo-luminarist style, were not *replaced* by the third; rather, this was added as a modifying element that further enriched his total theory of art.

Seurat's belief that the underlying basis of painting should be a configuration of abstract elements that might convey a variety of emotions became increasingly popular among artists in the late 1880s and early 1890s and in essence parallels the theories developed at this time by the Symbolist painters. There are, of course, important differences between Seurat's later views and those held by the Symbolists, but they have in common the conviction that a painting is essentially an abstraction that can communicate feelings through the inherent evocative power of visual forms. In his concern with specific emotional states and the pictorial means by which they could be conveyed, Seurat entered a phase of his development that, in spite of the name of the movement he instituted—Neo-Impressionism—had little to do with Impressionism in theory or practice.

From a scientific "reform" of Impressionism, his major interest from 1884 to 1887, he gradually devised a more conceptual, schematic, and symbolic art that, with its accompanying theory of expression, was to have many implications for twentieth-century painting. In the first stage of his career, then, Seurat brought to a final point of development the artistic innovations of the Impressionists; in the second phase, which was cut short in 1891 by his fatal illness, his art and theory pointed prophetically to the future.

SEURAT AND PIERO DELLA FRANCESCA (1965)[1]

Albert Boime

The question of a possible relation between the work of Georges Seurat and that of Piero della Francesca is one that arises periodically,[2] but is never satisfactorily answered. The frequent observation by critics and historians that Piero and Seurat manifest considerable stylistic affinities is often coupled with the implication that these affinities are temperamental and "spiritual" in nature. Longhi [3] and Clark,[4] two of Piero's major biographers, as well as a host of others,[5] allude to this relationship.

Indeed, even the most cursory examination will reveal some of Seurat and Piero's similarities. Both were devoted students of mathematics and science, and Piero's interest in the geometric aspects of early Renaissance architecture parallels Seurat's fascination with the new industrial technology.[6] Both had orderly, exact minds, intent on systematizing the practices of their contemporaries. Their works were composed with such

Albert Boime, "Seurat and Piero della Francesca," *The Art Bulletin*, 47, June 1965, 265–71. These excerpts, pp. 265, 266, 267-70. By permission of *The Art Bulletin*.

Albert Boime, (19?-) Professor of Art History at the State University of New York, Binghamton. Author of *The Academy and French Painting in the Nineteenth Century* (1971).

1 The substance of this article was delivered in a lecture at the Frick Symposium of 1963. [This and all subsequent footnotes are the author's,—Ed.]
2 A recent allusion to this relationship was made by Benedict Nicolson. See his article, "Reflections on Seurat," *Burlington Magazine*, 104, 1962, p. 214.
3 Roberto Longhi, *Piero della Francesca*, Rome, 1927, p. 56.
4 Clark posits a connection in a number of places. See Sir Kenneth Clark, *Piero della Francesca*, New York, 1951, p. 2. Also his *Landscape into Art*, London, 1950, p. 116, and *Looking at Pictures*, London, 1960, p. 136.
5 Among others, Roger Fry, *Transformations*, London, 1926, p. 191; Daniel Catton Rich, *Seurat and the Evolution of "La Grande Jatte,"* Chicago, 1935, p. 46; R. H. Wilenski, *Seurat*, Faber Gallery Publication, London, 1949, p. 2; Lionello Venturi, "Piero della Francesca, Seurat and Gris," *Diogenes*, No. 2, Spring, 1953, pp. 20–21.
6 For Piero's interest in the architecture of his time see Clark's monograph, *op. cit.*, pp. 19, 31, 49–50. Seurat's attachment to the technical side of society is discussed by Meyer Schapiro in his articles "Nature of Abstract Art," *Marxist Quarterly*, 1, 1937, p. 9, and "Seurat and 'La Grande Jatte,'" *Columbia Review*, 17 1935, p. 7.

mathematical precision as to lead some to believe that they were in possession of a formula.[7] And although neither left behind a school, they both exercised an influence on subsequent generations.[8] Moreover, they both show a preference for mass-spectacle situations, parades and festivals, and unusual characters in colorful costumes.[9]

Perhaps the most salient feature shared by these painters is the stylization of figural attitudes and the calculated expression imposed on their figures. Both artists exploit coordinate views, showing the figure in full-face, in profile, or from the rear. This can be explained by their obvious desire to reduce figural activity and induce a static effect. When this treatment of the figure is applied on a large scale it expresses a classic monumentality. Thus there can be little doubt that Piero and Seurat stand in a definite temperamental relationship to each other.

But now we must inquire whether these similarities are coincidental or whether they reveal a deliberate attempt on the part of Seurat to model his work after Piero . . . [and we must] examine the critical events within the Beaux-Arts administration that deeply affected Seurat and gave rise to his relationship with Piero. Paradoxically, the artist credited with anticipating contemporary trends was caught up in the ideological conflicts of the Academy itself, and was perhaps in this respect more conservative than has hitherto been suspected. Many of Seurat's closest associates have alluded to his strong ties with the École.[10] Seurat entered that institution in 1878 when he was eighteen years old.[11] At that time, the conservative artists of the Beaux-Arts Academy led by Gérôme, Baudry, Bouguereau and Seurat's teacher, Lehmann, were entrenched in a moribund romanticism. They painted stereotyped themes and anecdotal subjects, allowing a slick technique to supplant a lack of intrinsic motivation. However, more sophisticated members of the Beaux-Arts administration sought a

[7] Clark, *op. cit.*, p. 20. Signac implies a Neo-Impressionistic formula in the last paragraph of his book. See Paul Signac, *D'Eugène Delacroix au néo-impressionnisme*, Paris, 1899, p. 129.

[8] This aspect of Piero is rarely discussed. But he profoundly affected many Umbrian painters, including his pupils, Luca Signorelli, Melozzo da Forli, Lorenzo da Viterbo and probably Raphael. See J. A. Crowe and G. B. Cavalcaselle, *A New History of Painting in Italy from the Second to the Sixteenth Century*, 3 vols., London, 1864–1866, 2 pp. 552–555. Also Jean Alazard, *Piero della Francesca*, Paris, 1948, pp. 48–49.

[9] In Piero these characteristics are evident in such works as the *Queen of Sheba's Visit to Solomon, Discovery and Proof of the Cross, Battle of Constantine* and *Heraclius Restores the Cross to Jerusalem.* Piero's love for parade and luxurious costumes is discussed by Lionello Venturi in his *Piero della Francesca*, Geneva, 1954, p. 10.

[10] Félix Fénéon in Julius Meier-Graefe, *Modern Art*, Florence Simmonds and George W. Chrystal, trans., 2 vols., New York, 1908, 1, p. 311. Signac noted that Seurat followed the courses offered at the École but resisted the teaching of his professors by a supplementary study of "classical masters" (*op. cit.*, pp. 66–67). However, Pissarro once wrote to Signac: "For the future of our art 'Impressionism,' it is absolutely essential that we remain outside of the influence of Seurat's school . . . *Seurat is of the École des Beaux-Arts*, he is impregnated with it, therefore take guard, there is a danger. . . ." (John Rewald, *Seurat*, Paris, 1948, p. 115.)

[11] Jacques de Laprade, *Seurat*, Paris, 1951, p. 11.

more genuine mode of expression and countered the conservatives by participating in a revival of the Italian "Primitives." [12] Men like Paul Mantz and Georges Lafenestre [13] both express admiration for Piero at a time when others, like the parochial Henri Delaborde, would dismiss Piero's importance.[14] However, at the same time that an interest in the early Italian masters was revived, an even more extreme tendency, Impressionism, emerged from without to challenge the official art.

Impressionism produced a polarization, forcing the otherwise responsive members of the Beaux-Arts administration reluctantly to take up the cudgels in defense of a conservative position. The outstanding example of this conservative withdrawal was Charles Blanc, who occupied the office of Director of Beaux-Arts five years before Seurat's enrollment in the École.[15] Once a friend of Delacroix and intimate with Chenavard, he was aware of the rigidity of the Academy, but like many others he could not adjust to the revolutionary work of the Impressionists. Although Blanc already had opposed the Barbizon school and criticized it for its trivial subject matter, it presented no serious threat to his concept of "elevated" art. But the rise of the Impressionists dramatized the scope of the Barbizon influence, and underscored the need for an urgent counter-program to arrest what he considered a shallow movement. In 1872 Blanc had tried

[12] The national taste for the Primitives developed during the July Monarchy and continued through the century, but it received its greatest impulse in the early years of the Third Republic. See Müntz, "The Italian Primitives," in *The Great Masters in the Louvre Gallery*, 2, Paris, 1898–1900, p. 4. Also Léon Rosenthal, *Du romantisme au réalisme*, Paris, 1914, p. 95.

[13] As a critic, Mantz championed Millet and praised the talent of young Monet. Officially, he held the position of Minister of Interior, served on the Committee of the Societies of Beaux-Arts, and was appointed Director of Beaux-Arts in 1882. Reviewing the Salon of 1872, Mantz derided the "philosophers" who predicted that in the aftermath of the Franco-Prussian War, painting would reflect a greater range of emotional expression. He sympathized with their hopes but noted that ". . . the physiognomy of the Salon differs little from the expositions which have preceded the crisis. . . ." For him the same lack of sentiment that characterized the previous Salons still remained. See Paul Mantz, "Salon de 1872," *Gazette des Beaux-Arts*, 2nd ser., v, 1872, pp. 449–450. Two years earlier he wrote of his appreciation for Piero and was disturbed that the master's work was "ignored by France." Mantz, *Les chefs-d'oeuvre de la peinture italienne*, Paris, 1870, p. 148. Georges Lafenestre, like Mantz, served in several official positions. He was Inspector of Beaux-Arts in the late seventies, Chief of the Office in the administration, was Curator of Paintings in the Louvre and wrote numerous articles for the *Gazette*. For his interest in Piero see Georges Lafenestre, *La peinture italienne*, Paris, 1885, pp. 243–249.

[14] See Henri Delaborde, "La collection de tableaux de M. le Comte Duchâtel," *Gazette des Beaux-Arts*, 12, 1862, pp. 9–14. A general article dealing with the Madonna subsequently given to Baldovinetti by Berenson, Delaborde includes a biographical sketch of Piero and contrasts his art with that of Ingres. Calling Piero's work the product of an "adolescent art," and that of Ingres a "consummation," he thus accounts for Ingres' popularity and Piero's obscurity. Also see note 39 below.

[15] For Blanc's biography see L. Fiaux, *Charles Blanc*, Paris, 1882. For a record of his accomplishments see Eugène Guillaume, "Charles Blanc," in *Notices et Discours*, Paris, 1882, pp. 2–48. Blanc served as Director for the second time during the years 1871–1873.

to block a new Salon des Refusés,[16] and that year Puvis de Chavannes had resigned from the Salon jury because of Blanc's intolerance for the Impressionists.[17] Rejecting both the moribund works of the Academy and the incomprehensible innovations of the Impressionists, Blanc tried to deliver the "National Art" from this impasse by reinstating the Renaissance tradition, particularly the Primitives. In pursuit of his program, he tried to indoctrinate the public and the rising generation of artists by advancing a spectacular plan for the organization of a museum that would house full-scale copies of the great Renaissance works.[18] On October 26, 1871, Blanc submitted his official report to the Minister of Beaux-Arts and introduced his idea for a Musée des Copies.[19] He urgently admonished the Minister to provide him with funds adequate to commission copies of masterpieces not owned by the Louvre.[20] The purpose was to encourage French artists and to "strike the eyes of the people in a . . . lasting fashion." [21] Discussing his plans for a "magnificent gallery without parallel" to house these projects, he wrote that it would include Raphael's frescoes in the Stanze, the Prophets and Sibyls of Michelangelo, the *Swan* of Leonardo, the frescoes by Masaccio, Ghirlandaio, Mantegna and Andrea de Sarto.[22] And in the

16 Rewald, *The History of Impressionism*, New York, 1946, p. 227.

17 Camille Mauclair, *Puvis de Chavannes*, Paris, 1928, p. 13.

18 The first to call attention to this museum in recent years was Longhi in his monograph on Piero. Referring to copies after the Arezzo frescoes hanging in the chapel of the École des Beaux-Arts, he mentions that they were originally commissioned for the Musée des Copies (*op.cit.*, p. 143n). Clark also refers to these copies in the chapel (Landscape, *op.cit.*, p. 116).

19 The original report, together with its rough drafts, may be found in Archives Nationales F21 572 (herein referred to as Arch. Nat.). The museum was also referred to as the *Musée européen*. For a full historical description of the museum see A. Boime, "Le Musée des copies," *Gazette des Beaux-Arts,* October, 1964, pp. 237–247.

20 Arch. Nat. This was to be one of the principal arguments used by apologists for the museum. Another was the preservation of deteriorating frescoes by means of the copy. See Louis Auvray, *Le musée européen*, Paris, 1873, pp. 1, 11. Auvray also contrasts the copies with examples from the Salon of 1872 to the detriment of the latter (pp. 6–7).

21 Arch. Nat. Blanc complained that French artists have been "reduced to misery by the prolonged cessation of work" and were being lured away from their homeland by offers from other countries, "not only England, Russia, Austria, but especially America." Blanc feared that America was the greatest threat to the superiority maintained by the French in the arts and industries. In order to halt this "expatriation" Blanc suggested a large-scale governmental operation to provide for a number of commissions. In a period following the Franco-Prussian War, French prestige was indeed at its lowest ebb. But Blanc was also concerned with the success of the Barbizon painters in America and probably with the patronage of Durand-Ruel in London of the young Impressionists. It was this kind of patronage that encouraged the landscape painters. See Rewald, *op. cit.*, pp. 211–212. Also Lionello Venturi, *Les archives de l'impressionnisme*, 2 vols., Paris and New York, 1939, 1, pp. 17–19, 2, pp. 175–180.

22 Arch. Nat. Many of these copies had been previously executed. The two brothers, Raymond and Paul Balze, had copied Raphael's frescoes in 1835, and Paul Baudry had copied Michelangelo's Prophets and Sibyls. The fact that these copies were used in the Museum of Copies points to contradictions in the proposal by Blanc. To include objects of a previous period was to deny the museum's value as an immediate stimulus to artistic activity.

concluding paragraph of this report he wrote that in striking the eyes of the people the copies would "initiate them to the magnificent discoveries of modern science, by reviving the cult of the highest national tradition."

We may never know how this passage affected the Minister but to any student of the period its implications are profoundly significant. For Blanc, a utopian socialist in the tradition of Saint-Simon, modern science promised on the one hand to liberate the working class from the yoke of animal labor, and on the other to cultivate in the emancipated proletariat a taste for the industrial and fine arts.[23] Hence the passage is rendered meaningful by the association of modern science and technology with an aesthetic metamorphosis; according to Blanc, however, the model for progress was to be the Renaissance tradition. This paradox did not torture Blanc, for he could recall that the great scientific and artistic achievements of the Quattrocento were also inspired by classical materials. Thus the great social transformations of the fifteenth and nineteenth centuries are marked by a humanistic revival.[24] Crucial to this concept was Blanc's belief, which he shared with Chenavard, that painting had ceased to express an elevated picture of society, that it neglected the image of man and began to substitute the insignificant imagery of landscape.[25] To Blanc, a dehumanized art denied the human gain of technological innovation.[26] Hence, convinced there was a wide gap between scientific progress and that of the arts, he attempted to halt what he considered a decline in the arts and to direct attention to the classic creations of the past. He thus invoked the work of the Renaissance to emphasize the virtues of a humanistic and individualistic point of view; to restore the image of man in a period when landscape was being increasingly used as subject matter.

Two of Blanc's major commissions for the Museum of Copies were full-scale facsimiles of the Arezzo frescoes, the *Battle of Heraclius* and the *Discovery and Proof of the Cross*.[27] Blanc had praised Piero in his monu-

[23] In this Blanc shared the views of his brother, the famous socialist, Louis Blanc. See Fiaux, *op.cit.*, pp. 24–25, 35, 50. Also Philippe de Chennevières, "Charles Blanc," in *Souvenirs d'un Directeur des Beaux-Arts*, Paris, 1883, pp. 87–88. The notion had been expressed in the catalogues for the Expositions Universelles of 1855 and 1867. See also E. du Sommerard, *Notice sur M. Charles Blanc*, Paris, 1883, pp. 26–27.

[24] See Blanc, *Le Cabinet de M. Thiers*, Paris, 1871, pp. 75–76.

[25] Blanc, "Exposition Universelle," in *Les Artistes de mon temps*, Paris, 1876, pp. 414–415. In his discussion of the awards for painting, Blanc was disheartened by the fact that Rousseau won a Medal of Honor: ". . . to suppose that even landscape could compete with a more elevated painting, that is to say, in which the human figure plays the principal role." For Chenavard's view see Théophile Silvestre, *Histoire des artistes vivants, français, et étrangers*, Paris, 1856, p. 7; in Joseph C. Sloane, *Paul Marc Joseph Chenavard*, Chapel Hill, N.C., 1962, p. 73. Chenavard assisted Blanc in forming the Museum of Copies. Arch. Nat. F21 494.

[26] Henri Delaborde, "Musée des copies," *Revue de Deux Mondes*, 105, May 1, 1873, p. 211. For more of Blanc's philosophy see his introduction to the first issue of the *Gazette des Beaux-Arts*, 1, 1859, pp. 1–15.

[27] The copy of the *Battle of Heraclius* was commissioned early in 1872 and the finished work shipped to Paris in October; the *Discovery and Proof of the Cross* was commissioned in February, 1873 and the copy shipped to Paris in August of that year. The size

mental *Histoire des peintres de toutes les écoles,*[28] as well as his *Histoire de la Renaissance artistique en Italie.*[29] In the preface to the latter work, Blanc's literary assistant wrote that the aim of the book was to present a good guide to the Primitives.[30] This was necessary because the visitor to Italy who is always going to admire Michelangelo, is generally less experienced with works by the "immortal precursors," among them Piero della Francesca.[31] Writing of the unforgettable frescoes of Arezzo, Blanc calls Piero "a singular genius who strangely combined the qualities of an artist with the geometrical exactitude of a scientist." [32] Blanc sadly laments the deteriorating condition of the Arezzo works, but states that "they have escaped complete loss thanks to the beautiful copies that have been made by the French government." [33] And in a footnote adds: "These precious frescoes were copied by Monsieur Loyeux when we had the honor of directing the Administration of the Beaux-Arts, and on our proposal they are now in the École des Beaux-Arts. . . ." [34]

Charles Loyeux [35] was an obscure artist recommended to Blanc by Gérôme on the basis of his skill as a copyist.[36] Indeed, the accuracy of Loyeux's copies after Piero was never questioned by his contemporaries in France and Italy.[37] Because of his exceptional skill, Loyeux became

of the two copies is 3.37 × 7.45 meters. See Arch. Nat. F21 495A, 235 for this documentation and correspondence between the artist and Blanc. As Auvray's work was published at the time of the museum's opening, April 15, 1873, only the *Heraclius* is listed (*op.cit.*, p. 56). A complete catalogue of all copies exhibited appeared in the *Journal des débats*, Dec. 30, 1873, p. 5; also in *La chronique des arts*, 3 parts, Jan. 3, 1874, pp. 1–2; Feb. 7, p. 51; Feb. 14, p. 62.

28 Blanc, *Histoire des peintres de toutes les écoles*, "École Ombrienne et Romaine," Paris, 1861 *et seq.*

29 Blanc, *Histoire de la Renaissance artistique en Italie*, 2 vols., Paris, 1889 (pub. posthumously by Maurice Faucon), 2, pp. 96–106.

30 Blanc, *Histoire de la Renaissance*, 1, p. ix. In preparation for this book, Blanc had undertaken a special trip to Italy for study of the Primitives. Significantly, he based a course on this subject at the Collège de France, where he taught during Seurat's student years. In Tullio Massarani, *Charles Blanc*, Paris, 1885, p. 75. Part of his research was published in a series of articles for *Le Temps*. See Blanc, "Une Excursion en Italie à la recherche des précurseurs," *Le Temps*, Jan. 7, March 3, April 14, Sept. 2, Oct. 5, Nov. 3, 1881; Jan. 29, Feb. 5, 1882. It was the last work he wrote. He died on January 18, 1882 while two of the articles were still in manuscript form. See Mantz, "Charles Blanc," *Le Temps*, Jan. 19, 1882.

31 Blanc, *Histoire de la Renaissance*, 1, p. ix.

32 Blanc, *ibid.*, 2, pp. 99–100.

33 *Ibid.*, pp. 101–102.

34 *Ibid.*, p. 102n.

35 Charles Loyeux (1823–1898). See Thieme-Becker references. He is primarily remembered for his portraits which he exhibited often in the annual Salons. Trained in the studio of Delaroche, he became friendly with Gérôme, Yvon, and Jobbé-Duval, who studied there at the same time. It was through their influence that Loyeux received the commission to copy the frescoes by Piero. See Arch. Nat. F21 235.

36 Arch. Nat. F21 235. Answering Blanc's request for a recommendation, Gérôme wrote: ". . . Loyeux . . . is a man with some talent, and especially a very skillful copyist. . . ."

37 Loyeux's copy of the *Heraclius* was so faithful that an official of Arezzo requested permission from Blanc to photograph the copy, stating: "It would be extremely difficult to photograph the original, and the . . . copy is of a marvelous resemblance." (Arch. Nat. F21 235) Auvray notes that the copy was a "conscientious work" indicating the deteriorated parts of the fresco (*op.cit.*, p. 56).

the local hero in Arezzo.[38] The resulting publicity placed Piero in a new light at the École, where these copies were to be retained long after the demise of the Museum of Copies.[39]

But Blanc's effort to revive an early Renaissance model was never fully realized; at the end of 1873 the museum was dismantled and Blanc was discharged from his position as Director.[40] Yet his visionary scheme marks the institutional manifestation of a turning point in the history of art. And it is here that the twenty-four-year-old Georges Seurat enters the picture. Synthesizing the conflicting trends, he embodied in part the École tradition, Blanc's distinctive outlook, and the technique of the Impressionists. The result was "a vigorous conventional structure" adorned by the new color conceptions.[41] His indebtedness to Blanc was revealed by Signac, who as late as 1925 still declared the debt that he and Seurat owed to the writer.[42] Blanc's most notable literary effort, *Grammaire des arts du dessin*,[43] apparently served as a bible for the two artists. Signac often invoked the authority of this work in his own writings, and we know that Seurat had a copy of this book in his studio.[44] But Seurat inherited more

38 When Loyeux returned to Arezzo for the second time to copy the *Discovery and Proof of the Cross*, the Petrarch Academy of Arts and Sciences of that city conferred on him an honorary diploma and struck a special medal in his honor (Arch. Nat. F21 494, 235). See also the letter of the Secretary-General of the Academy to Blanc describing the ceremony held in Loyeux's honor (Arch. Nat. F21 494).

39 For special references to Loyeux's commission see *La chronique des arts*, No. 33, Sept. 10, 1872, p. 346; *Le Galois*, Sept. 2, 1872, p. 1. Few of the copyists received this attention and the response of Arezzo dignitaries to Loyeux's work delighted the officials of the Beaux-Arts administration. See Arch. Nat. F21 494, 235. Fifteen years later, an Italian art historian would recall the event of Loyeux's commissions, claiming that it had been a great honor for Piero and his country. See Luigi Guinti, "Borgo San Sepolcro," in *Arte e Storia*, Oct. 18, 1887, pp. 215–216. While the museum was being dismantled at the end of 1873 Blanc's successor summoned a special committee to decide the fate of the 157 copies. It was decided to retain the important works and relegate "secondary" copies to provincial museums, churches and public buildings. A controversy ensued over the value of keeping the Piero della Francescas, with Delaborde against. It was finally resolved by the member of the committee responsible for the disposition of the copies, Eugène Guillaume, then Director of the École. Apparently urged by Blanc to retain the copies, Guillaume wrote on January 16, 1874 that "the Piero della Francescas will be kept by us in any case; I believe that they should be sent to the École . . . [they] have interest only for study and for the artists. . . ." For this information and other details of the museum's dismantling and dispersal of the copies see Arch. Nat. F21 486, 572. Early in 1874 the two copies were hung in the chapel on the right wall and later recorded by Müntz. See Müntz, *Guide de l'École Nationale des Beaux-Arts*, Paris, 1889, p. 288. The works are still in situ.

40 Blanc was replaced on December 23, 1873, one week prior to the special session summoned by his successor. See *La chronique des arts*, Dec. 27, 1873, p. 1. The article deceptively states that Blanc resigned voluntarily to devote more time to writing. Later Chennevières revealed the truth of Blanc's dismissal (*op.cit.*, pp. 93–94). Also Fiaux, *op.cit.*, pp. 45–46.

41 Meier-Graefe, *op.cit.*, p. 311.

42 Jacques Guenne, "Entretien avec Paul Signac," *L'art vivant*, 1, March 20, 1925, p. 3. Blanc's influence on Seurat is discussed in detail in William Innes Homer, *Seurat and the Science of Painting*, Cambridge, 1964, pp. 29–36, 208–211.

43 Blanc, *Grammaire des arts du dessin*, Paris, 1867. It had many editions.

44 Signac, *op.cit.*, pp. 21, 67, 89, 103–104, 106. See also F. Cachin's edition of Signac's work in the series *Miroirs de l'Art*, Paris, 1964, p. 168. For Seurat's copy see Émile Verhaeren, *Sensations*, Paris, 1927, p. 200.

from Blanc: an interest in scientific innovation and the use of the human image as subject matter for his monumental paintings. As Professor Schapiro suggests, he imposed a systematic structure on fleeting impressions in order to bring "Impressionism up to date in light of the latest findings of science." [45] Moreover, Seurat's preoccupation with Blanc's ideas and a humanistic concern led him beyond the Impressionists. He reasserted the importance of the human subject and projected it in the monumental style of the Italian Primitives.[46]

[45] Schapiro, *Marxist Quarterly, op.cit.,* p. 9.
[46] See Robert L. Herbert, *Seurat's Drawings,* New York, 1962, pp. 30–31.

NEW LIGHT ON SEURAT'S "DOT": ITS RELATION TO PHOTO-MECHANICAL COLOR PRINTING IN FRANCE IN THE 1880's (1974)

Norma Broude

In the winter of 1885–86, Georges Seurat adopted the technique of *peinture au point* in order to facilitate the optical mixture that is central to the theory of Neo-Impressionism.[1] From the start, the technique suggested to Seurat's contemporaries analogies with mechanical forms of color reproduction. Typical of these reactions was Gauguin's hostile view of the Neo-Impressionists, whom he described as "petits jeunes chimistes qui accumulent des petits points," an activity, he said, which "mène tout droit à la photographie en couleurs."[2]

More recently, the apparently uniform and texturally abstract surfaces of Seurat's mature canvases have elicited similar analogies, though in a far different spirit. Meyer Schapiro, who has taught us to attach a new and positive value to "Seurat's sympathetic vision of the mechanical in the constructed environment,"[3] has proposed the intriguing possibility of comparison between Seurat's "laborious method" and "the mechanical process of the photo-engraved screen."[4] But, as Schapiro himself has been among the first to stress, Seurat's technique is an "intensely personal" one ("his touch is never mechanical, in spite of what many have said")[5] and

Norma Broude, "New Light on Seurat's 'Dot': Its Relation to Photo-Mechanical Color Printing in France in 1880's," *The Art Bulletin*, 56, December 1974, 581–89. By permission of *The Art Bulletin*.

Norma Freedman Broude (1941–) Associate Professor of Art History at The American University in Washington, D.C., Ph.D., Columbia University, 1967. She is the author of articles on Seurat, Degas, and the Italian Macchiaioli, which have appeared internationally in scholarly journals that include *The Art Bulletin, The Burlington Magazine* and the *Gazette des Beaux-Arts*. She is currently preparing a book on the writings of Henri Matisse and is planning a work on the sources and origins of French Impressionism.

[1] On the evolution of Seurat's theory and technique, see the excellent study by William I. Homer, *Seurat and the Science of Painting*, Cambridge, Mass., 1964, which provides the background and foundation for much of the discussion that follows.

[2] Cited by John Rewald, *Seurat*, Paris, 1948, 125.

[3] Meyer Schapiro, "New Light on Seurat," *Art News*, 57, April, 1958, 52.

[4] *Ibid.*, 24.

[5] *Ibid.*, 23, 44; observed, too, by John Rewald, *Post-Impressionism*, New York, 1956, 105.

the surfaces of his pointillist pictures, unlike those produced by the photo-engraved screen, are, in reality, neither uniform nor mechanical. Further analogies between pointillism and the modern, photo-mechanical technique of three-color "process" printing [6] are equally specious and without historical foundation, first, because three-color screen printing did not become a practical commercial reality in Europe until well into the 1890's,[7] and second, because it has long been clear that such a simplistic system of optical mixture, based on the primary colors alone, was never Seurat's goal. [8]

In the more primitive procedures and effects of photo-mechanical color printing in France during the 1880's, however, some remarkable parallels do in fact exist, not only for the technical methods and visual effects that Seurat exploited, but also for some of the general visual problems that he set himself. Of particular relevance in this regard are examples of the contemporary *chromotypogravure,* a form of early, photo-mechanical color printing, unique to France, which flourished briefly but impressively during the mid-1880's before being superseded in the next decade by the far more mechanized procedures of photographic color separation and three-color "process" printing. In the *chromotypogravure,* an odd and largely forgotten cul-de-sac in the development of modern commercial color printing, one can find several parallels to the practice and goals of the Neo-Impressionists, parallels that, explored below, lend new support as well as historical qualification to Schapiro's characterization of Seurat as "the first modern painter who expressed in the basic fabric and forms of his art an appreciation of the beauty of modern techniques." [9]

• • •

Prior to the 1880's, color printing for mass circulation magazines and newspapers was virtually unknown in France, although it had long been employed in England by papers like the *Graphic* and the *Illustrated London News.*[10] It was in avowed imitation of such English publications that the first color work appeared in France in the early 1880's, principally in *L'Illustration,* beginning with the Christmas issue of 1881 (engraver: Lahure), and in *Paris Illustré,* which was begun in 1883 by Boussod, Valadon & Co. (engraver: Gillot).[11] Although color supplements were published occasionally throughout the decade in other magazines like *Le Monde Illustré,* it was in *L'Illustration* and *Paris Illustré* that examples of the French *chromotypogravure* appeared with the greatest frequency and where its rapid and impressive technical development can be most readily followed.

[6] See, e.g., the comment by Aaron Scharf, *Art and Photography,* London, 1968, 284.

[7] Among others, see R. M. Burch, *Colour Printing and Colour Printers,* New York, 1910, 237–39; R. A. Peddie, *An Outline of the History of Printing,* London, 1917, 49; and E. Courmont, *La Photogravure, histoire et technique,* Paris, 1947, 54, 75.

[8] See William I. Homer, "Notes on Seurat's Palette," *Burlington Magazine,* 101, May, 1959, 192–93; Homer, *Seurat,* 146–53, 171–75; and Robert Herbert, *Neo-Impressionism,* New York, 1968, 18–19.

[9] Schapiro, "New Light on Seurat," 52.

[10] Burch, *Colour Printing,* 235–36.

[11] *Ibid.,* 234–36.

From the late 1860's on, experimental work in color photography, involving the principles of three-color separation and synthesis, had been carried on in France by such innovators as Louis A. Ducos du Hauron and Charles Cros. However, this work, though it would eventually form the basis for modern, three-color "process" printing, remained entirely experimental throughout the 1880's and had no effect upon the techniques of commercial color printing used in France during that decade.[12] According to the author of one contemporary printing manual: "La photographie en couleurs proprement dite n' existe, pour le moment, qu'à l'état théorique . . . ce sont, tout bonnement, des procédés de laboratoire ayant leur mérite, mais qui restent absolument dans le domaine théorique et ne peuvent prendre aucune place sérieuse en industrie et encore moins dans les questions d'art." [13]

While it may be, as Aaron Scharf asserts, that Seurat's connection with a circle that included Charles Cros "would have put him in close touch with the latest developments in natural-color photography," [14] the quality of the images then produced as well as the basically simplistic and, by then, well-known color theory involved could have had little substantive effect upon Seurat's increasingly subtle and complex color practice, the procedures and effects of which are far more closely paralleled by the still only partially mechanized color practice of the contemporary printer.

The aspect of contemporary photography that did seriously affect commercial color printing in France in the 1880's was the photo-mechanical process of printing plate production, a process which had first been introduced commercially in that country during the previous decade.[15] Eliminating the expensive and time-consuming skilled labor that the production of hand-engraved plates had formerly required, the technique of photo-engraving, which, in the late seventies, had revolutionized black-and-white illustrative printing in France, now, in the eighties, facilitated and rendered economically feasible the preparation of the multiple plates required for the reproduction of a polychrome subject. Throughout the decade, however, in the absence of a commercially feasible method of photographic color separation, the crucial task of separating the constituent colors of the subject to be reproduced was one that still depended entirely upon the discriminating and practiced eye of the engraver-printer, whose work required of him, so the technical manuals stressed, "une somme de connaissances et de goût qui en fait un véritable artiste." [16]

12 *Ibid.*, 230–31; also, Courmont, *La Photogravure*, 54–55, and C. Angerer, "Photochromo-typographie," *L'Imprimerie*, May 31, 1887, 1285–87.

13 A.-L. Monet, *Procédés de reproductions graphiques appliquées à l'imprimerie*, Paris, 1888, 236–37.

14 Scharf, *Art and Photography*, 284; also, Homer, *Seurat*, 292, n.64.

15 The first commercial photo-engraving firm in France was opened in 1876 by Charles Gillot (see Courmont, *La Photogravure*, 67). The process, in use experimentallly since the 1850's, depended on the fact that a metal plate covered with a combination of gelatin and bichromate of potash becomes acid-resistant upon exposure to light through a photographic negative, and can then be etched in proportion to its exposure. For a technical description and history of the process, see Peddie, *An Outline of the History of Printing*, 29–30, and W. K. Burton, *Practical Guide to Photographic and Photo-Mechanical Printing*, London, 1887, 11–33.

16 Monet, *Procédés de reproductions graphiques*, 251.

Also required of the color printer in France during the 1880's was a grounding in the same kind of popularized, scientific color theory that fascinated and influenced Seurat. Professional manuals of the period, for example, often included a summary of the work of Chevreul and a discussion of the practical applications of this work to the problems of color printing. Thus, the printer may be advised that, due to the phenomenon of complementary contrast, "l'oeil sera donc mieux disposé à apprécier les moindres nuances de la gamme d'une couleur après avoir absorbé les rayons lumineux de la couleur complémentaire"; and on the basis of the fact that the mixture of two complementary colors will produce black, he is warned against printing, for example, with a transparent orange ink upon a blue paper, for such a combination will produce "une teinte désagréable à l'oeil." [17]

While it was acknowledged that, in theory, the printer could obtain all of the hues of the spectrum from mixtures of the three pigmentary primaries, red, yellow, and blue, in practice it was felt that, normally, "six ou sept couleurs parfaitement décomposées suffisent pour déterminer les effets de chromo," but, "en certains cas plus de six couleurs sont indispensables." [18] The so-called "palette" of printing inks supplied during the eighties by one commercial firm, the house of Lorilleux & Co., consisted, typically, of the following:

Teinte neutre	Chair
Sépia	Rouge violacé
Bistre	Rose
Bleu foncé	Rouge orange
Bleu ciel	Laque rouge
Jaune foncé	Ecarlate
Jaune clair	Sanguin
Vert bleuâtre	Violet.[19]
Vert jaunâtre	

Although the "palette" of the French printer, unlike that of Seurat after *Une Baignade,* contained both earth colors and black,[20] like Seurat's it was made up of a number of colors that are produced by mixing hues that are contiguous to one another on the chromatic circle, for example, *vert bleuâtre, vert jaunâtre, rouge violacé, rouge orange.*[21] Using such a range of graduated hues, the printer, it was claimed, could render "tous les objets de la nature," including, for example, "la grande variété des verts" which are present in a landscape.[22] In seeking to reproduce his

[17] *Ibid.,* 250.
[18] *Ibid.,* 246.
[19] *Ibid.,* 252.
[20] Homer, *Seurat,* 150–51.
[21] Seurat's palette consisted of eleven spectral hues, each of which, according to Neo-Impressionist theory, could be mixed physically only with a color adjacent to it on the chromatic circle or with white. This system was capable of producing extremely subtle gradations both in hue and in value. See Homer, "Notes on Seurat's Palette," 192–93, and *Seurat,* 146–53.
[22] Monet, *Procédés de reproductions graphiques,* 252.

model, usually a watercolor painted specially for the purpose of color reproduction, the color printer, according to the author of a manual published in 1888, relying only upon his eye and taking into consideration the range of colored inks at his disposal, must first "separate" the colors present in the model and then skillfully recombine them, so that, "par leur juxtaposition et leur superposition," a great variety of tones and nuances may be obtained, "de façon que les teintes se transforment l'une par l'autre et produisent des effects rendant exactement l'aquarelle qui a servi de maquette." [23]

In the earliest examples of the French *chromotypogravure*, like those that appeared in the Christmas, 1881, issue of *L'Illustration*, modeling was normally established by means of a photo-engraved line drawing. The latter was usually printed in black, and supplied not only the outline details and half-tones of the image, but also served as the "key" plate to control the registration of the color, which, in these earliest examples, might be limited simply to a single flat tint.[24] From about 1884 on, however, with the introduction into commercial use in France of the half-tone screen,[25] the black line drawing was usually replaced by a screened photograph of the subject, printed in black over the color impressions, which were pulled from a series of uniformly grained plates.[26] This uniform grain, a prominent and distinctive surface feature of the color prints made by this method, was achieved by mechanically covering the plates with a fine dust of powdered resin.[27] Although the texture that results makes possible the speckled juxtaposition as well as superimposition of a great variety of colors that may be printed one after the other, this property of the surface and the effects of optical mixture that might result were in practice usually ignored or only very tentatively exploited by most of the printers who employed this technique. When a screened, black-and-white half-tone plate was used in conjunction with the grained color plates, in practice, very little overlapping between or among the colors was ever permitted. Thus, the graining of the color plates served primarily as a

23 *Ibid.*, 244, 246.

24 *L'Illustration*, 78, No. 2026, December 24, 1881. See also Burch, *Colour Printing*, 234.

25 Here, the negative from which the photo-engraved plate will be made is created by interposing a cross-line screen between the camera lens and the film plane, thus breaking up the continuous modeling of the subject into a series of dots, which recreate through optical mixture all of the tonal gradations of the original. Although experiments with the concept of the half-tone screen date back as far as the 1850's, it was not until the early eighties that the first commercially feasible process was developed. This was the "autotype" process, patented in the year 1882 by the printer George Meisenbach of Munich (Courmont, *La Photogravure*, 69ff). The earliest report of the Meisenbach process in the French press seems to have appeared in the May 15, 1883 issue of the professional journal, *Le Moniteur de la Photographie* (page 73), which published, one month later, in the issue of June 15, a laudatory article and an impressive specimen of Meisenbach's work (pages 91–92). The process does not seem to have been taken up commercially in France until the next year, when, for example, *L'Illustration* used it for the first time in its important *Salon* issue of May 3, 1884, replacing its customary facsimile drawings with half-tone illustrations made directly from photographs of the paintings themselves.

26 Burch, *Colour Printing*, 234.

27 The method used for graining the plates is described by Monet, *Procédés de reproductions graphiques*, 247.

means for making use of the white paper ground in order to vary the intensity of each discrete hue; modeling and relief were still furnished almost exclusively by the screened, half-tone block. This method, which produced a print with the appearance of a tinted, black-and-white half-tone, was the method most frequently employed throughout the decade by *Paris Illustré,* and especially toward the end of the decade, it became the standard method of color printing used in the pages of *L'Illustration* as well.

An alternative method, however, which dispenses with the screened half-tone key plate and relies instead for the creation of modeling upon the grained texture of the color plates themselves, was in use earlier in the decade, particularly for the color work that was published in *L'Illustration* during the years between 1884 and 1887. The earliest examples of the type, published in 1884 and early 1885, employed for the most part a very limited palette of essentially red and green, but often exploited not only the overlapping but also the adjacent placement of the specks of these colors, printed from grained plates, in order to produce a delicate optical brown. This, along with a grained key plate printed in dark grey, provided the modeling for the forms.[28]

Beginning, however, with its special issues for December of 1885 and continuing on into 1887, *L'Illustration* published a series of photo-engraved, color supplements of unprecedented complexity and sophistication in which the forms are no longer simply tinted with a local color, but skillfully modeled by virtue of both the overlapping and the optical mixture of an extraordinary number of speckled hues. The first and most interesting of these, a series of three prints that appeared in the issues of December 5, 12, and 19, 1885,[29] deal, atypically, with subjects whose natural settings (as opposed to the neutral backdrops which prevail in earlier color work of this type) create very specific and complex qualities of atmosphere and illumination, properties that the printing technique itself has been skillfully used to convey. Both of the prints reproduced here deal with contemporary genre subjects: *Le Vieux garçon,* a maid serving coffee to a gentleman who is reading his newspaper on a sunny, outdoor terrace; *L'Hiver,* a maid preparing the traditional Christmas Eve feast. The latter is seated in a semi-darkened interior, back lit, before a window which is partially covered by a transparent curtain, with the buildings in the street beyond lost in a shimmering haze of winter light and snow.

Mass-produced specially for the readers of *L'Illustration,* these ex-

28 See the following color supplements in *L'Illustration:*
 Désappointement (fac-simile d'aquarelle d'après Méry), 84, No. 2173, October 18, 1884;
 Vicenza (fac-simile d'aquarelle d'après Zezzos), 84, No. 2181, December 13, 1884;
 Andreina (fac-simile d'aquarelle d'après Zezzos), 84, No. 2183, December 27, 1884;
 La Réception du 1er janvier à l'Elysée (fac-simile d'aquarelle d'après Émile Bayard), 85, No. 2184, January 3, 1885;
 Au printemps (fac-simile d'aquarelle d'après Gilbert, Michelet SC. imprimature), 85, No. 2209, June 27, 1885.
29 *Le Vieux garçon (peint par Worms)*, 86, No. 2232, December 5, 1885; *La Vieille fille (peint par Worms)*, 86, No. 2233, December 12, 1885; *L'Hiver (préparatifs de Réveillon) (peint par Victor Gilbert, 1884)*, 86, No. 2234, December 19, 1885.

amples of the photo-engraver's art are of extremely high quality for the period. Pulled from grained, relief-etched plates, they present granulated surfaces that are remarkably similar in their appearance and abstract textural consistency to those displayed by Seurat's pictures after the artist's adoption of a pointillist mode of execution at approximately this same time.

It is not, however, simply the similarity in texture and general appearance of the surface that is striking and suggestive (especially if we consider an enlarged detail from one of these prints, as, for example, Fig. 31), but also, and far more important, the optical effects induced by the printed specks of color in their relationships to each other and to the image as a whole. The prints under discussion are distinguished, first of all, by their use of a relatively coarse grain, so that when the 12 x 18″ image is viewed, as intended, at normal reading distance,[30] one's awareness of the grain is not obliterated. Although optical mixture takes place, it does so only partially and produces as a function of scale and viewing distance an optical vibration, which is of course a crucial element in the experience of Seurat's pointillist pictures as well.[31] This optical phenomenon, known as "lustre," which had been observed by the German physicist Dove and described in *Modern Chromatics* by Rood, lends to a painting, in the words of Rood, "a soft and peculiar brilliancy to the surface, and gives it a certain appearance of transparency; we seem to see into it and below it."[32] And it was to this same optical effect that Fénéon referred in 1886 when he wrote of *La Grande Jatte*: "The atmosphere is transparent and singularly vibrant; the surface seems to vacillate."[33]

As Homer reminds us, Seurat used optical mixture "not to create resultant colors that were necessarily more *intense* than their individual components but rather to duplicate the qualities of transparency and luminosity in half-tones and shadows experienced so frequently in nature."[34] Thus, in *Les Poseuses* [Fig. 19], the first of Seurat's pictures to be conceived and executed from the start in small, separately applied dots, Seurat aimed, through the incomplete optical mixture of a wide variety of hues, at producing a shimmering union of color and chiaroscuro, a series of warm and cool neutrals that are vibrant rather than inert, and that color and model forms simultaneously.[35] In the *chromotypogravure,* as in Seurat's pointillist pictures, a set of hues ranging far beyond the pigmentary primaries is also employed, and their juxtaposition, as well as their graduated relationship to the white of the page, is carefully manipu-

30 The supplements are printed across folded pages of the magazine, which, when closed, measures 11 × 15½ in.

31 See Homer, *Seurat*, 142–43, 171–75.

32 *Ibid.*, 143.

33 "L'atmosphère est transparente et vibrante singulièrement; la surface semble vaciller," "La VIIIe exposition impressionniste," *La Vogue*, June 7, 15, 1886, in Félix Fénéon, *Au-delà de l'impressionnisme*, ed. F. Cachin, Paris, 1966, 67. Cited and translated by Homer, *Seurat*, 142.

34 Homer, *Seurat*, 170.

35 *Ibid.*, 167, 169. *Les Poseuses* appears as No. 185 in the two-volume catalogue of Seurat's paintings and drawings by César M. de Hauke, *Seurat et son oeuvre*, Paris, 1961 (to be cited hereafter as CdH).

lated to create, through incomplete optical mixture, not hues of greater intensity, but subtle half-tones and shadows that model the forms chromatically and create an ambient that is remarkably luminous and transparent.

For the optically induced effects of chromatic modeling that Seurat finally achieved in *Les Poseuses,* the *petit point* was the perfect and, it would appear, the inevitable vehicle, for not only did it facilitate optical mixture, but it also enabled the artist to record, by means of carefully controlled dosages of pigment, the most minute alterations and transitions in color and tone from point to point across his canvas. Yet for several years prior to his adoption of the *petit point,* and with optical mixture already his goal, Seurat had experimented with a variety of far more conventional modes of pigment application from which he had tried to wrest the desired optical results with only limited success. These techniques, from which the *petit point* may be considered, in some sense, to have evolved, provide us with the necessary context and background for the final emergence of Seurat's fully developed facture. Therefore, they are reviewed below briefly, to help us in assessing the importance that parallel developments in commercial color printing may have had for Seurat at this time.

In his search for the optically induced half-tone, Seurat developed a technique of black-and-white drawing, long before his pointillist painting, which, though unrelated to pointillism as a method of execution, nevertheless implies the possibilities and parallels some of the effects of the mature painting style. The first of the dated drawings in which he fully and consistently exploited this technique—a technique for which drawings by older artists like Millet provide the precedent—was *La Couseuse* (CdH 512), inscribed "18 Juillet '82" [Fig. 2].[36] This drawing is executed, typically, in conté crayon on the rough-toothed Michallet paper that Seurat favored, a paper with an emphatic grain that permits the draftsman's crayon to adhere only to the peaks of the granulations, leaving the hollows between untouched. The luminous and vibrating "screen" thus created functions through optical mixture to model forms continuously, producing half-tones of great richness and subtlety. But although the possibilities of pointillist execution may be, as Homer has said, "implicit" in such drawings from Seurat's pre-pointillist period,[37] it was in reality not the "dot" that was discovered by Seurat in his drawings before his pointillist paintings, but, rather, the optical advantages that may accrue from the use of a relatively uniform and abstract surface texture. The apparently discrete points of black and white revealed by close examination of the surface of one of Seurat's mature conté crayon drawings were not applied singly, but were achieved in a technically much more traditional manner, by dragging the crayon across the paper's surface.

In his paintings, as early as the *Sous-bois à Pontaubert* of 1881–82 [CdH 14; Fig. 1],[38] Seurat tried experimentally to achieve a surface

36 On the evolution of Seurat's drawing style, see Robert Herbert, *Seurat's Drawings,* New York, 1962.

37 Homer, *Seurat,* 103.

38 On the dating of this picture, Robert Herbert has written: "Many observers have felt that the only explanation for the dabbed texture is a later reworking by the artist, but

texture consonant with the requirements of optical mixture, in this instance, both by dabbing the pigment irregularly in the manner of the Barbizon painters and by exploiting in certain sections of the work the weave of the canvas itself to create, with a broadly stroked, dry-brush technique, the effect of a two-color grid. The latter is composed of elements that are apparently uniform and discrete, but which, as in Seurat's drawings of the same period, have not been applied individually.[39] This dry-brush translation into painting of a technique that Seurat had already explored in his conté crayon drawings occurs again in *Une Baignade, Asnières* [CdH 92; Fig. 6], where it is used to engender, through optical mixture, the modeling effects of half-lights and shadows in the description of the flesh and the clothing of the figures [Fig. 7]. Optical mixture is also achieved in this picture by the use of short, multi-directional, *balayé* strokes, found particularly in the grass and trees [Fig. 7]. These are applied as regular cross-hatchings and serve, in the words of Homer, "as a uniform web or mesh to conceal part of the underlying hue while simultaneously adding a new component." [40] These methods of execution, related in principle to those already explored by Seurat in earlier drawings, are limited in practice by the fact that, in any small area of the work, they can efficiently induce the optical mixture of just two elements—for example in the dry-brush method, one color, picked up by the projecting threads of the canvas weave, modifying a second, underlying color, which remains untouched and still visible in the interstices. In painting, this method will produce nowhere near the rich range of modeling and transparent atmospheric effects that the application of a similar principle, with similar limitations, can achieve in black and white. In these pre-pointillist paintings, moreover, unlike the drawings, Seurat never used a single method of execution exclusively in any work. Instead, he avoided a uniform surface texture and continued to manipulate his variegated brushwork in a more traditional manner, in response to the shapes, textures and directions of things described.

Although much has been written about the sources and application of Seurat's color theory, remarkably little is known about the origins of the unusual technique of paint application that he began to use consistently from the winter of 1885–86 on in order to achieve his theoretical ends. The isolated occurrences of small spots of pigment, cited by Homer

this does not seem to be the case. Instead, it is a perfectly logical outgrowth of Seurat's immersion in Barbizon style. The pigments are those he used in 1881–1882 and not the ones of 1883 and after. There are several earth tones, a russet color and an olive green, and he has not yet begun to use the wine reds, lavenders, pale blues and blue-greens he later favored. Since a number of the dabs supposedly added later are of the earth tones, one must assume that they were a part of the picture from the beginning" (*Neo-Impressionism*, 101).

39 These comments are based on Herbert's description of the surface (*Neo-Impressionism*, 101).

40 Homer, *Seurat*, 87–88. A third type of brushwork which Homer describes in this picture is found primarily in the water (see Fig. 7) and consists of long, thin, parallel strokes that are uniformly horizontal in direction. While this type of brushwork permits the introduction in any area of a great variety of hues, it is also, as Homer points out, less conducive to optical mixture than are the other two techniques described.

as precedents, in canvases by Murillo, Delacroix, and Monet, all artists whom Seurat had studied,[41] could not have provided a sufficient source of inspiration for Seurat's unprecedentedly systematic pointillist facture, and do not help to explain why the new technique emerges in Seurat's painting precisely when it does. Nor can we regard the theoretical sources available to Seurat as the immediate or sufficient stimuli for his adoption of a pointillist technique. Such a technique, designed to facilitate optical mixture, had been described and diagrammatically illustrated as early as 1867 by Charles Blanc in his *Grammaire des arts du Dessin*,[42] a book that Seurat read sometime before 1879, while still "au collège." [43] And a similar technique, to be applied toward similar ends, had also been recommended by Dr. Jean Mile and John Ruskin, whose ideas would have reached Seurat via Ogden Rood's *Modern Chromatics* (New York, 1879), the translation of which Seurat had in his possession by 1881. [44] But while inspired by these readings to pursue the benefits of optical mixture in his paintings for several years prior to *La Grande Jatte,* Seurat had not acted concurrently upon the related technical recommendations that these same sources made. These recommendations, in themselves, were apparently insufficient to induce him to abandon the scientifically less satisfactory but artistically more conventional mode of variegated pigment application that he employed in 1883–84 for his first major canvas, *Une Baignade,* and to which he still adhered in 1884–85 when he painted the first completed version of *La Grande Jatte.* The latter [CdH 162; Fig. 15], according to Seurat's own account, was begun in the spring of 1884 and was ready to be shown in March of 1885 at the Indépendants, an exhibition that was canceled. Back in Paris in October, after summering in Grandcamp, Seurat resumed work on the canvas, which was finally shown at the eighth and last Impressionist exhibition in May of 1886.[45] During this interval Seurat repainted his large canvas, superimposing upon the irregular brushwork of the already completed picture a layer of small dots, which are relatively uniform in size and in shape, and which optically modify but do not entirely cancel or conceal the areas of local color that lie beneath. Although a separated or dotted stroke appears in several of Seurat's earlier studies for *La Grande Jatte,* these still partake of the scale and informality of the preliminary sketch, and the brushwork remains, accordingly, broad and irregular. The same observation may be made of the *plein air* studies executed by Seurat at Grandcamp during the summer prior to his final adoption of the pointillist technique [CdH 146–54, 156, 158]. A finely textured, dotted stroke is an integral part of the execution of at least one of the finished paintings done by Seurat on the basis of these studies

41 Homer, *Seurat*, 145–46.

42 Cited and summarized by Homer, *Seurat*, 32–33.

43 Letter from Seurat to Fénéon (June 20, 1890), in CdH, 1, xxi. See, also, Homer, *Seurat*, 17, 268–69, n.21.

44 Homer, *Seurat*, 17, 18–19, 270, n.28; 144–45.

45 See the letter from Seurat to Fénéon (June 20, 1890) in Henri Dorra and John Rewald, *Seurat; l'oeuvre peint; biographie et catalogue critique,* Paris, 1959, xxvii–xxviii. On the three extant versions of this letter, see Homer, *Seurat*, 268, n.20.

[*Le Bec du Hoc à Grandcamp,* CdH 159], but all of these works [see, also, CdH 155 and 157], executed probably in the fall or early winter of 1885, are still painted to varying degrees in the manner of *Une Baignade,* displaying descriptive variations in stroke size and direction.

Although it may now seem to us that the dot was the "inevitable" solution to the optical problems Seurat set himself, we must not forget that there was an important factor that would have militated against his immediate acceptance of this method of execution and the uniformly textured pigment surface it implied. Indeed, the reactions that Seurat's pointillist pictures elicited when they were first exhibited may help us to grasp the nature of the reservations Seurat himself may have initially entertained. For, notwithstanding Fénéon's contention that "cette peinture n'est accessible qu'aux peintres," [46] the "mechanical" technique of the Neo-Impressionists (as it was called by Sisley [47]) proved understandably offensive not only to the public at large but also to many artists of the Impressionist and Post-Impressionist generations, artists whose attachement to a romantic conception of originality and spontaneous self-expression in painting was threatened by the apparently impersonal attitude of Seurat and his followers toward the execution of their works. But if the "mechanical" aspects of the *petit point* may have had negative associations when viewed within a purely aesthetic context, they may well have assumed a more positive value when considered from the point of view of the progressive political and social attitudes with which Seurat was then associating himself. It was, in fact, precisely the "mechanical" aspect of the technique, so foreign to contemporary notions of fine taste and "high art," that, in these terms, may ultimately have proved attractive to Seurat, whose radical political leanings and "democratic" predilection for popular art forms had already become important formative factors in the evolution of his attitudes toward his own art.[48]

Given Seurat's sensitivity to popular and commercial art forms in general, it is reasonable to suppose that he would have been at the very least interested in the unusual and impressive examples of illustrative chromotypography that appeared in the popular press in France from 1884 on, and provided at so many points both visual and technical analogies with what he was trying to achieve in his own work at this time. Such an interest conceivably could have been fostered or augmented by Seurat's connection with Lucien Pissarro, eldest son of Camille Pissarro, the Impressionist painter who met and became a follower of Seurat in October of 1885, when the latter was about to undertake the repainting of *La Grande Jatte.*[49] Lucien, who was later to make a name for himself as an art printer and book illustrator, had learned the processes of commercial color printing at the Parisian publishing firm of the art dealer Manzi,

[46] Félix Fénéon, "L'Impressionnisme scientifique," *L'Art moderne,* September 19, 1886, in Félix Fénéon, *Au-delà de l'impressionnisme,* 80.

[47] In a letter of April 21, 1898, cited by Rewald, *Seurat,* 126.

[48] See Eugenia W. Herbert, *The Artist and Social Reform, France and Belgium, 1885–1898,* New Haven, 1961, 181–82, 184–85.

[49] Rewald, *Post-Impressionism,* 86.

where he took a job possibly as early as the spring of 1884, and where he apparently continued to work during the years when, as a follower of Seurat, he, too, painted in the pointillist mode. That Seurat was not unaware of these activities is indicated by his letter of August 1887 to Signac, in which he remarked: "Lucien fait de la chromo rue du Cherche-midi (dure chose) ." [50]

But whatever its source, an interest on Seurat's part in the products of commercial chromotypography would not have been out of keeping with what we already know of the predilections of this artist, who, from early youth, collected primitive broadsides and popular illustrations, and, later, the lithographic posters of Jules Chéret,[51] an artist who could see beauty in modern technology, and who could respond in these terms to a structure like the sleek and shimmering, iridescently enamelled Eiffel Tower, at a time when to assume such an attitude was of course to present a challenge to all conventional notions of fine taste.[52] Nor was it unusual for Seurat, at various times during his career, to assimilate the techniques and effects of contemporary commercial image-making into his own artistic practice. As Robert Herbert has shown, not only were some of Seurat's late works like *Le Cirque* [Fig. 29] influenced in imagery, drawing style, and composition by the posters of Jules Chéret,[53] but even as a youth, between the ages of about twelve and fifteen, Seurat was already fond of copying and imitating journalistic illustrations, paying scrupulous attention to their surface features and preserving in his copies, as Herbert has noted, many of the printed linear irregularities of the technically crude reproductions from which he worked. [54]

In the light, then, of Seurat's established sensitivity to popular imagery and to the mass media, both at the very beginning and at the end of his career, the similarities between the surface effects of the contemporary *chromotypogravure* and the revolutionary conception of surface that he and his followers first presented to the public as "high art" in May of 1886 become intriguing in their implications. The abstract surface texture of these unusual color prints, relatively uniform and impersonal, yet at the same time remarkably responsive to the eye and to the controlling sensibility of the commercial "artist"-printer, may conceivably have provided Seurat with timely reinforcement at a crucial moment in the evolution of his own technique, a technique that, like its commercial counterpart, had as one of its principle aims the achievement of chromatic modeling through optical mixture. At the very least, the emergence and mass circulation of the *chromotypogravure* in France dur-

50 The letter appears in Dorra-Rewald, *Seurat*, lxi. For the spring 1884 date, see John Rewald and Lucien Pissarro, eds., *Camille Pissarro, Lettres à son fils, Lucien*, Paris, 1950, 83, and John Rewald, "Lucien Pissarro: Letters from London, 1883–1891," *Burlington Magazine*, 91, 1949, 190.

51 See Robert Herbert, "Seurat and Jules Chéret," *Art Bulletin*, 40, June, 1958, 156–58, and Herbert, *Seurat's Drawings*, 12, 33, 166, n.6.

52 Discussed by Schapiro, "New Light on Seurat"; also, John Russell, *Seurat*, New York, 1965, 219.

53 Herbert, "Seurat and Jules Chéret," 156–58.

54 Herbert, *Seurat's Drawings*, 14, 166.

ing the mid-1880's provides us with a climate or a context, on the level of commercial color printing, in which Seurat's progressive departure during these years from established avant-garde attitudes toward questions of surface and brushwork can be freshly situated and its significance reassessed. It is a departure that may now be seen, in part, as yet another aspect of Seurat's complex and recurring response to commercial and popular printed images, a body of material that helped to shape his tastes and radically affected his vision at several points throughout his brief career.

Biographical Data

1859	Born in Paris, 2 December.
1875	Studies drawing with Justin Lequien at the *Ecole Municipale,* where he meets Edmond Aman-Jean.
1878–1879	Studies at the *Ecole des Beaux-Arts* with Henri Lehmann, a student of Ingres (admitted to the painting course on 19 March 1878); rents a studio in the rue de l'Arbalete with Aman-Jean; reads Charles Blanc and becomes acquainted with the precepts of Chevreul and Delacroix through this source.
1879	November, begins a year of military service at Brest on the Breton coast, his first contact with the sea; February–March, reads Sutter's ideas on Greek art in the magazine *L'Art.*
1880	November, returns to Paris and finds a studio on the rue de Chabrol; devotes himself to drawing.
1881	Reads a review published in *Le Figaro* on 26 January of Ogden Rood's *Théorie scientifique des couleurs* (the French edition of *Modern Chromatics*), and obtains a copy of the book shortly thereafter; studies and makes notes (dated February, May, and November) on paintings by Delacroix seen in Parisian galleries.
1882	July, the earliest dated example of his mature, fully tonal drawing style (CdH 512).
1883	Exhibits at the Salon—for the first and last time—a drawing of his friend Aman-Jean (CdH 588); begins work on the *Baignade.*
1884	15 May–1 July, exhibits the *Baignade* at the Salon of Independent Artists, where he meets Paul Signac; December, exhibits the *Baignade* and a study for the *Grande Jatte* at the First Exhibition of the Society of Independent Artists.
1885	Winter, works on the *Grande Jatte;* summer in Grandcamp; fall, introduced to Pissarro by Signac; resumes work on the *Grande Jatte.*
1886	March, exhibits *Baignade* in New York (exhibition entitled *Works in Oil and Pastel by the Impressionists of Paris,* organized by Durand-Ruel); 15 May–15 June, exhibits the *Grande Jatte,* upon Pissarro's invitation, at the Eighth Impressionist Exhibition; summer in Honfleur; 20 August–21 September, exhibits the *Grande Jatte* at the Second Exhibition of the Society of Independent Artists; becomes acquainted with Félix Fénéon and Charles Henry; accepts invitation

to exhibit with Les XX in Brussels; begins work on *Les Poseuses* in the fall.

1887 February, exhibits the *Grande Jatte* with Les XX in Brussels and attends opening of exhibit with Signac; retouches the *Baignade* upon its return from New York; works on *Les Poseuses* and *La Parade*.

1888 22 March–3 May, exhibits *Les Poseuses* and *La Parade* at the Fourth Exhibition of the Society of Independent Artists; summer in Port-en-Bessin.

1889 February, exhibits *Les Poseuses* with Les XX in Brussels; summer in Le Crotoy, painted borders appear on his canvases for the first time in the Le Crotoy seascapes (D.-R. 192, 193); 3 September–4 October, exhibits Le Crotoy seascapes at the Fifth Exhibition of the Society of Independent Artists; works on *La Poudreuse* (portrait of his mistress, Madeleine Knobloch) and *Le Chahut*.

1890 Jules Christophe's biography of Seurat appears in *Les Hommes d'aujourd'hui* (N. 368, March or April); 20 March–17 April, exhibits *La Poudreuse, Le Chahut,* and the Port-en-Bessin seascapes at the Sixth Exhibition of the Society of Independent Artists; summer in Graveline; 28 August, writes letter to Maurice Beaubourg correcting the exposition of his theories that had appeared in Christophe's biography; begins work on *Le Cirque*.

1891 February, exhibits *Le Chahut* with Les XX in Brussels; 20 March, opening of the Seventh Exhibition of the Society of Independent Artists, where Seurat shows his unfinished *Le Cirque*; 29 March, Seurat dies after a brief illness, variously described as an infectious angina or a form of meningitis, resulting from a cold that he reportedly caught at the exhibition; his son dies of the same illness shortly thereafter; 30–31 March, funeral services and burial at Père Lachaise Cemetery; Seurat's family appoints Signac, Luce, and Fénéon to help Seurat's brother with the preparation of an inventory of the artist's studio; [1] half of Seurat's estate is given by his family to Madeleine Knobloch.

[1] See CdH, pp. xxix–xxx.

A Selected List of Posthumous Exhibitions [1]

1892 * February, Les XX, *Retrospective Seurat,* Musée Moderne, Brussels.
 * 19 March–27 April, Society of Independent Artists, *Exposition Commémorative Seurat,* Pavillon de la Ville de Paris, Cours La Reine, Paris (46 works catalogued).

1900 * 19 March–5 April, *Georges Seurat,* La Revue Blanche, Paris (39 paintings and 14 drawings catalogued).

1903 January–February, *Weiner Secession,* Vienna.

1904 * 25 February–29 March, La Libre Esthétique, *Exposition des Peintres Impressionnistes,* Brussels (7 works).

1905 * March, Society of Independent Artists, *Exposition Retrospective Seurat,* Paris (44 works catalogued).

1908–1909 * 14 December–9 January, *Georges Seurat,* Galeries Bernheim-Jeune, Paris (205 works catalogued).

1910–1911 8 November–15 January, *Manet and the Post-Impressionists,* Grafton Galleries, London.

1920 * 15–31 January, *Georges Seurat,* Galeries Bernheim-Jeune, Paris (62 works catalogued, preface by Paul Signac).

1926 April–May, *Exhibition of Pictures and Drawings by Georges Seurat,* Lefevre Galleries, London.
 * 29 November–24 December, *Les Dessins de Seurat,* Galerie Bernheim-Jeune, Paris (140 works catalogued, preface by Lucie Cousturier).

1936 * 3–29 February, *Seurat,* Galerie Paul Rosenberg, Paris (130 works catalogued).
 2 March–19 April, *Cubism and Abstract Art,* Museum of Modern Art, New York.

1949 * 19 April–7 May, *Seurat, 1859–1891, Paintings and Drawings,* Knoedler Galleries, New York.

1950 *Disegni di Georges Seurat,* XXVᵉ Biennale, Venice.
 Disegni di Seurat, Galleria dell'Obelisco, Rome (preface by U. Appollonio).

1953 18 November–26 December, *Seurat and His Friends,* Wildenstein Galleries, New York (preface by John Rewald).

1958 * *Seurat*: 16 January–10 March, Art Institute of Chicago; 24 March–11 May, Museum of Modern Art, New York (prefaces by D.C. Rich and R.L. Herbert).

[1] This brief list has been selected from the comprehensive listing of Seurat exhibitions in D.-R., pp. 281–87. For entries marked with an asterisk, the reader will find a facsimile reproduction of the exhibition catalogue in CdH, vol. 1, pp. 215–54.

A Brief History of Some of Seurat's Major Paintings*

Une Baignade, Asnières (D.-R. 98; CdH 92)
 1883–1884; retouched, c.1887
 Collections:
 Mme. Seurat (the artist's mother), Paris; Émile Seurat (brother) and Léon Appert (brother-in-law), Paris; Félix Fénéon, Paris (acquired in 1900); Percy Moore Turner, London (acquired for 300,000 francs); Samuel Courtauld, London; Tate Gallery, London (Courtauld Fund, 1924)
Un Dimanche d'Été à l'Ile de la Grande Jatte (D.-R. 139; CdH 162)
 May 1884–March 1885; work resumed in October 1885; completed by May 1886
 Collections:
 Mme. Seurat, Paris; Louis Appert, Paris; Émile Seurat, Paris (until 1900); **Casimir Brû,** Paris (acquired for his daughter, Lucie, in 1900 for 800 francs); **Mme. Lucie Brû Cousturier** and Edmond Cousturier, Paris; Mr. and Mrs. Bartlett, Chicago (bought in Paris in 1924 for $24,000); The Art Institute of Chicago (Helen Birch Bartlett Memorial Collection, since 1926)
Les Poseuses (D.-R. 178; CdH 185)
 Autumn 1886–Spring 1888
 Collections:
 Gustave Kahn, Paris (from 1892); Vollard, Paris; Harry Comte Kessler, Weimar (acquired from Vollard for 1,200 francs); Hodebert, Paris (acquired in 1926); Dr. Barnes, Merion, Pa. (acquired in 1926); Barnes Foundation, Merion, Pa.
La Parade (D.-R. 181; CdH 187)
 Winter 1887–early 1888
 Collections:
 Seurat Family, Paris; Bernheim-Jeune, Paris; Knoedler, New York (in 1930); Stephen C. Clark, New York (from 1933); Metropolitan Museum of Art, New York (Stephen C. Clark Bequest, from 1961)
Le Chahut (D.-R. 199; CdH 199)
 1889–1890
 Collections:
 Gustave Kahn, Paris (acquired in 1890); Julius Meier-Graefe, Paris (acquired

* For a more complete history of these and other works by Seurat, the reader is referred to the *catalogue raisonné* by Dorra and Rewald, from which the information offered here is principally derived.

in 1897 for 400 francs); Druet, Paris; Grunewald, Berlin (?); Richard Goetz, Paris (Goetz, a German citizen, offered the painting to the Louvre in 1914 when war was declared, but his offer was not accepted); Mme. Kröller-Müller, The Hague (bought at auction in 1922 for 32,000 francs); Rijksmuseum Kröller-Müller, Otterlo

Le Cirque (D.–R. 211; CdH 213)

1890–1891

Collections:

Mme. Seurat, Paris; Léon Appert and Émile Seurat, Paris; Paul Signac, Paris (bought in 1900 for 500 francs); John Quinn, New York (until 1926); bequeathed by Quinn to the Louvre in accordance with an agreement made with Signac at time of purchase; Louvre, Paris (John Quinn Bequest, 1927)